廃墟

HAIKYO

THE MODERN RUINS OF JAPAN

PHOTOGRAPHY BY SHANE THOMS

KYO
RUINS OF JAPAN

ok are based on materials supplied to the publisher
has been made to ensure its accuracy,
der any circumstances accept responsibility for
t with regards to all contributions remains with

n. As publishers we're obliged to say it's not meant
al. So we are.

ailable from the British Library.

7 by Carpet Bombing Culture.
ns

co.uk
Communications

ngculture.co.uk

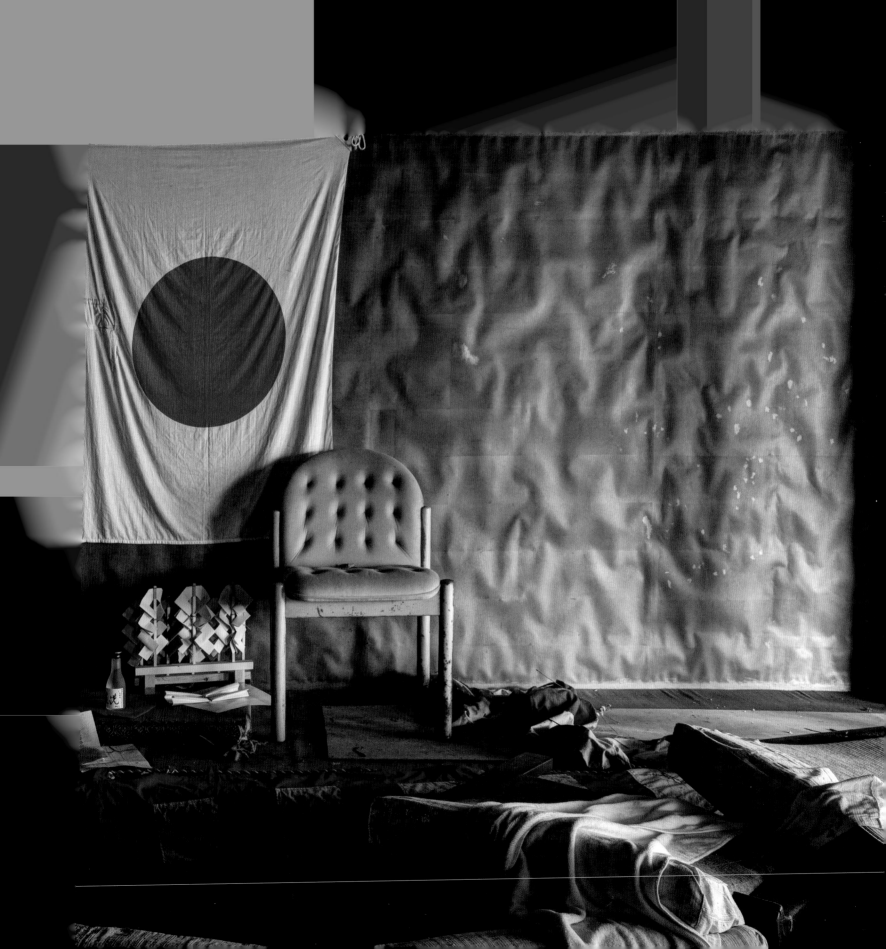

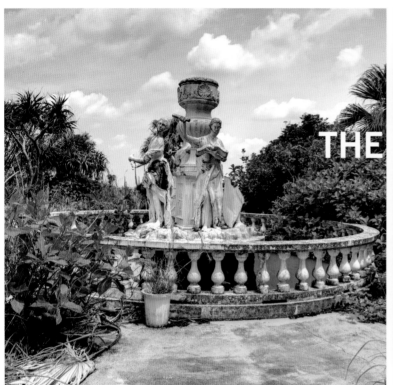

THE MODERN RUINS OF JAPAN

INTRODUCTION

With mazes of expressways pushing scores of traffic through densely populated, neon lit cities, there is perhaps no better platform than Japan to grasp the full motion and machinery of life. But sitting silently in the shadows waits another realm. Just as intoxicating, enchanting and engaging as its counterpart albeit not as animated or ablaze with flashing lights, hundreds of abandoned abodes lie forgotten and left to decay. From the snowy mountains of Hokkaido down to the southern tropics of Okinawa, these modern ruins or, *'haikyo'*, provide a paused and romantically silent contrast to a country known for the brightness, sound and movement that swells in so many of its thriving metropolises.

Miniature jungles sprout in the rooms of a discarded beachside resort. Filled with eccentric furnishings, a long forgotten love hotel crumbles on the outskirts of a rural town. After years of abandonment, vines and foliage engulf roller coasters in a swampy amusement park while rows of stools await more patrons in a dusty, dilapidated strip club.

As captivatingly curious as these visual narratives are, it is difficult to piece together each story without understanding the reasons behind such desertions. Questions are also raised as to the events that led to such a magnitude of derelict places with some

people arguing that, while not entirely responsible for the abandonment of all of the locations presented in this publication, the tumultuous economy of the 1990's is perhaps attributable in part to this outcome.

The industrious and affluent post World War II Japan of the 60's and 70's warranted the creation of a number of new buyer-driven industries. In the decades to follow, over-lending combined with problematic inflation resulted in a number of Japanese firms accruing financial losses and bad debts. A collapse in the asset price bubble subsequently threw the nations once thriving economy into a decline, leaving in its wake a

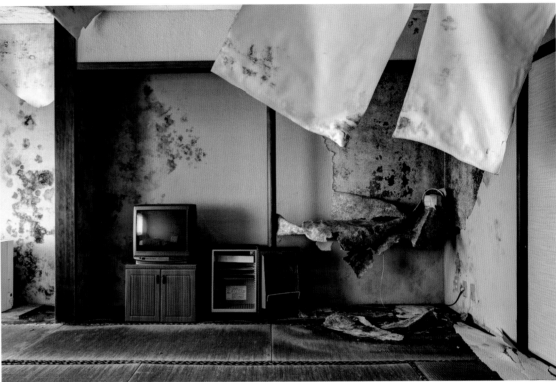

廃墟

number of liquidated companies whose discarded spaces formed the residue of this harsh financial downturn. Further enhancing these woes is Japans decreasing birth rate where dwindling population levels have impacted small town enterprises, forcing an abundance of young people to desert these areas to pursue employment opportunities in larger cities.

Japans modern ruins extend outwardly into a myriad of industries, services and trades - and again, the consequences of a problematic economy or shrinking birth rate are not the sole key drivers to be blamed for all of these diminishments. Schools,

hospitals, factories, mines and other entities all over Japan have ceased operating for a number of different reasons with the exploration of each space revealing at least some fragment of what is its own unique narrative.

As the explorer ventures further down the haikyo trail it becomes evident that the more leisure-focused enterprises form a large chunk of this abandoned realm. Initially constructed to provide an atmosphere of relaxation and escape from the daily routine, the abandoned hotel or beachside resort cannot be viewed without a dash of melancholy. As these empty guest rooms

crumble in the darkness, the ghosts of former patrons still linger in these empty shells of what were once places of joyful retreat.

Focusing on Japans infamous abandoned theme parks, these colourful, energetic spaces existed to inject a shot of excitement into the patron. Once filled with colour, sound and movement, these artificial and, usually, thematic domains fictionalized the living world, becoming universes unto themselves within a fenced off perimeter. Now abandoned, the emotional traces of a happiness long gone still remain. And while it's all very romantic as green vines engulf gigantic rollercoasters, the explorer realizes

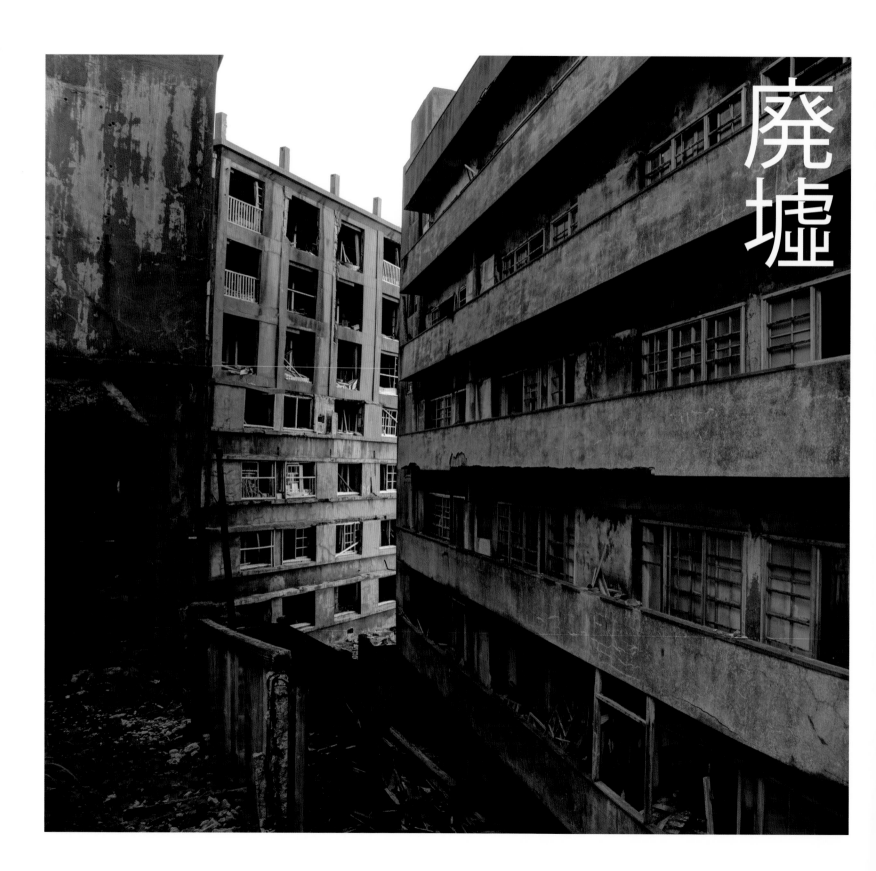

廃墟

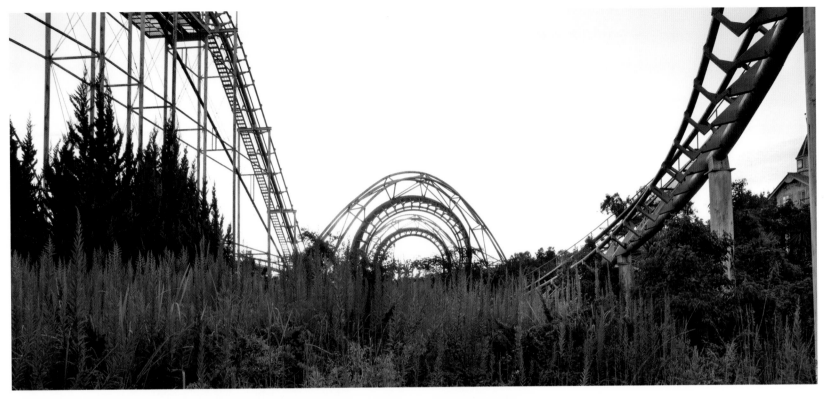

THE MODERN RUINS OF JAPAN

that the smiling people were the lifeblood of this now lifeless corpse.

Stepping away from the wider deserted commercial areas and into the more intimate interior of the traditional Japanese room *(washitsu)*, what makes these decayed dwellings so different to the forgotten haunts commonly explored in other parts of the world is the thoughtful structure of the space. Meticulously considered in accordance with the Japanese aesthetic, these delicate interiors embody a household area where tradition is valued and important. Culturally profound elements such as *shoji* screens, *tatami* mats, *tokonoma* alcoves and *fusuma*

doors all work cohesively to create an environment where the family spirit is encapsulated and preserved. When viewed in a state of decay, these sensitive realms invoke a magnified reflection on the inner journeys of the dwellings' former occupants. In contrast, the deserted living spaces explored in Europe, America and other western nations perhaps induce only a one dimensional, materialistic, money-focused examination on the loss of ones wealth and/or financial prosperity.

All visually enchanting and magical, these silently beautiful modern ruins offer a glimpse into a more secret side of Japan that is

seldom viewed or experienced by foreigners. Rich with cultural significance, each abode becomes a platform where the explorer can reflect upon this resilient countries' hidden journey from permanence to disposability, composition to decomposition and construction to deconstruction.

Shane Thoms, 2017

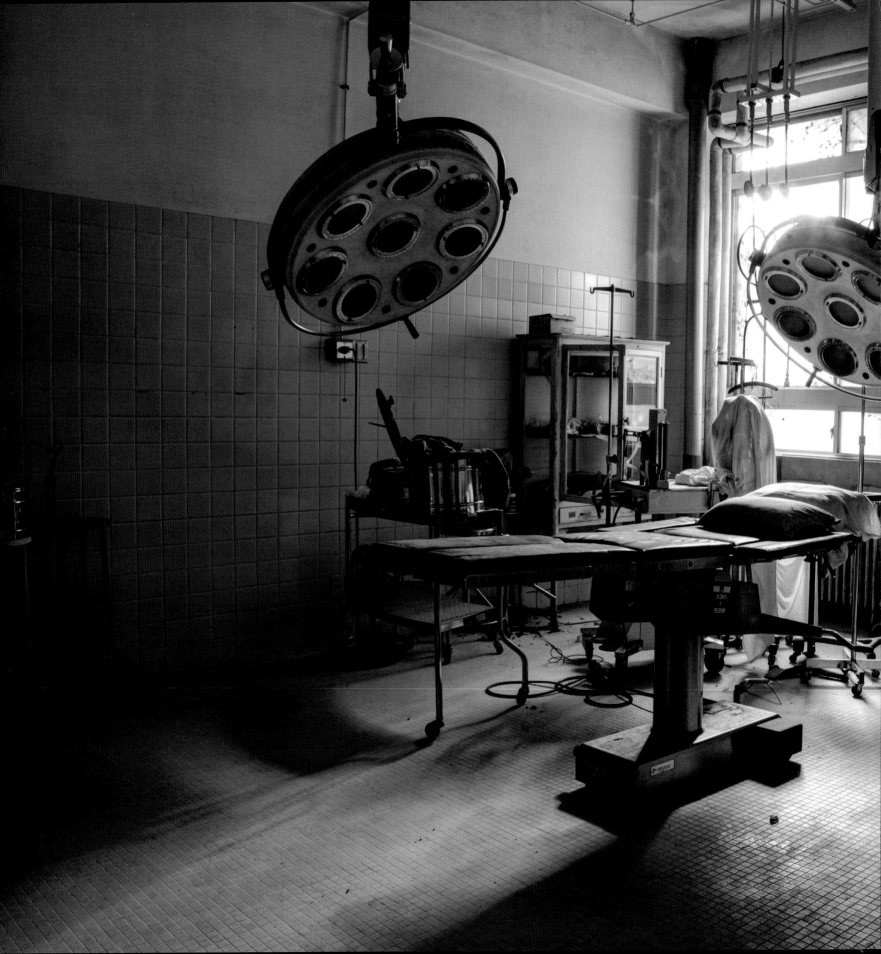

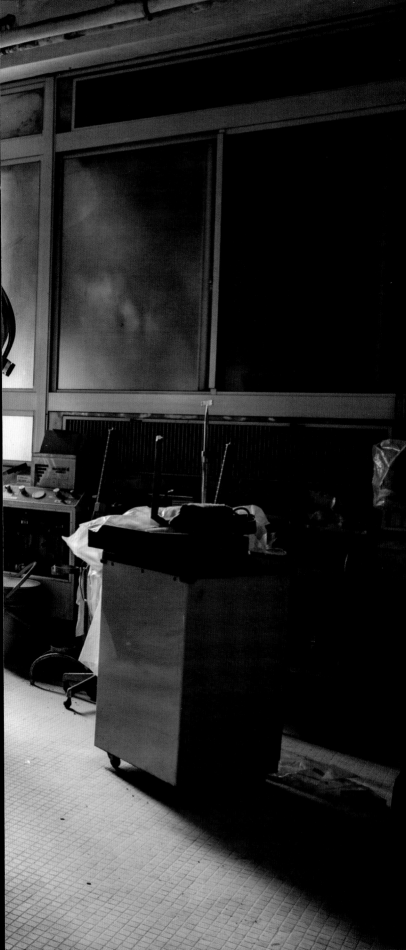

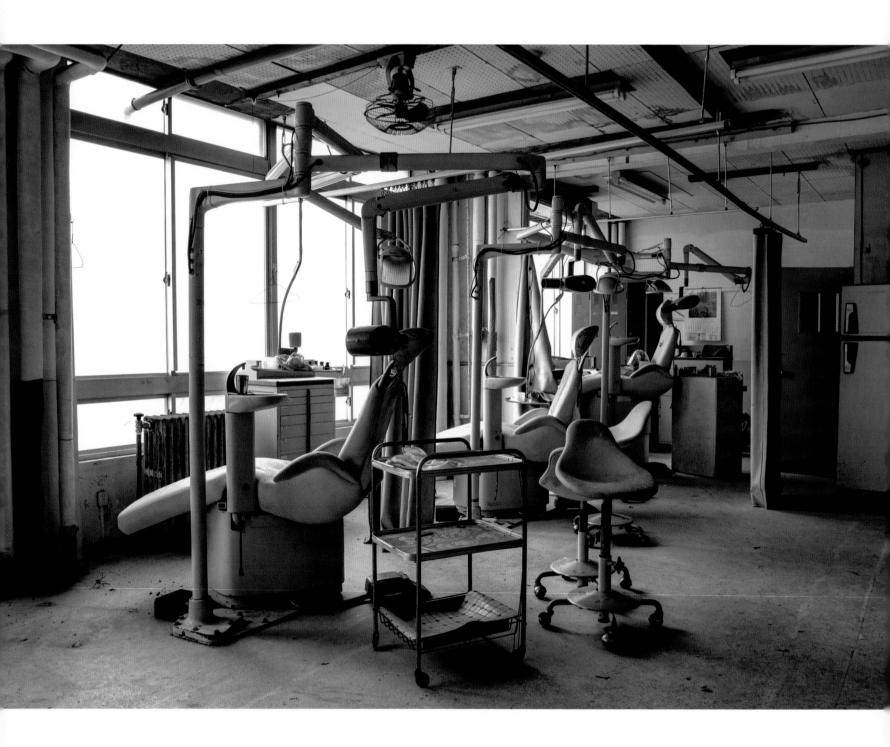

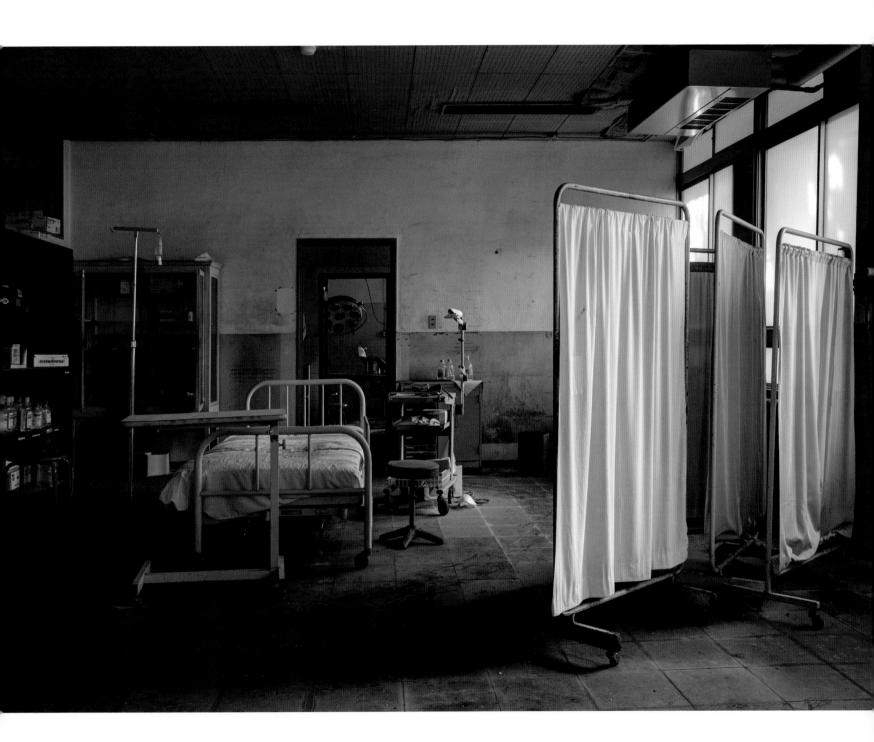

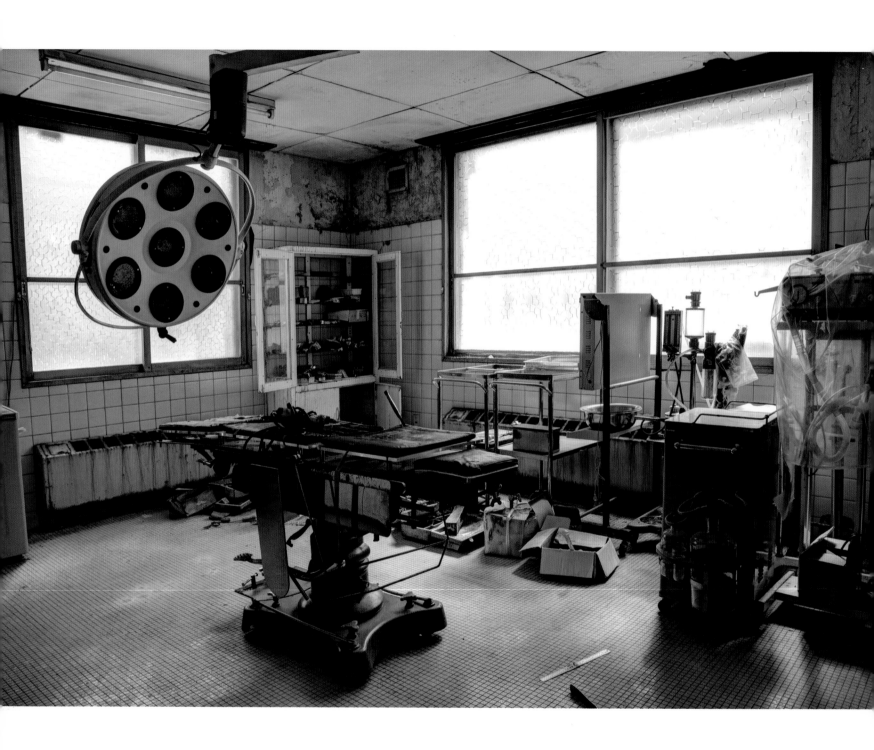

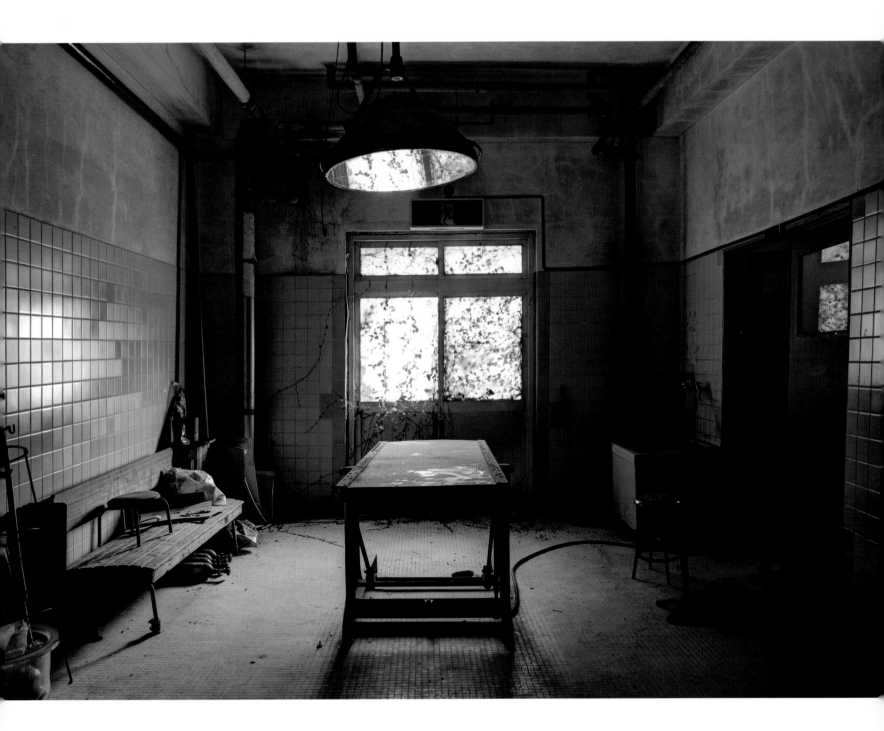

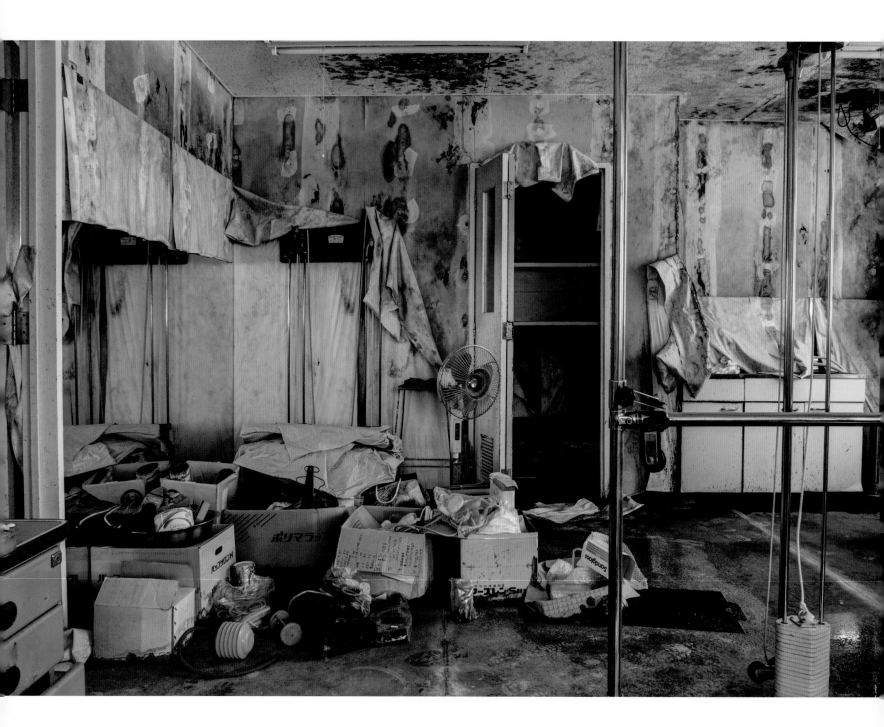

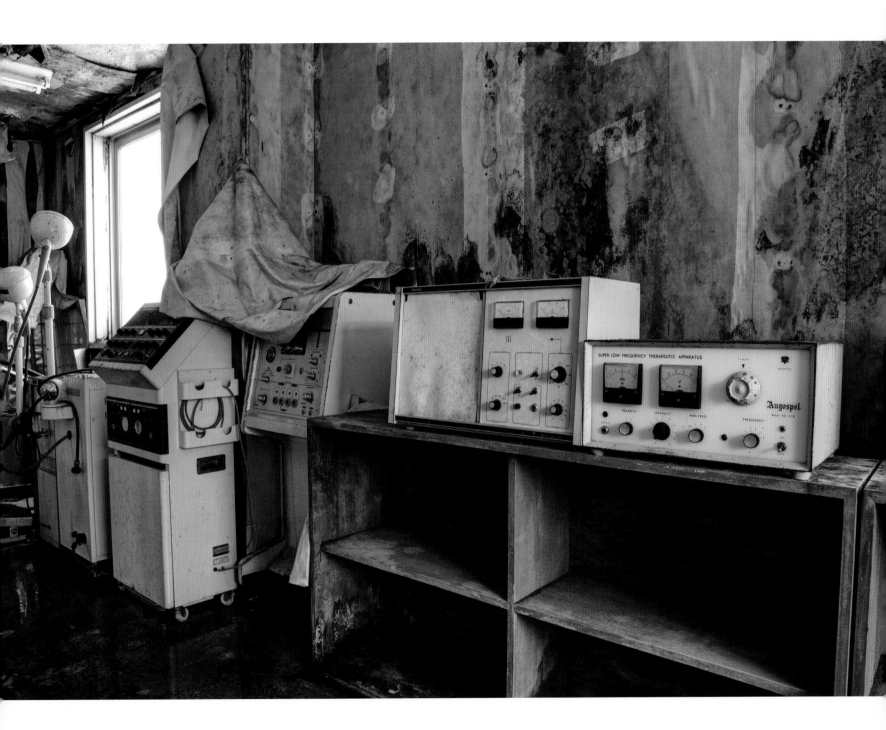

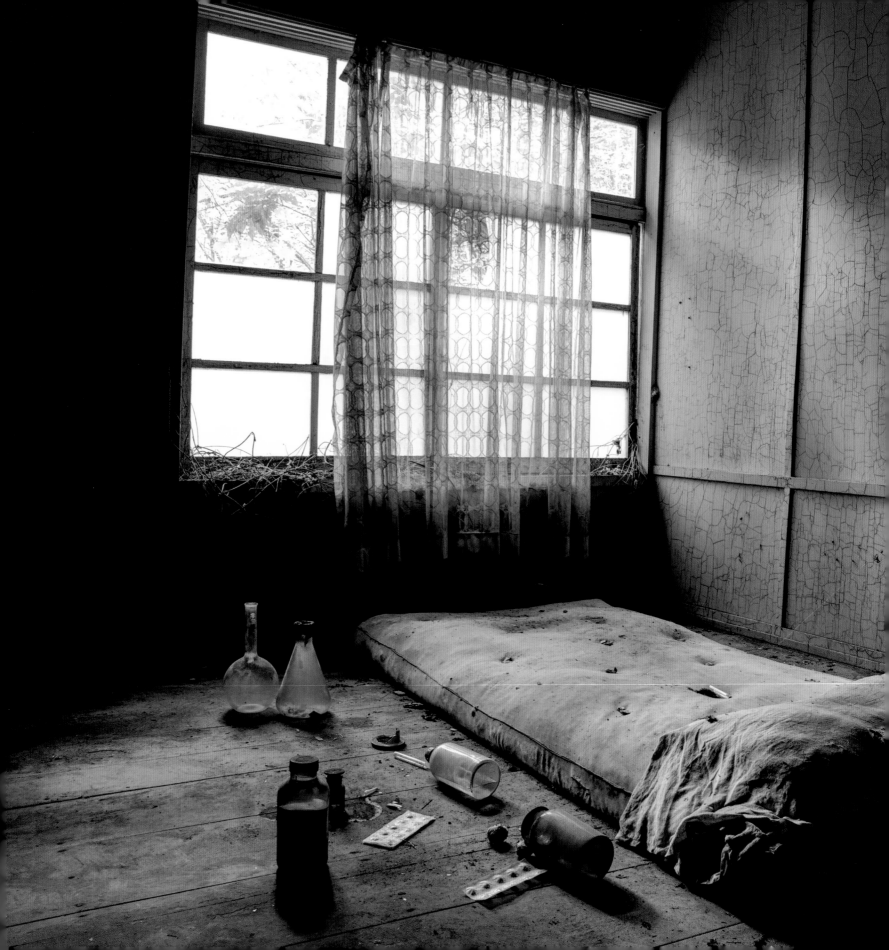

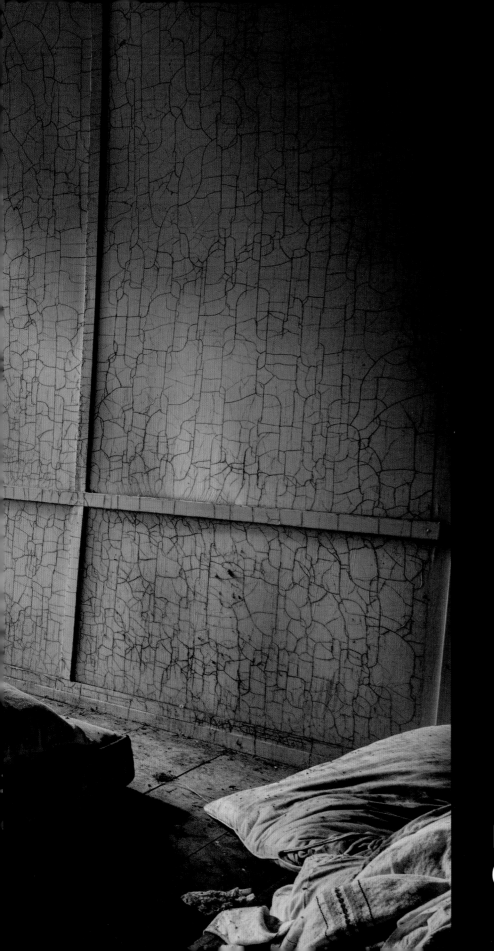

NICHITSU
GHOST TOWN CLINIC

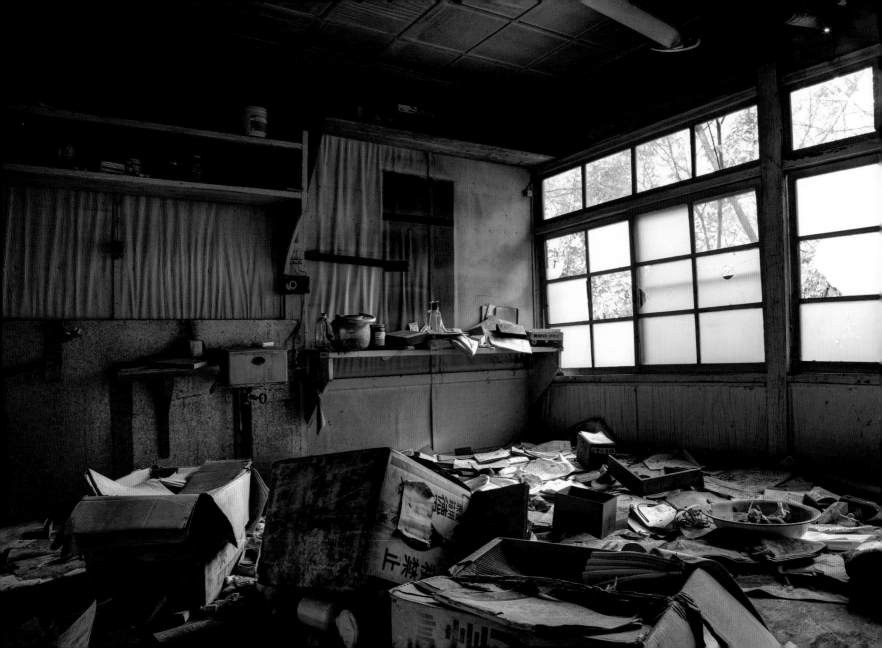

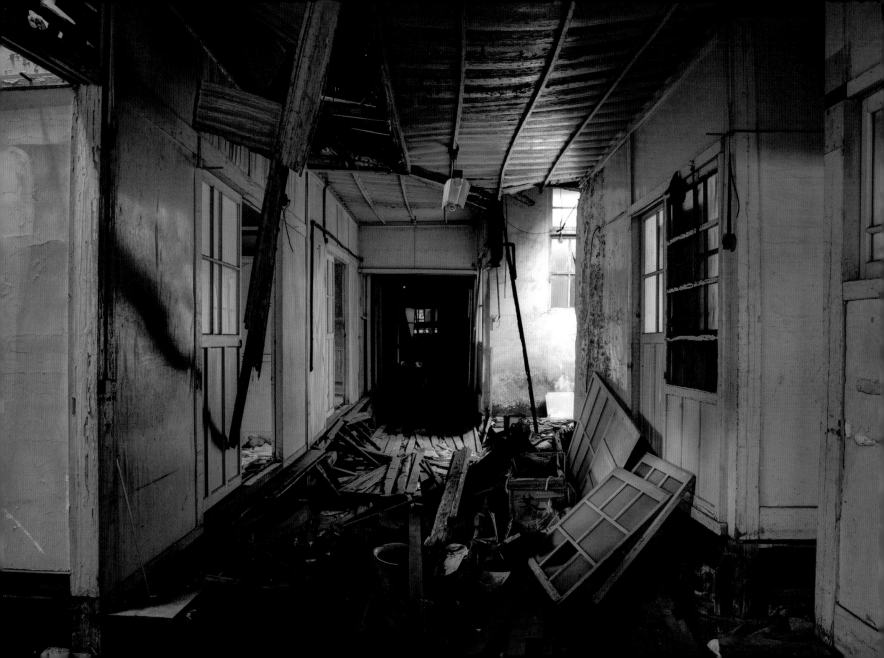

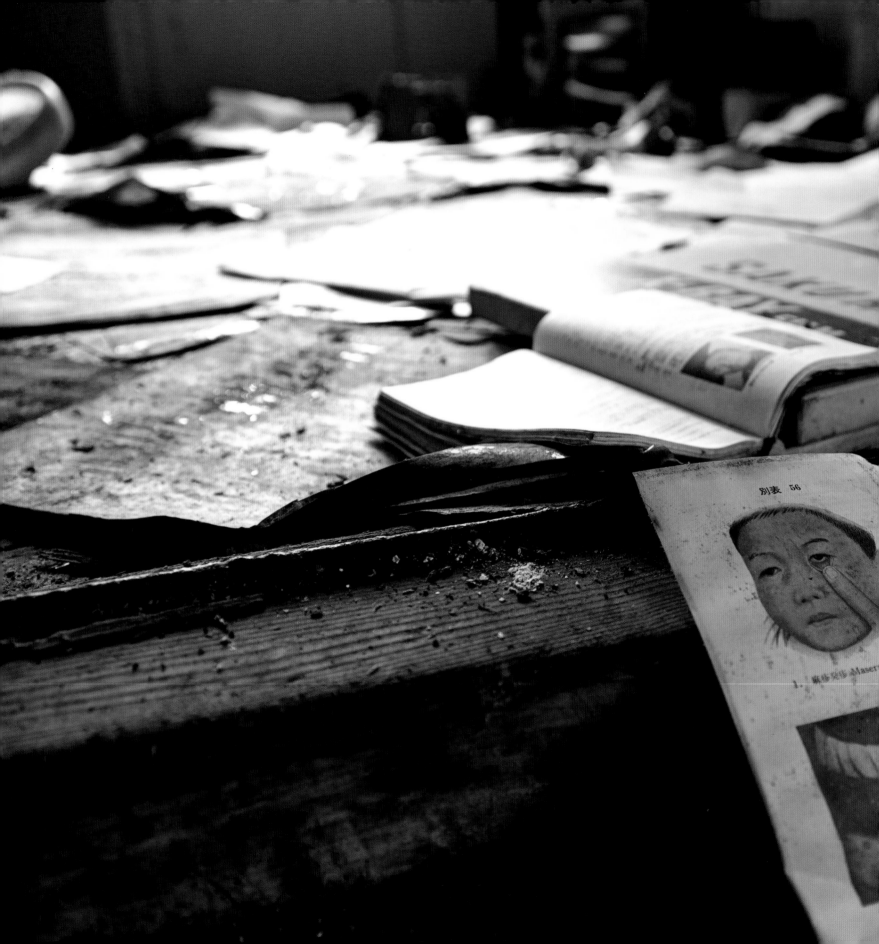

Filled with the medical treasures of years gone by, this crumbling mountain clinic hides behind trees and foliage at the foot of a forgotten ghost town. Gradually deserted throughout the 1970s due to the closure of a nearby mine, the now abandoned township initially housed its employees and families, some of whom utilised the small clinics services for health check-ups and medical concerns.

Inside, small but picturesque wards and consulting rooms run off its central hallway, revealing stories of vintage medical days long since passed. Mattresses, patient records and x-rays lay strewn across a number of floors while broken chairs sit clumped amongst scattered planks of wood in a mouldy, rotted dental room. Towards the back of the building, many unopened bottles of pills, medicines, powders and ointments remain on shelves in a dilapidated pharmacy.

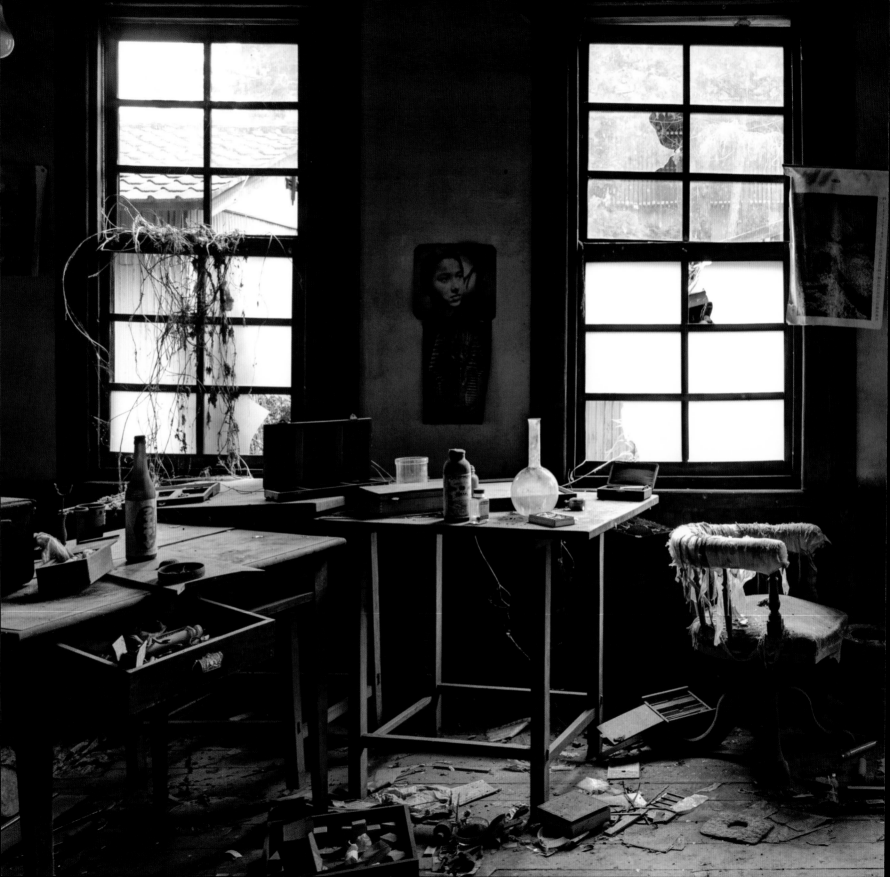

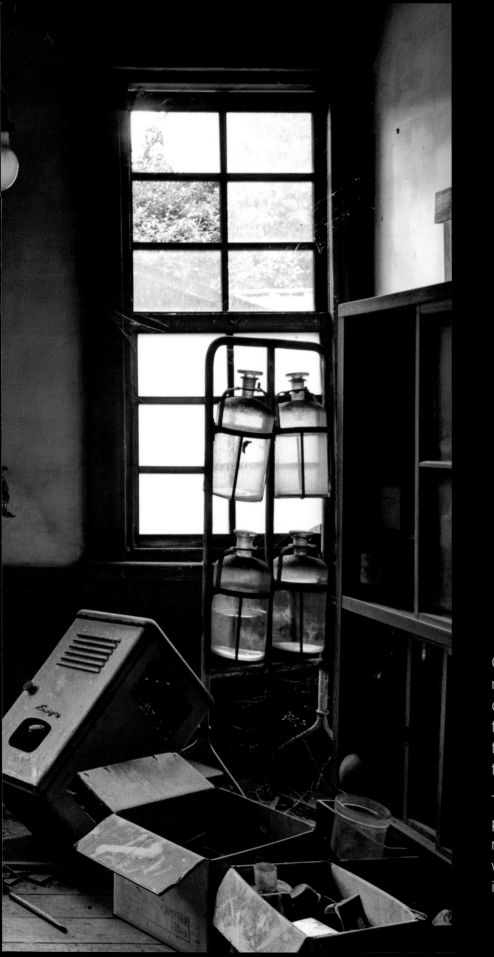

On the floor of a consulting area lie a number of medical textbooks containing illustrations of diseases and health conditions relevant to the time. In the centre of the hospital, daylight streams through an open ceiling to reveal the surgical theatre's now rusty operating table.

This quaint, dilapidated building is just a small piece in the enchanting puzzle that forms this movie-like ghost village, brimming with intricate wooden buildings and traditional Japanese interiors.

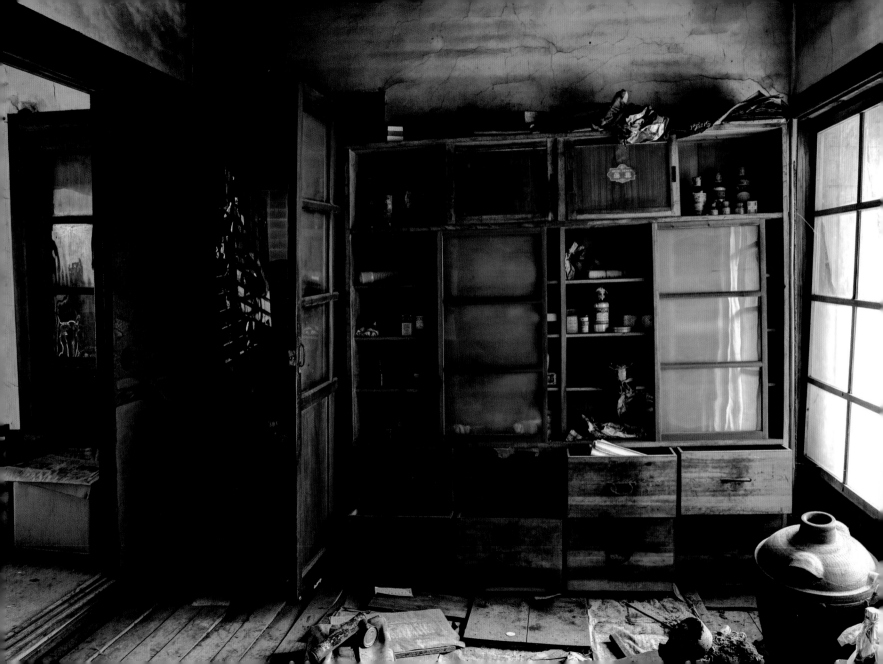

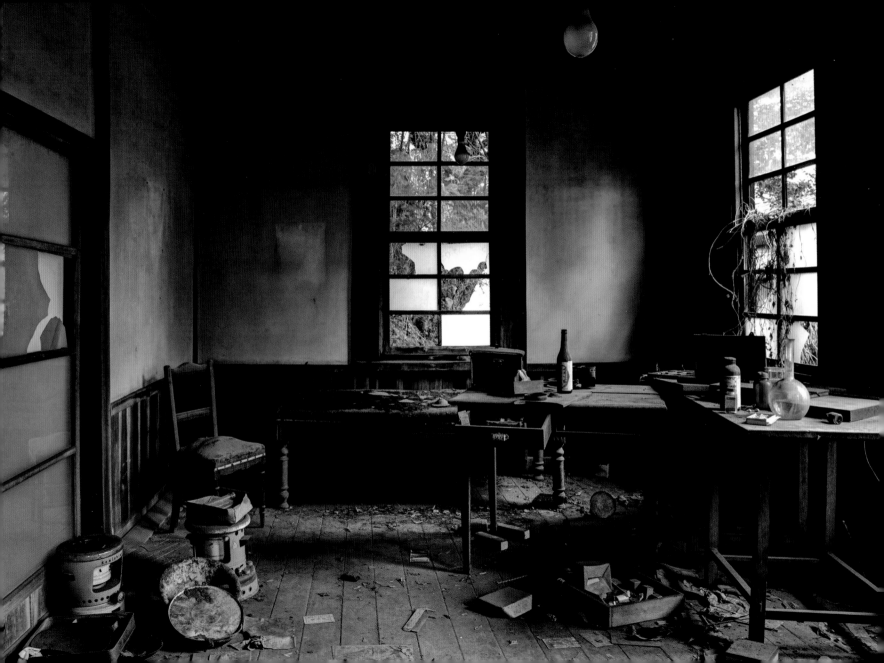

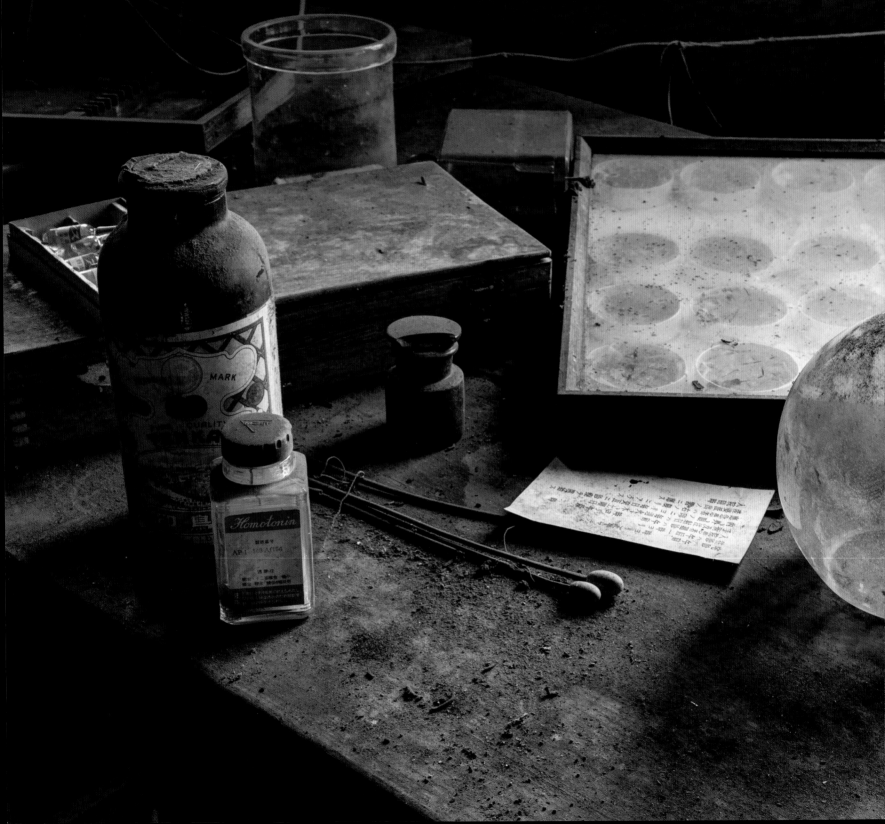

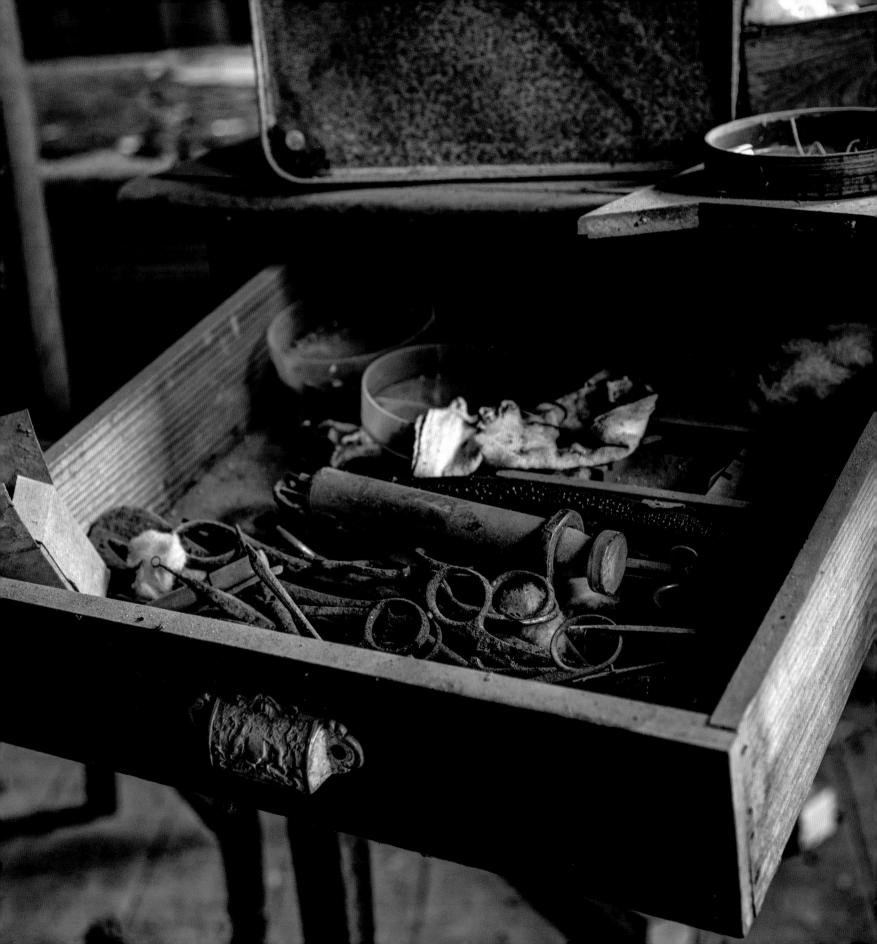

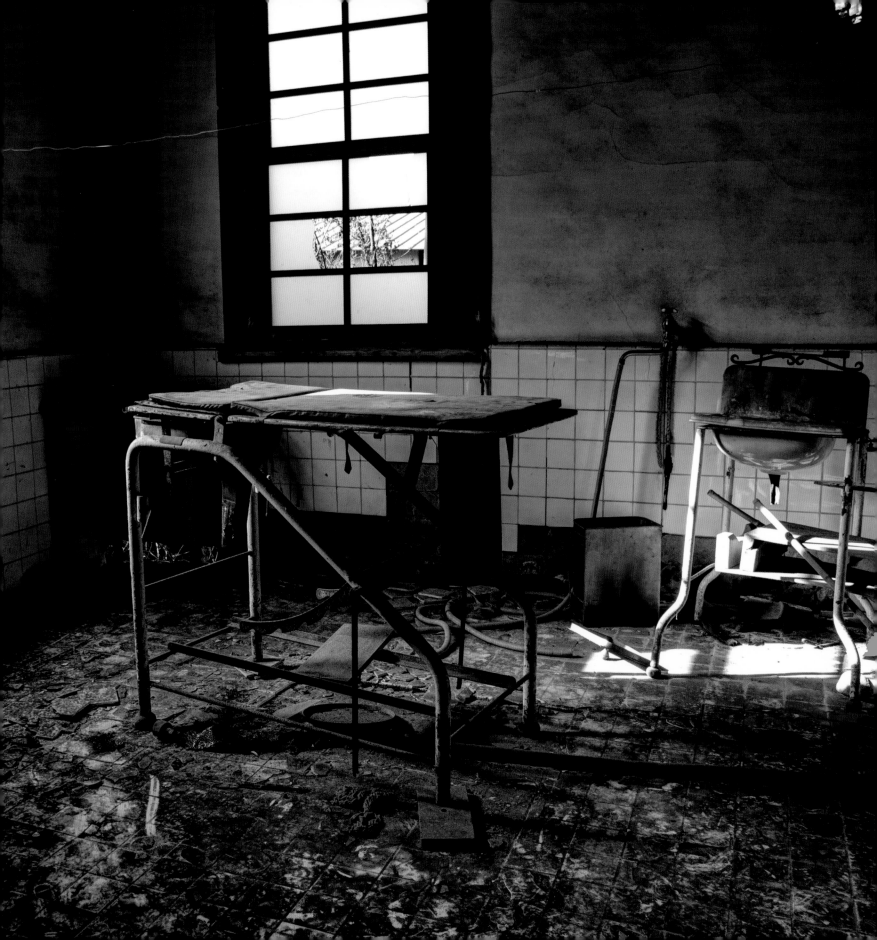

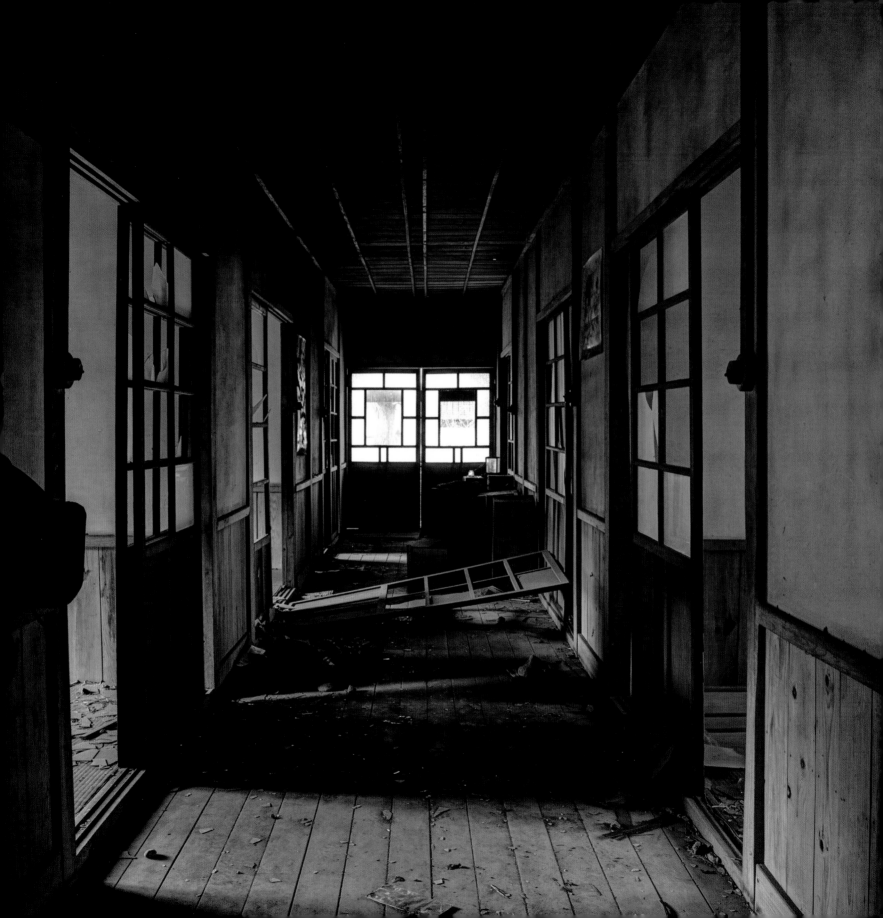

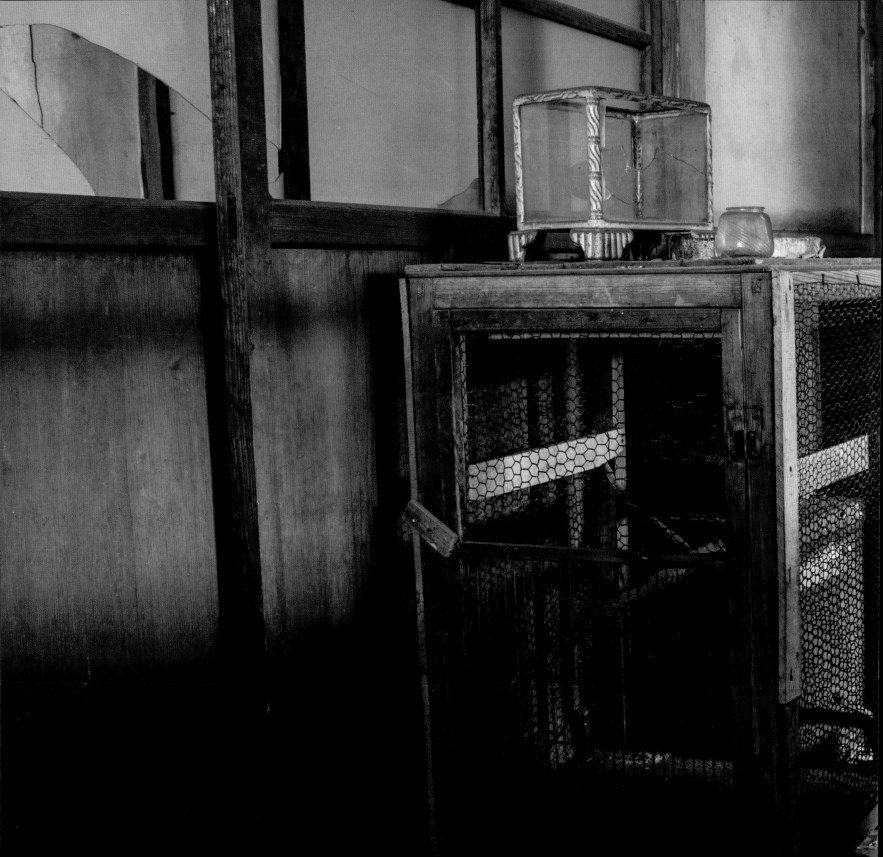

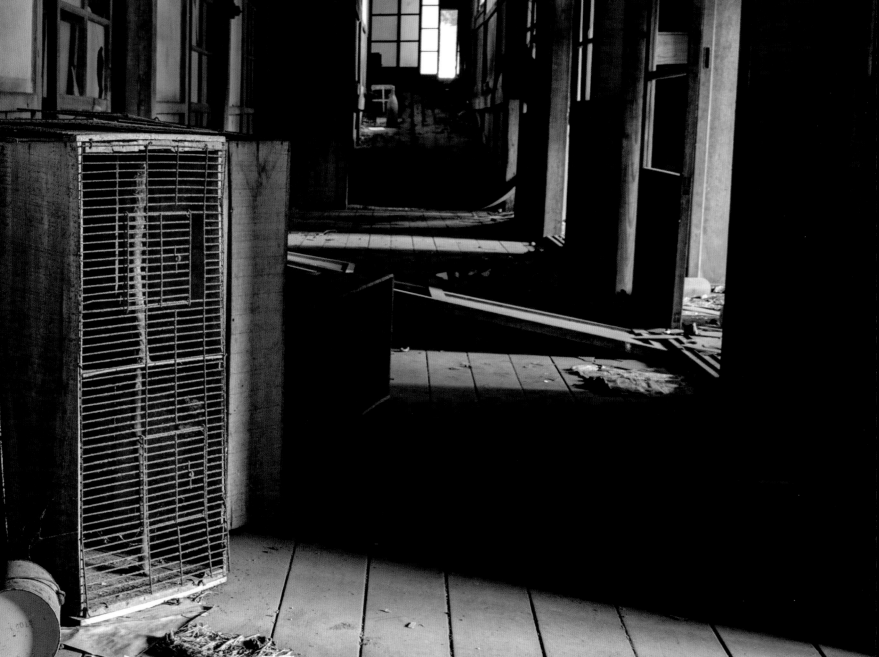

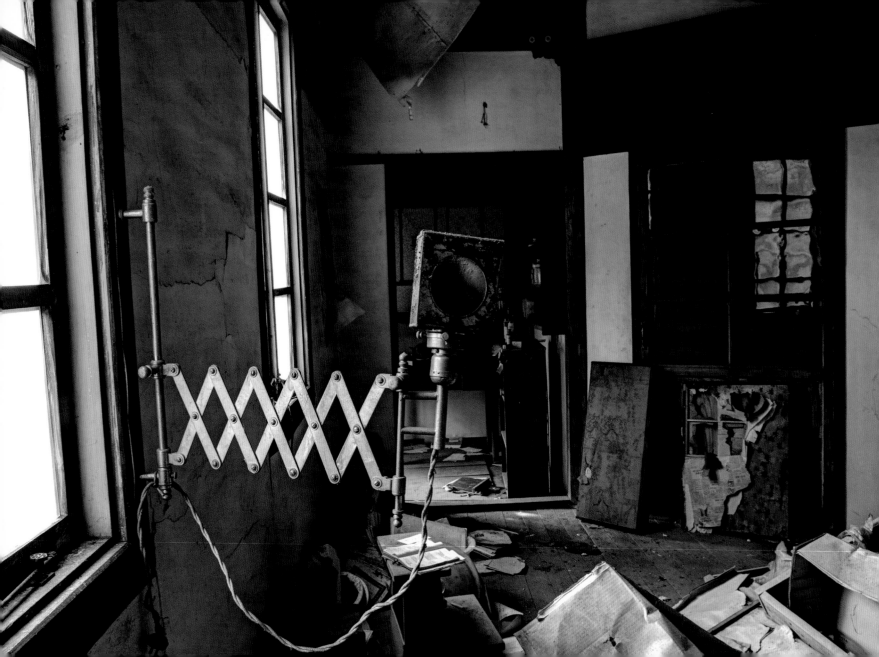

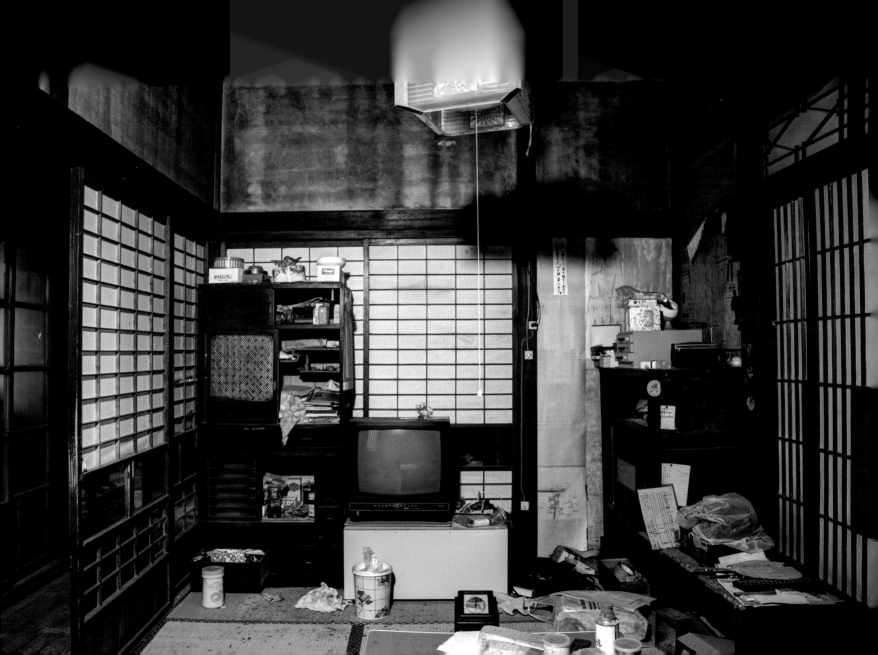

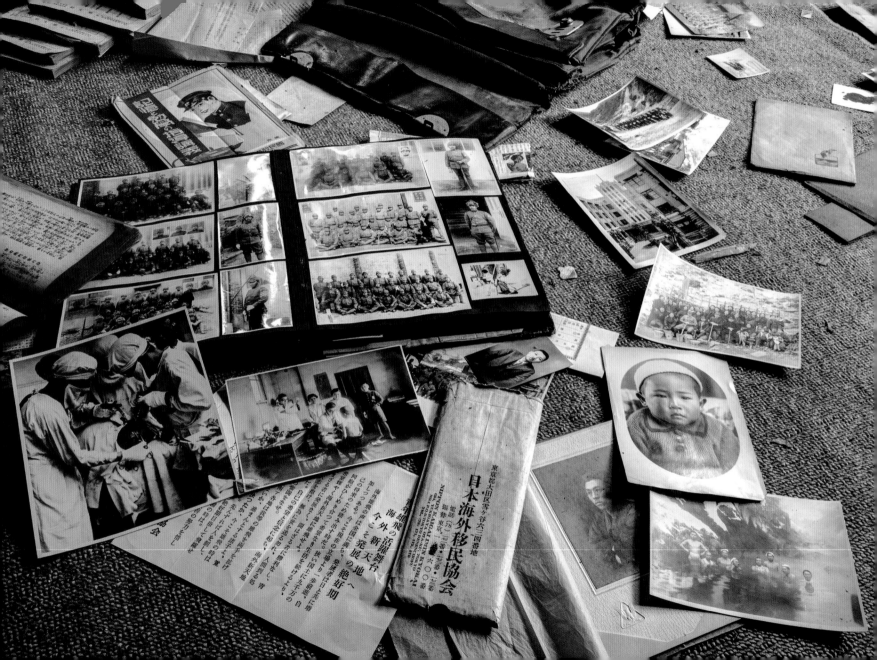

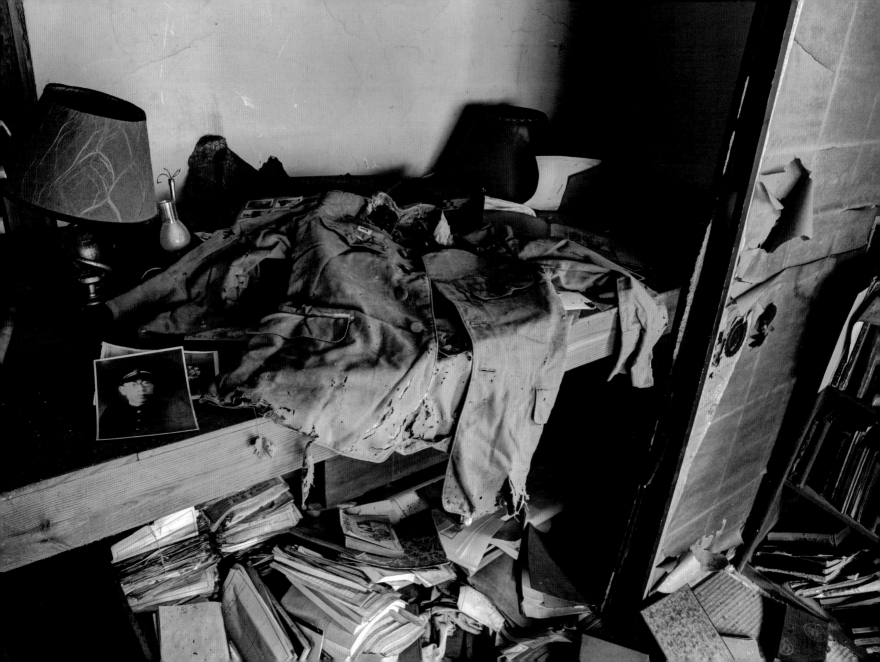

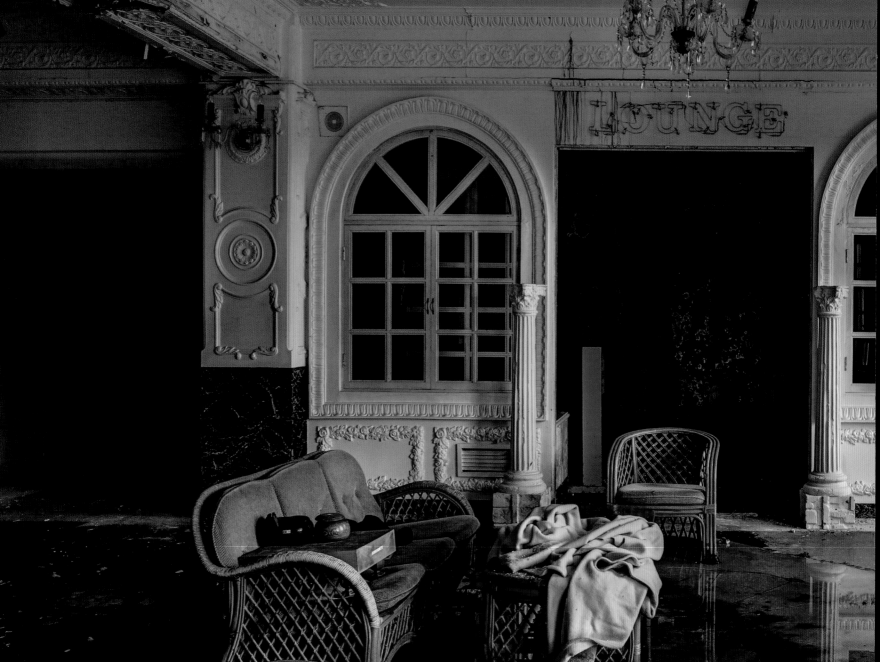

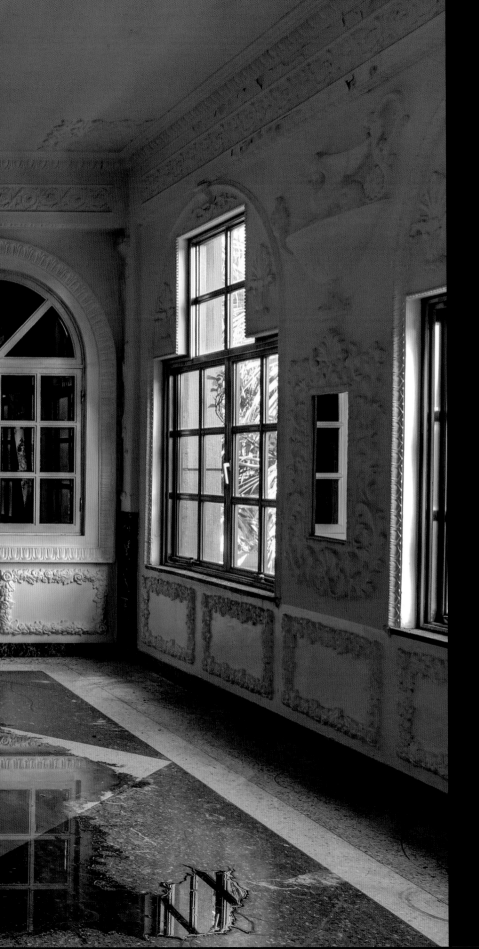

RESORTS, HOTELS & RESTAURANTS

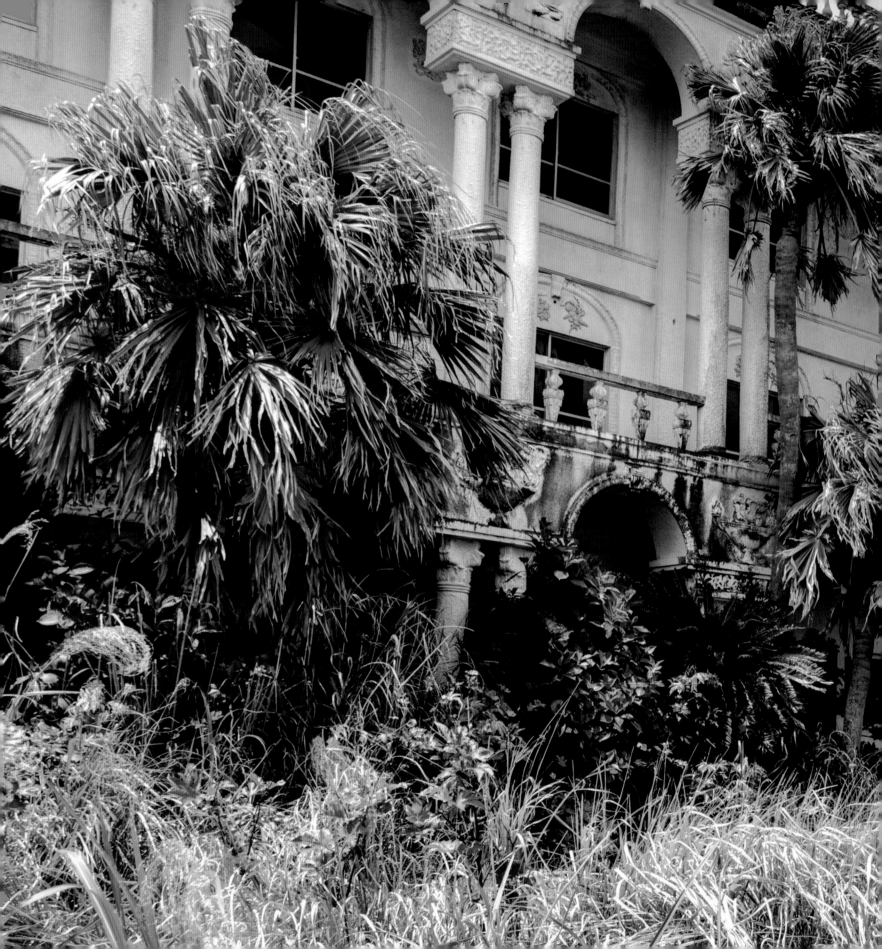

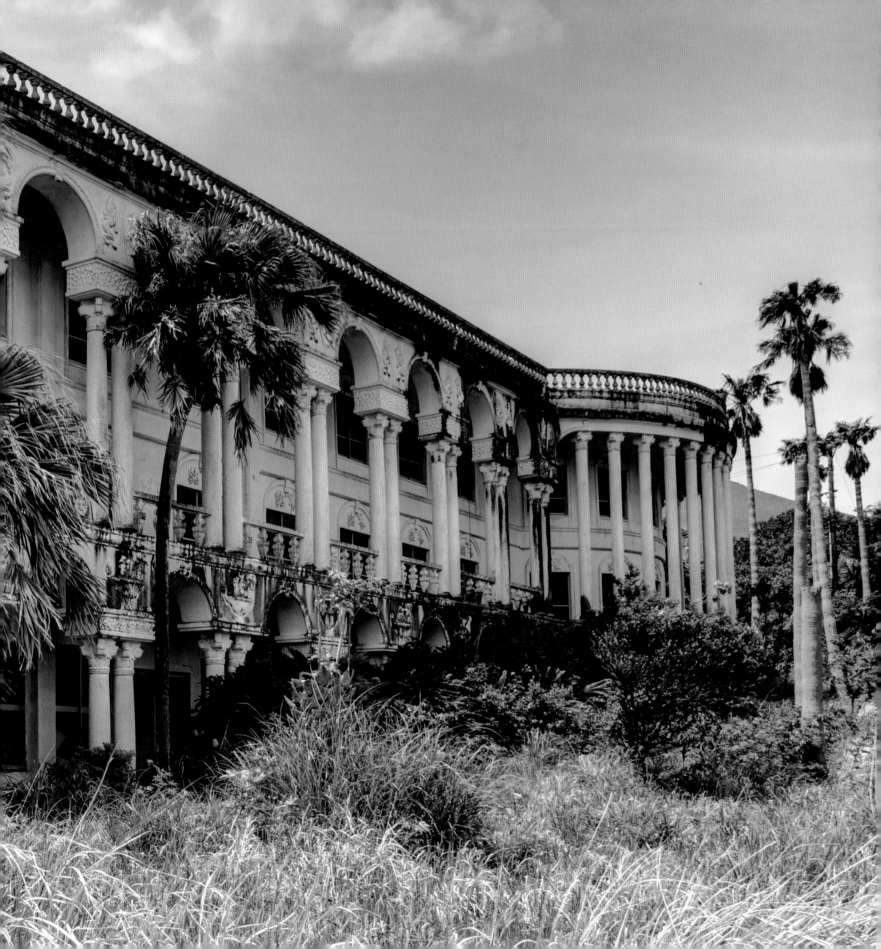

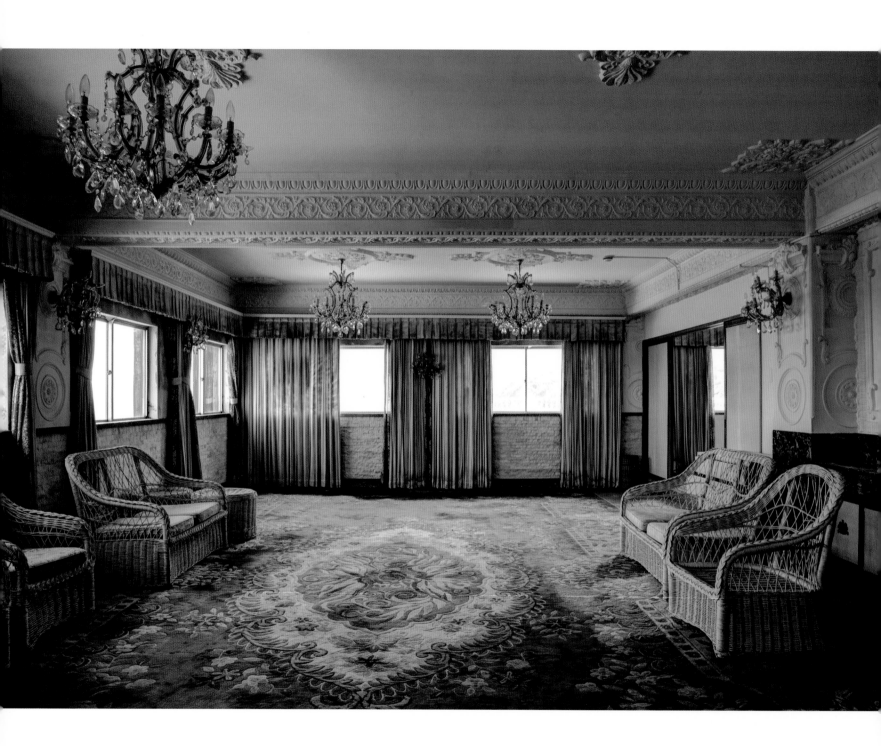

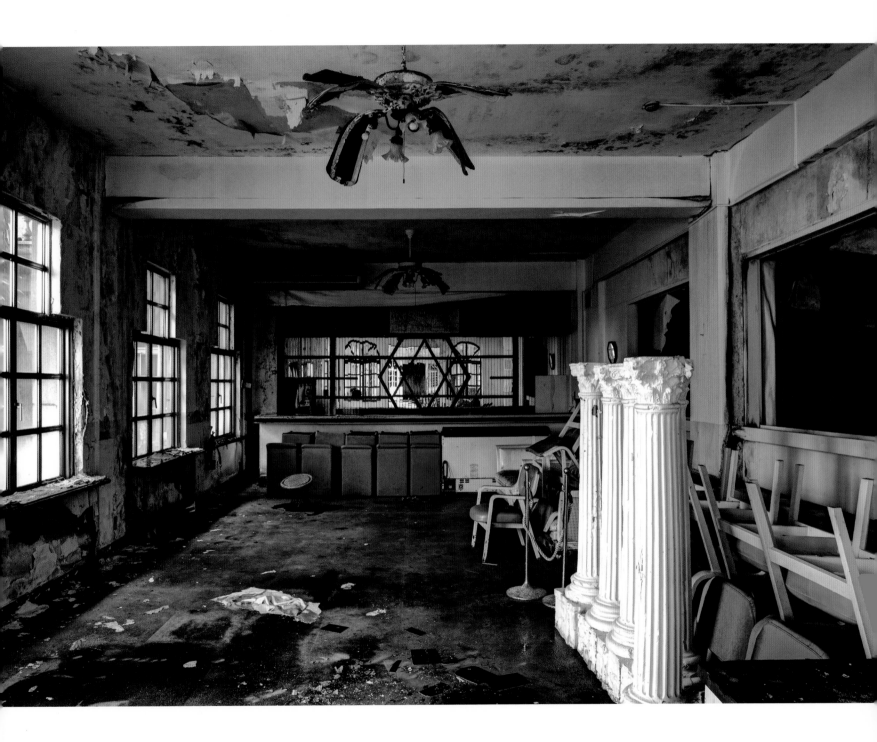

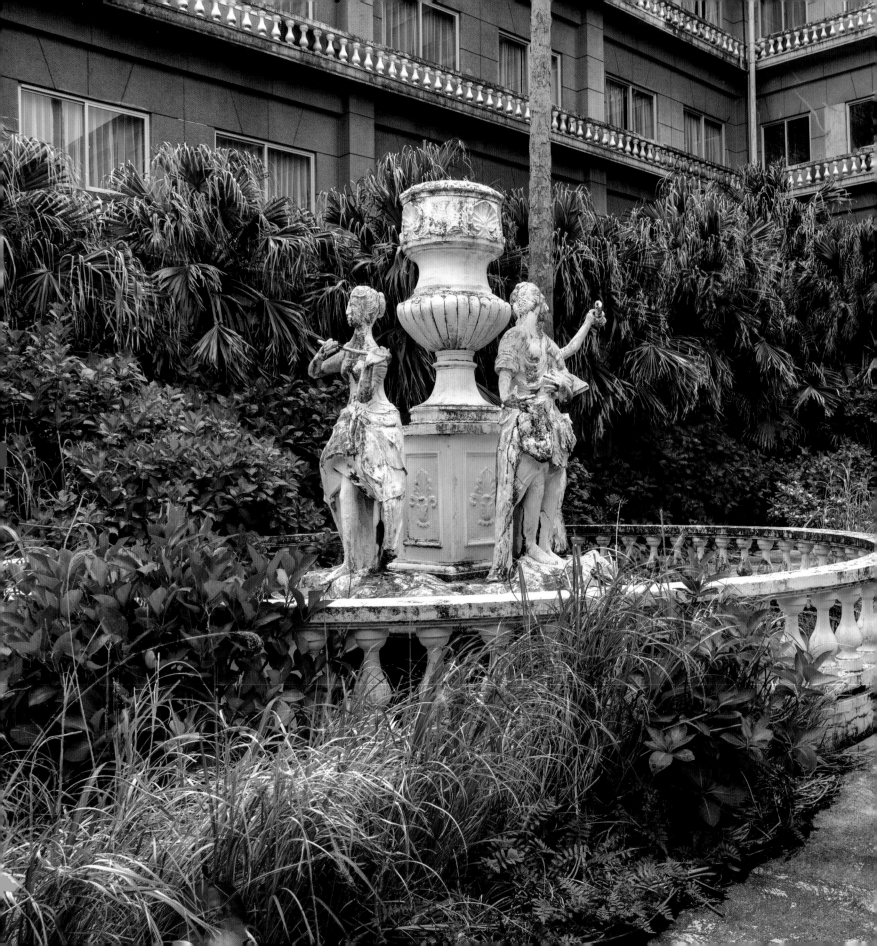

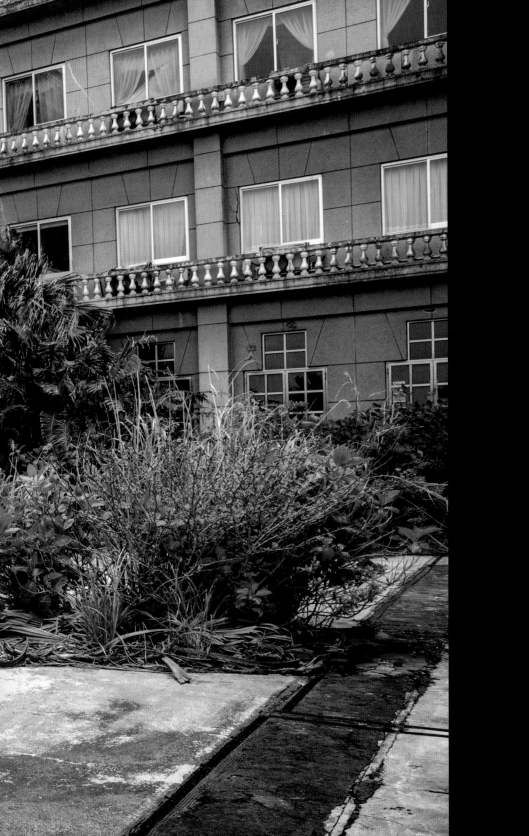

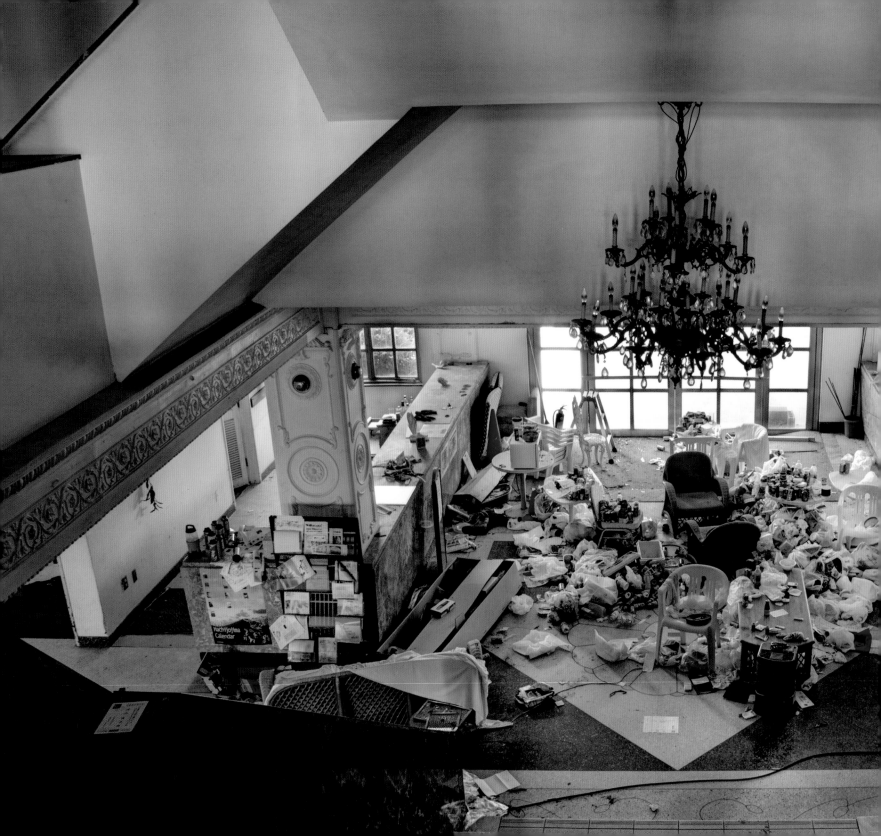

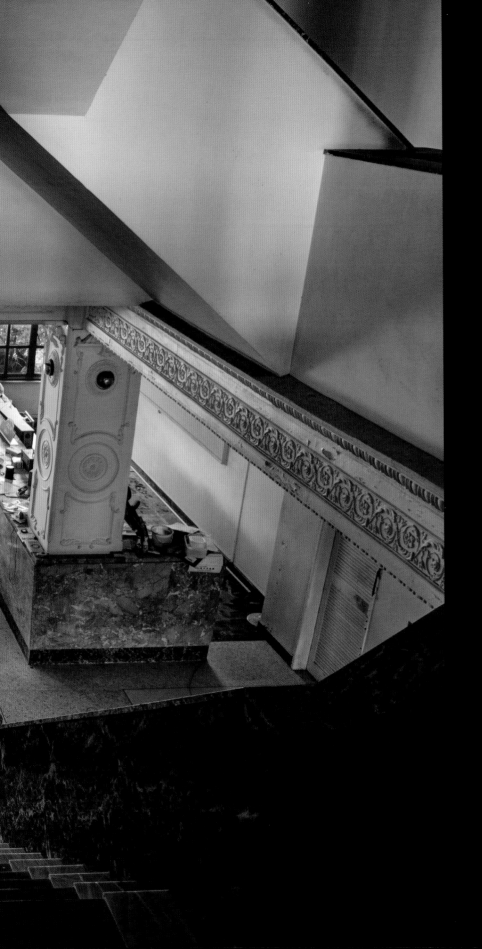

Sitting silently on the edge of the pacific, this massive seaside resort looms over the ocean like a gargoyle. It's once glorious and extravagant forecourt is filled with haunting pseudo European statues that stare out through overgrown ferns and plants. Inside, the foyer, what was once a grand marble entrance to greet affluent guests is now a swampy sea of rubbish and debris. On the upper floors, nature has truly reclaimed the guest rooms with plants now sprouting through floors and furnishings.

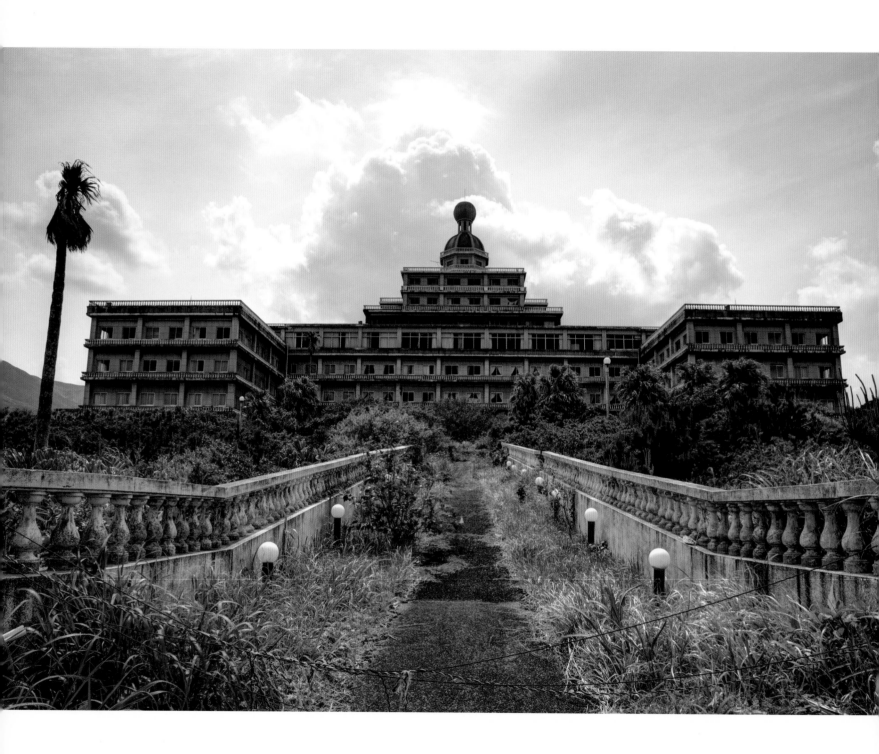

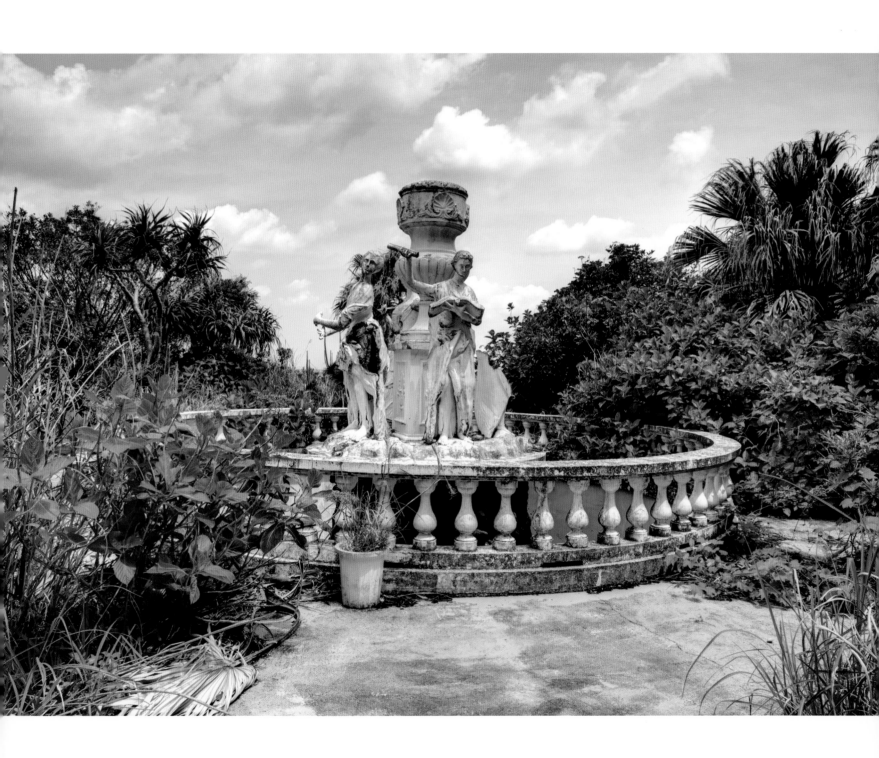

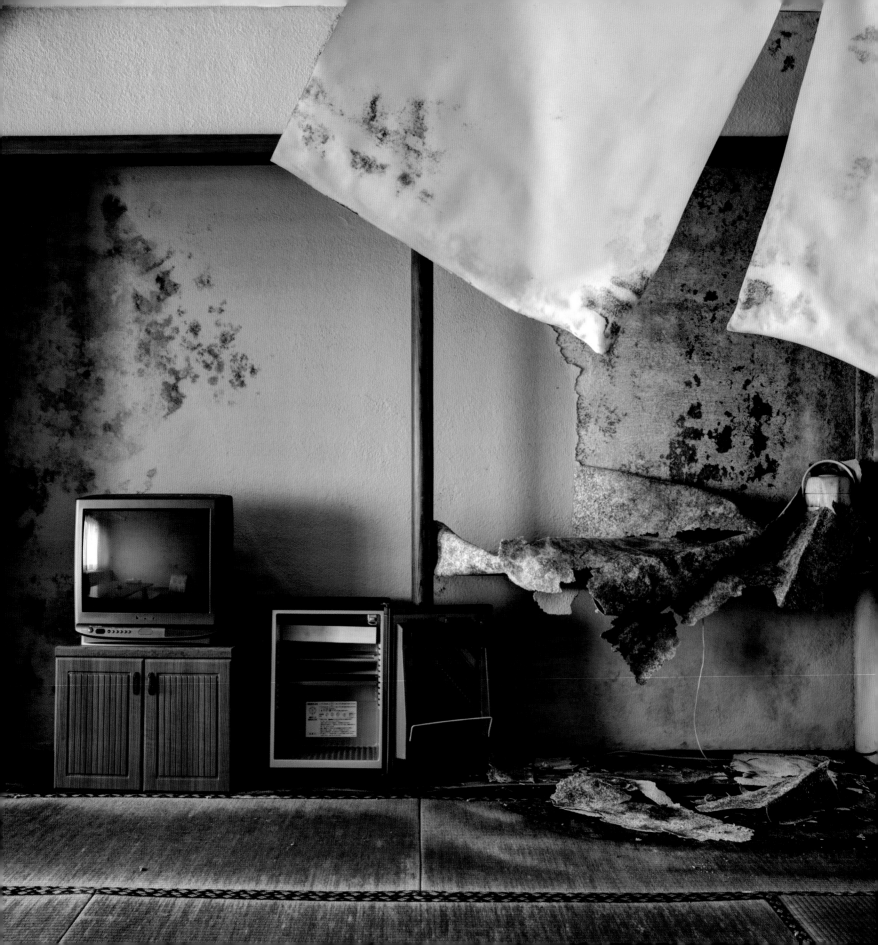

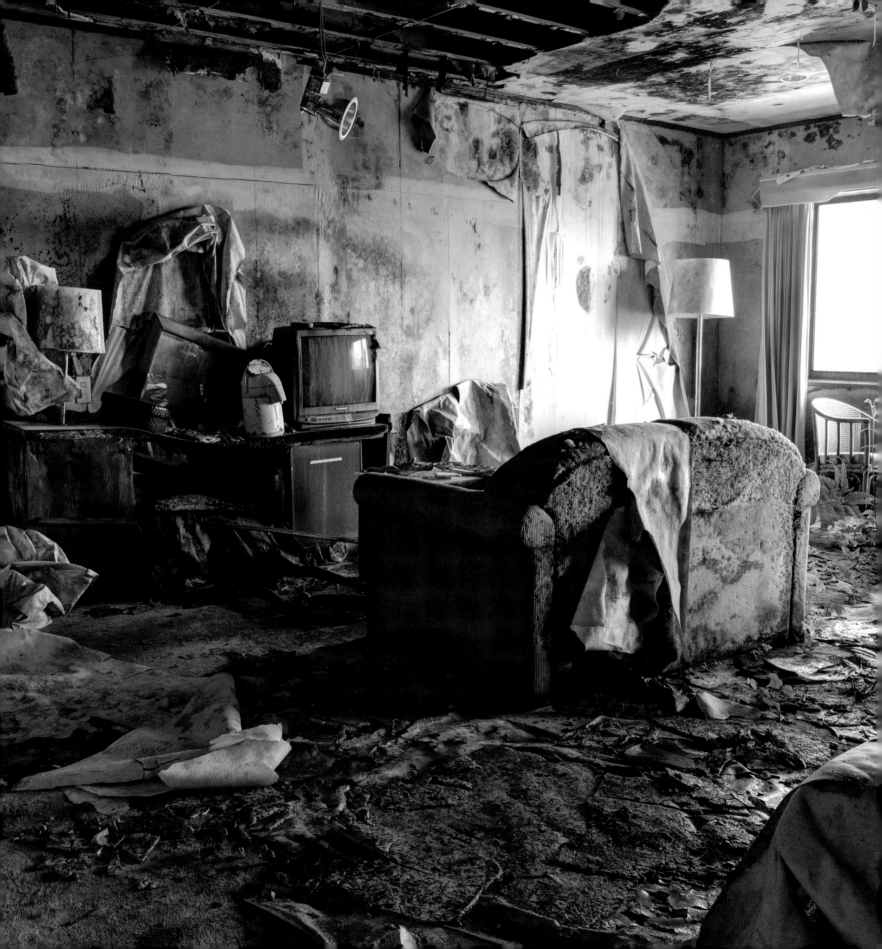

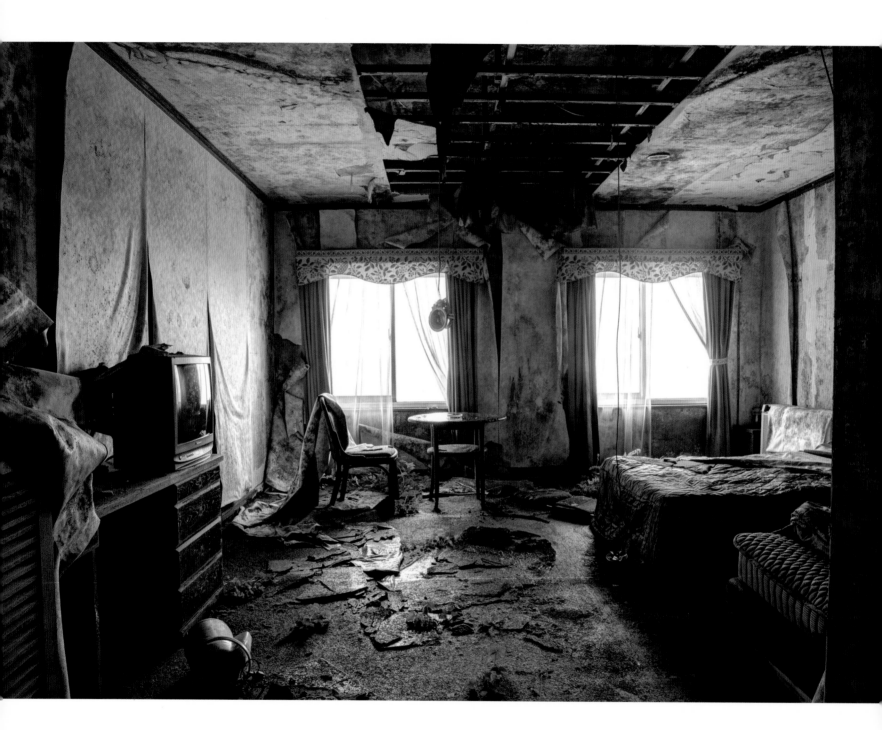

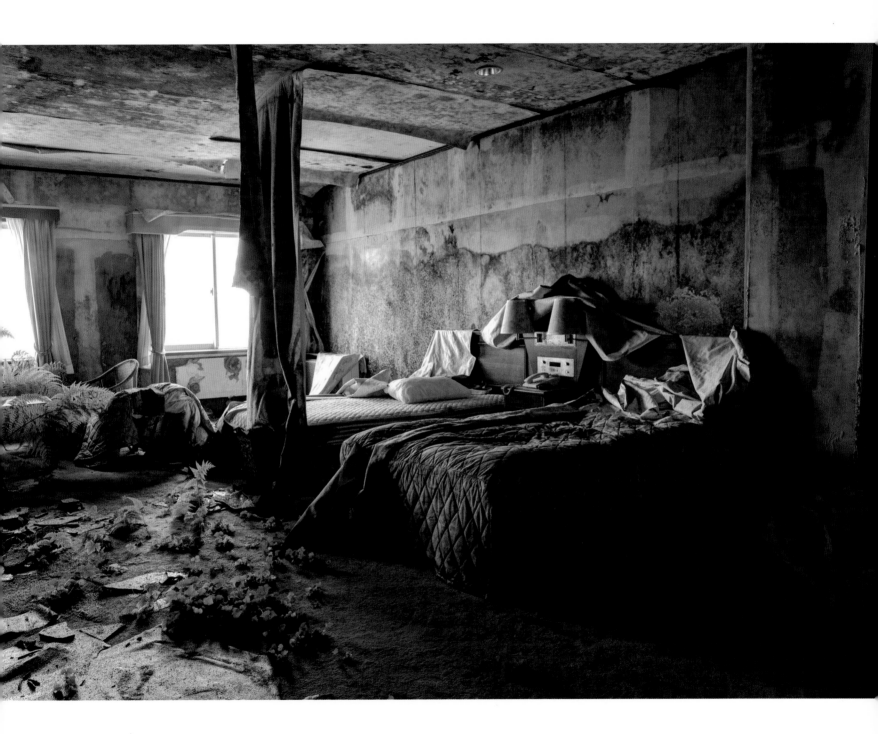

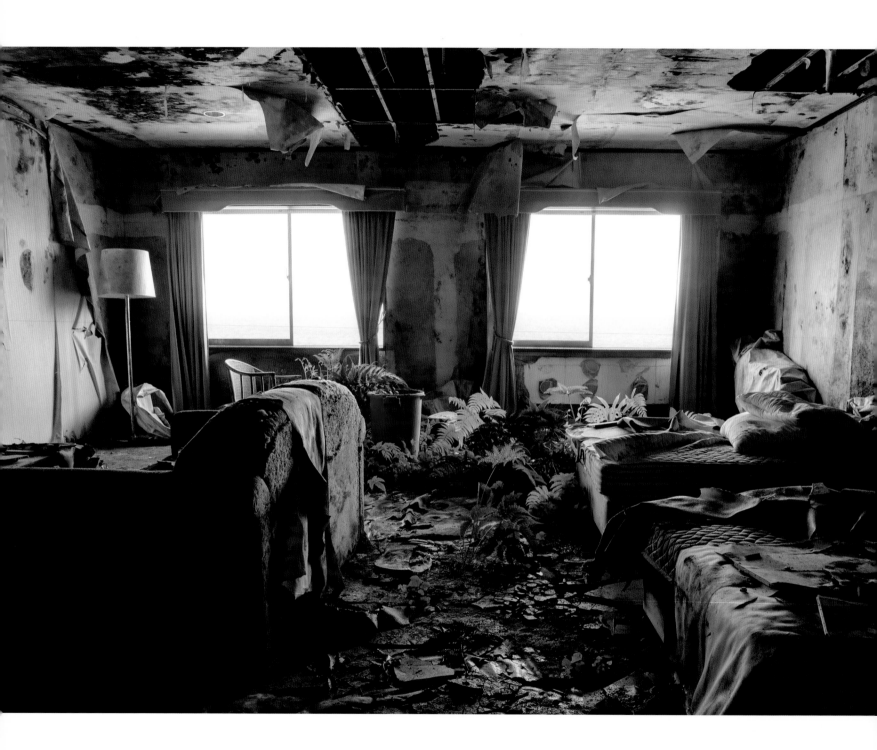

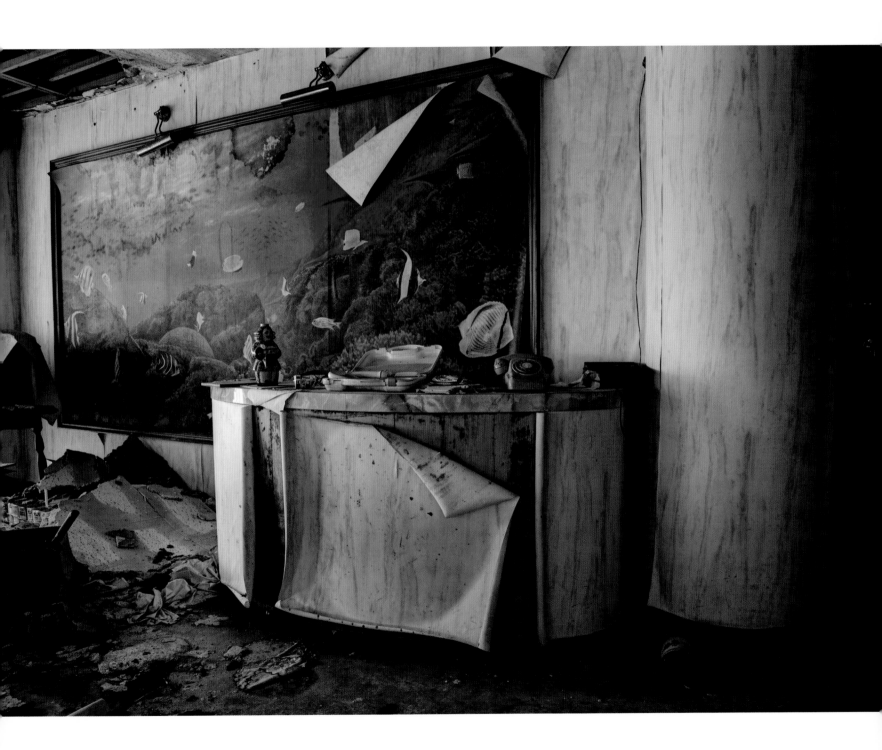

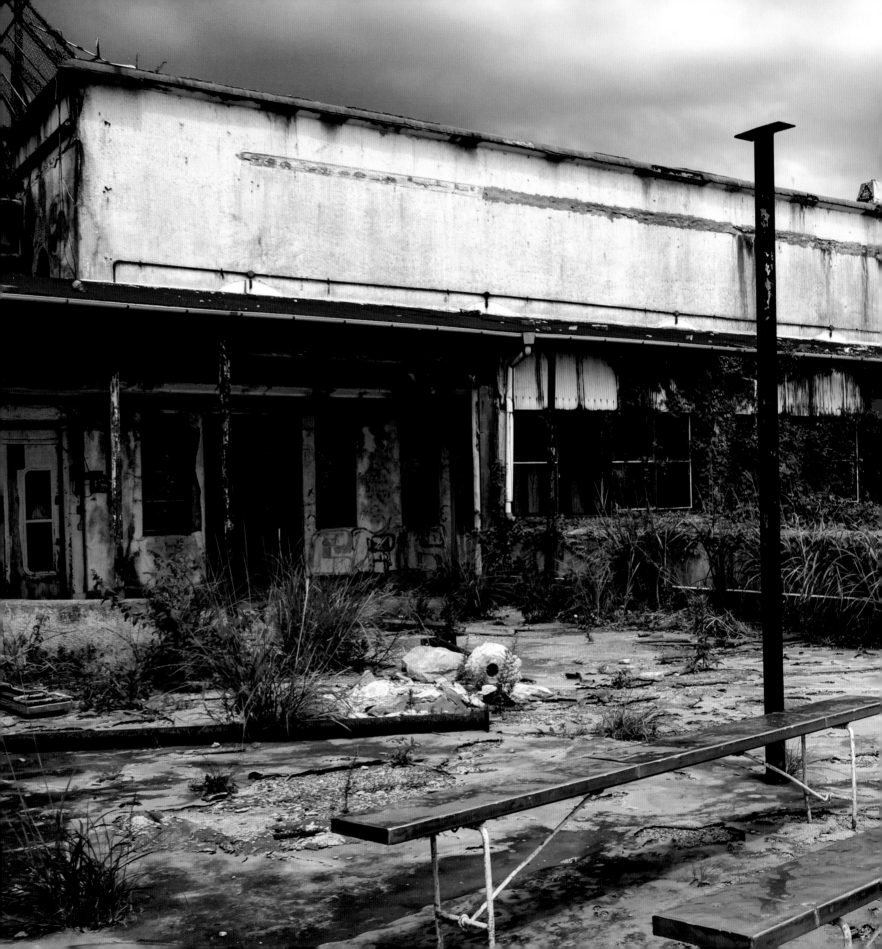

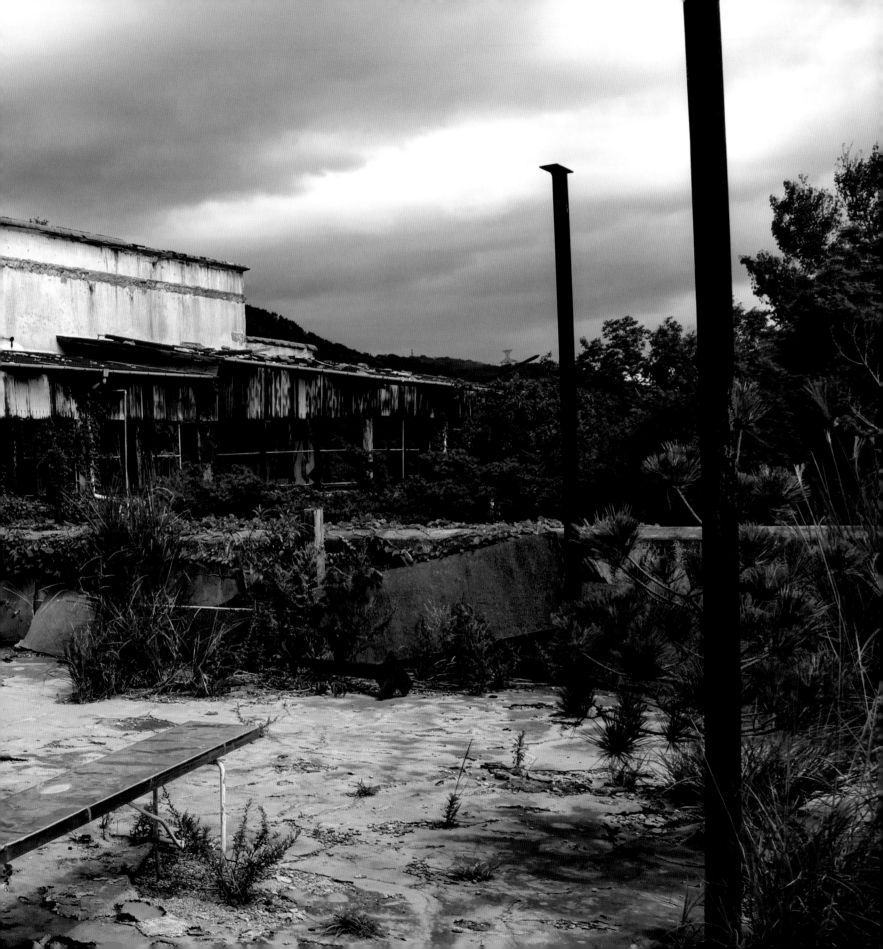

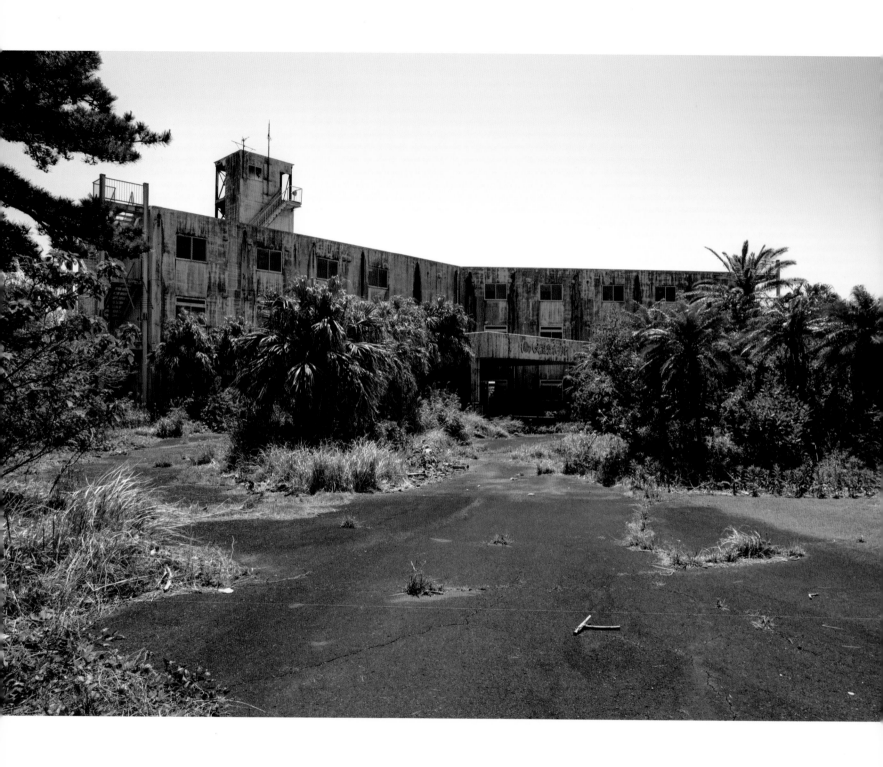

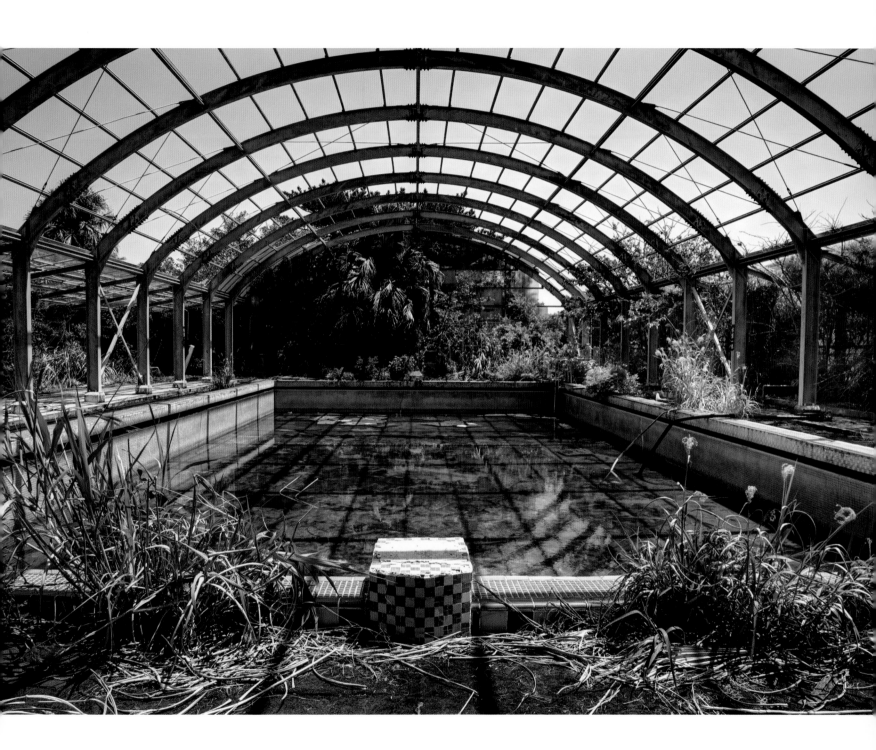

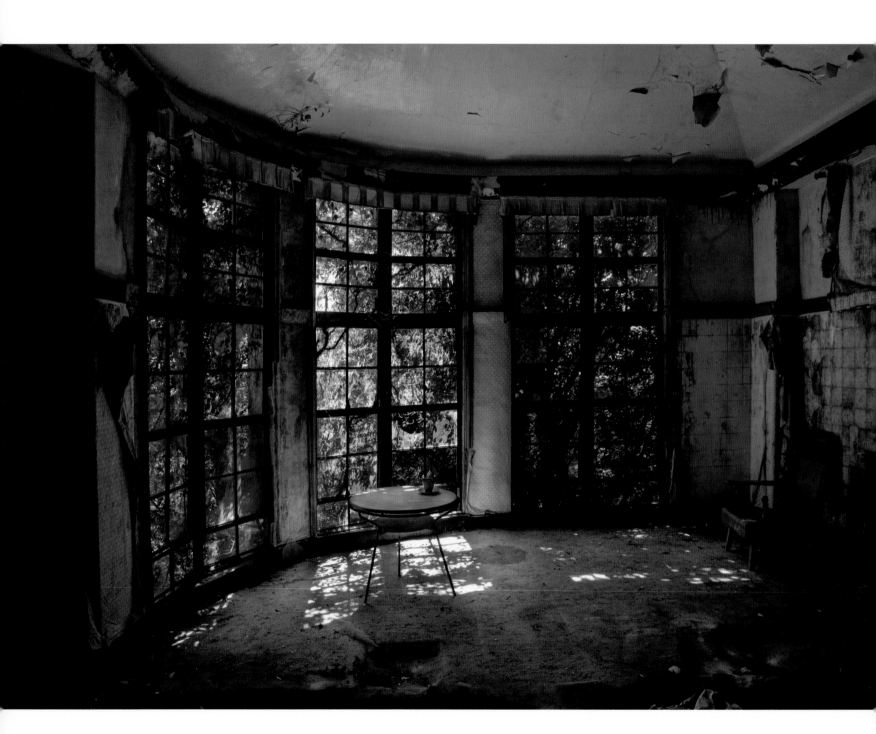

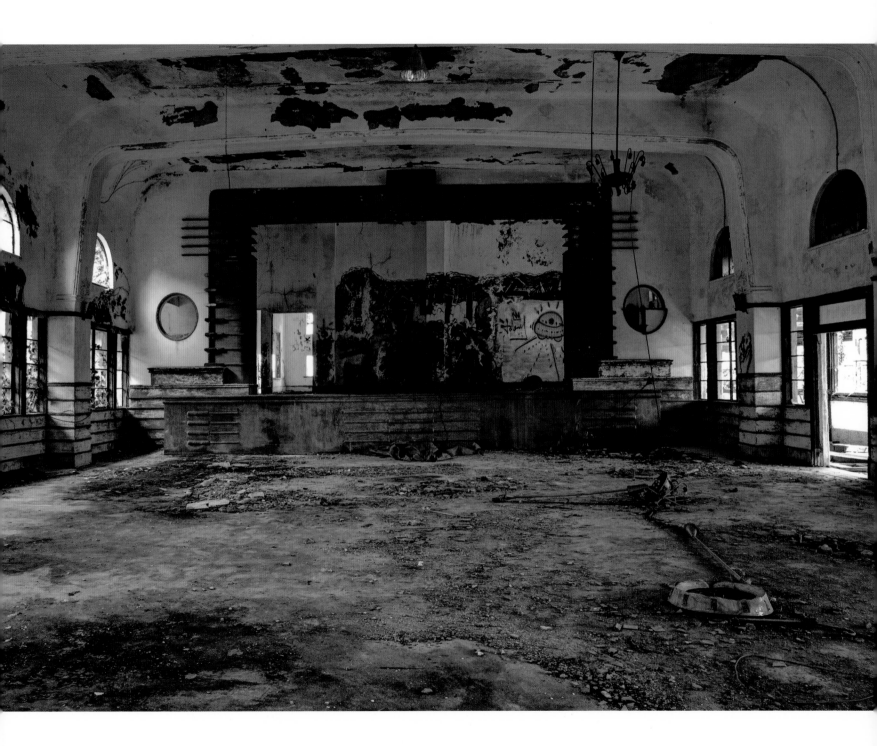

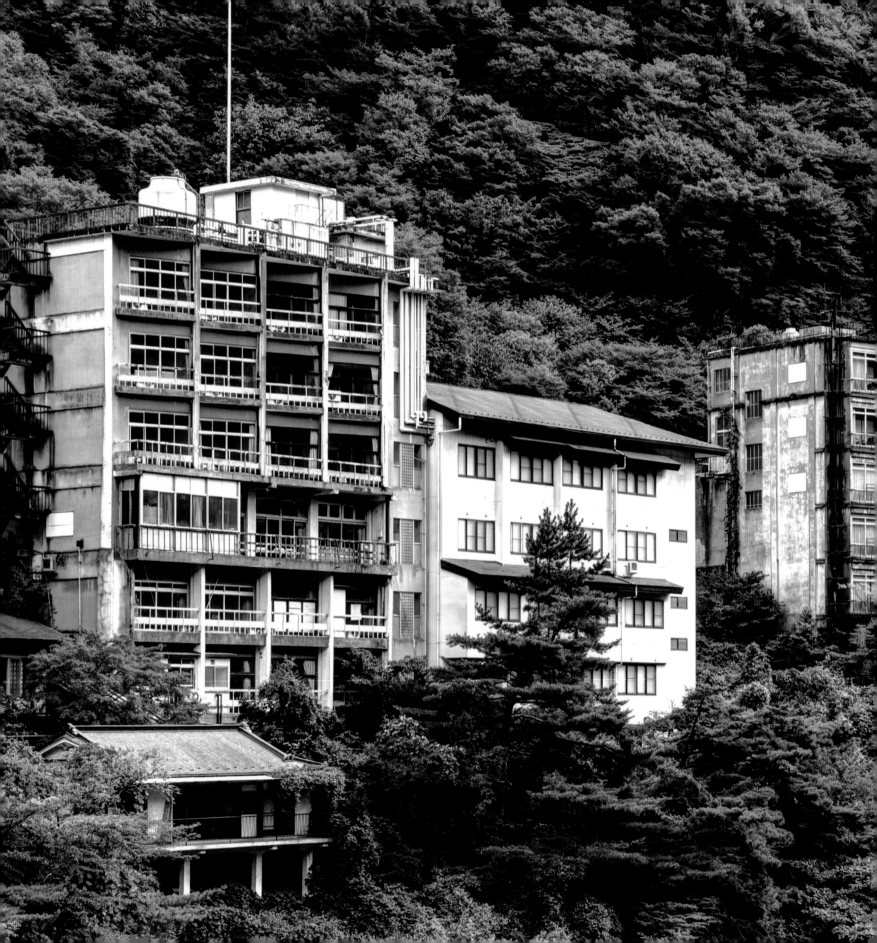

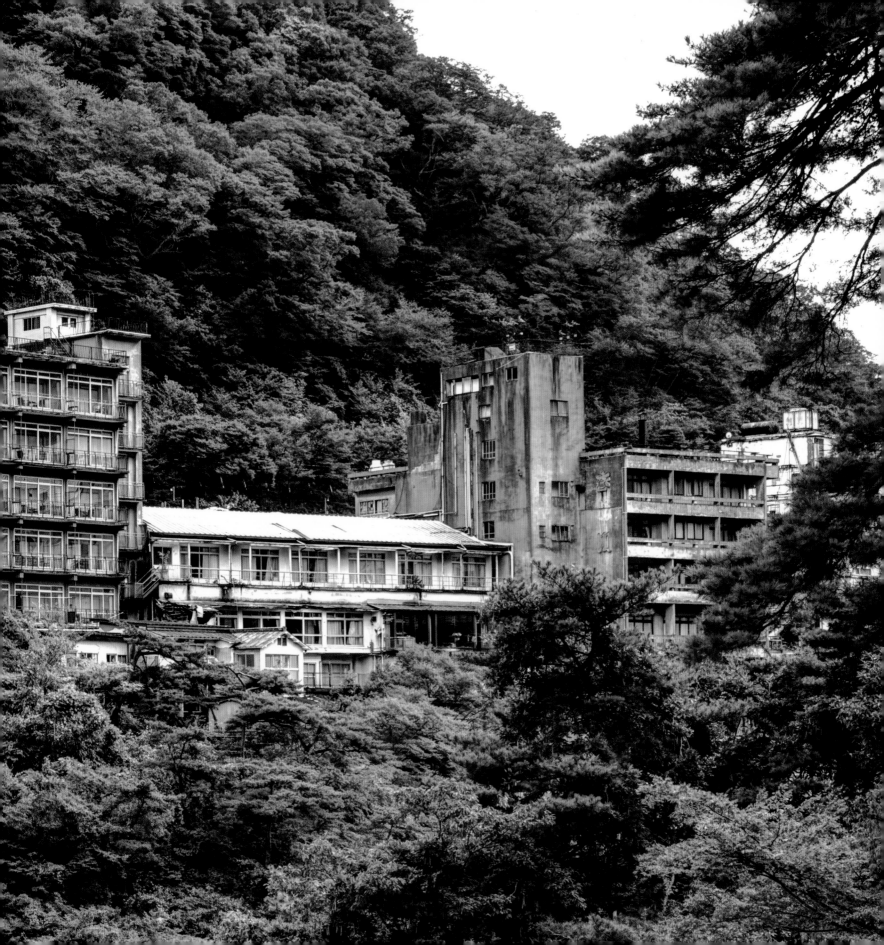

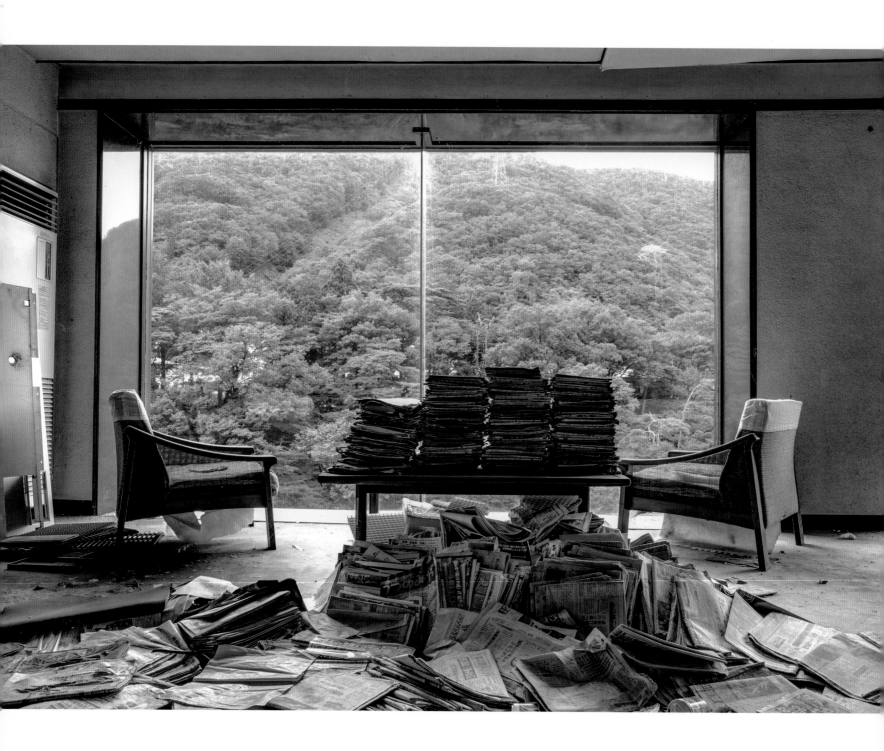

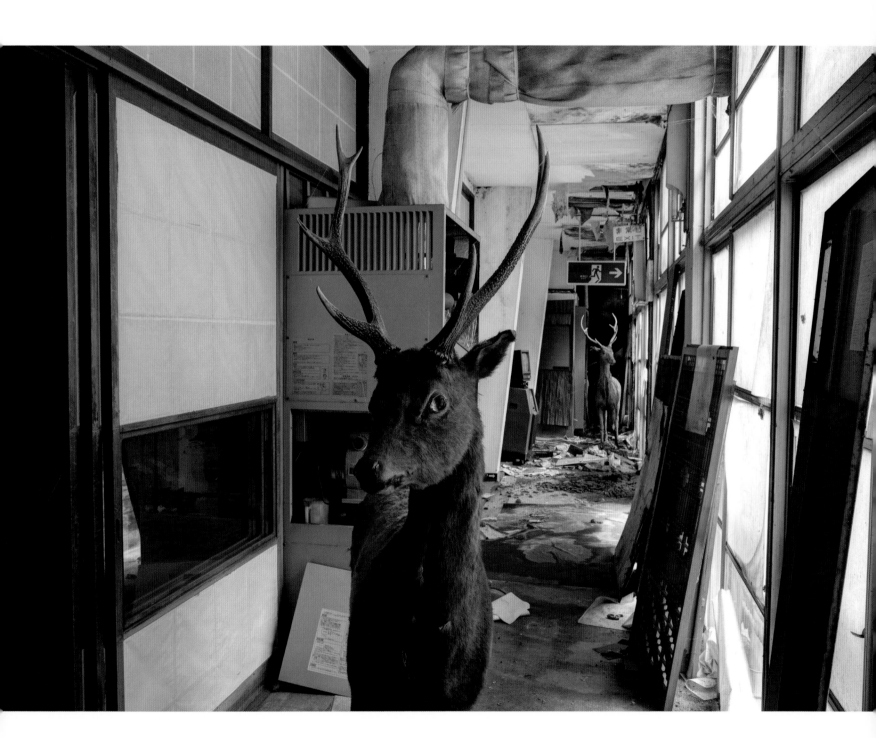

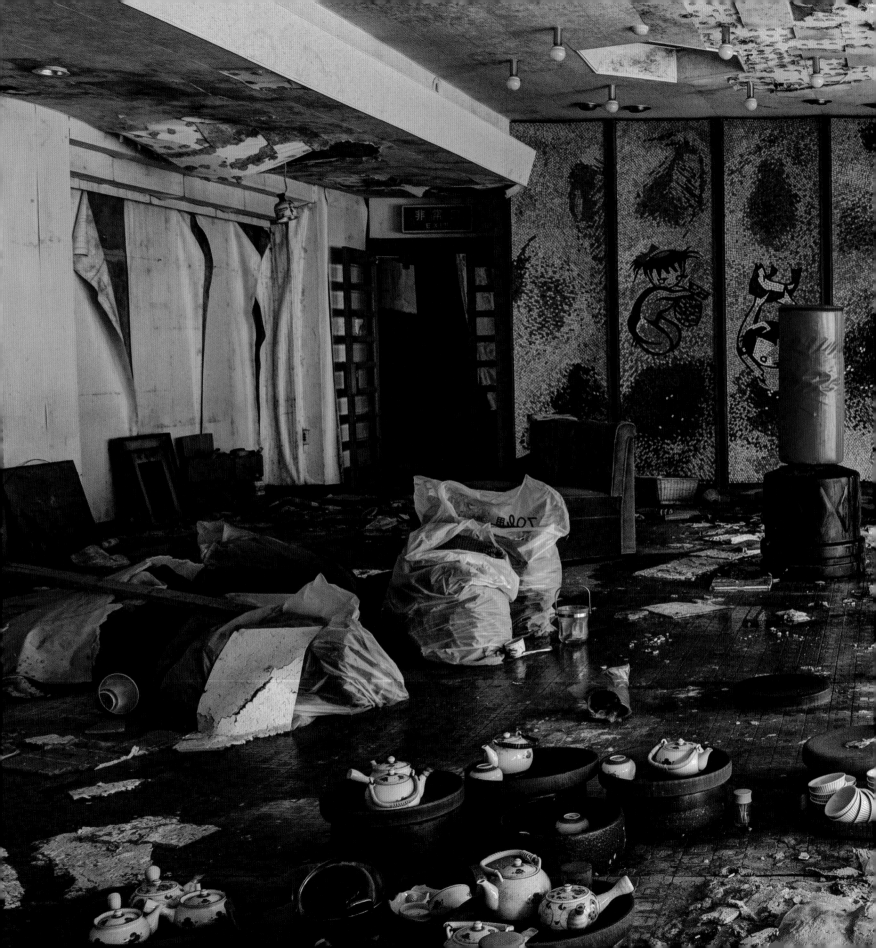

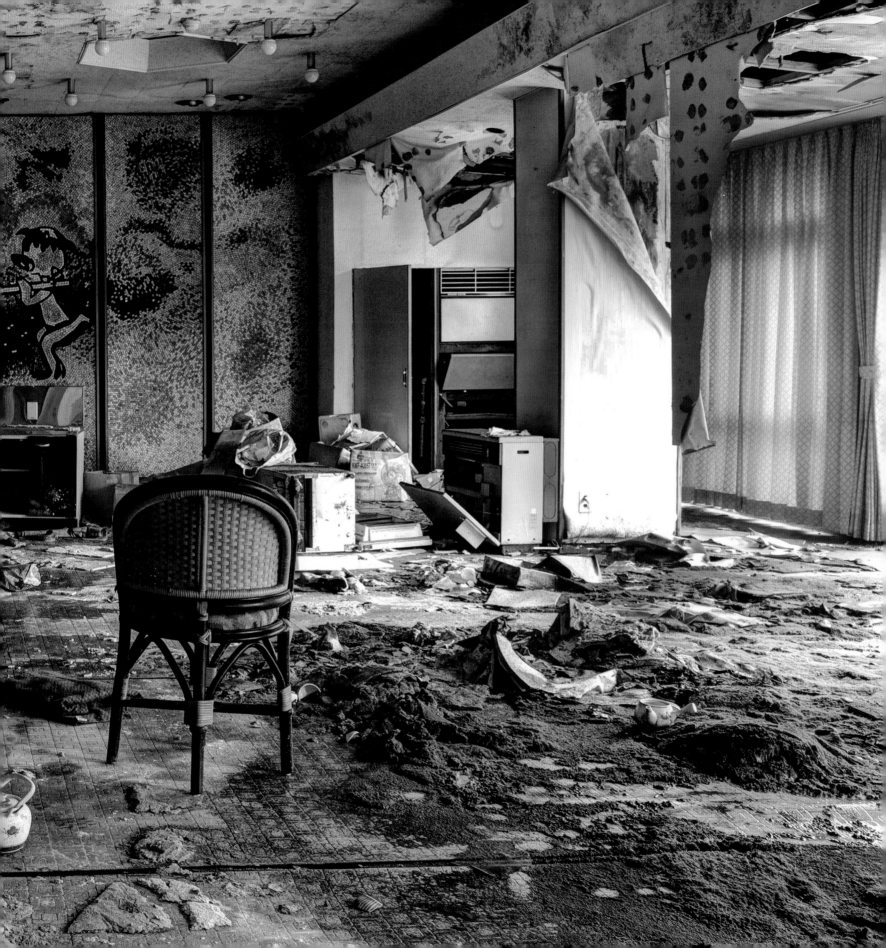

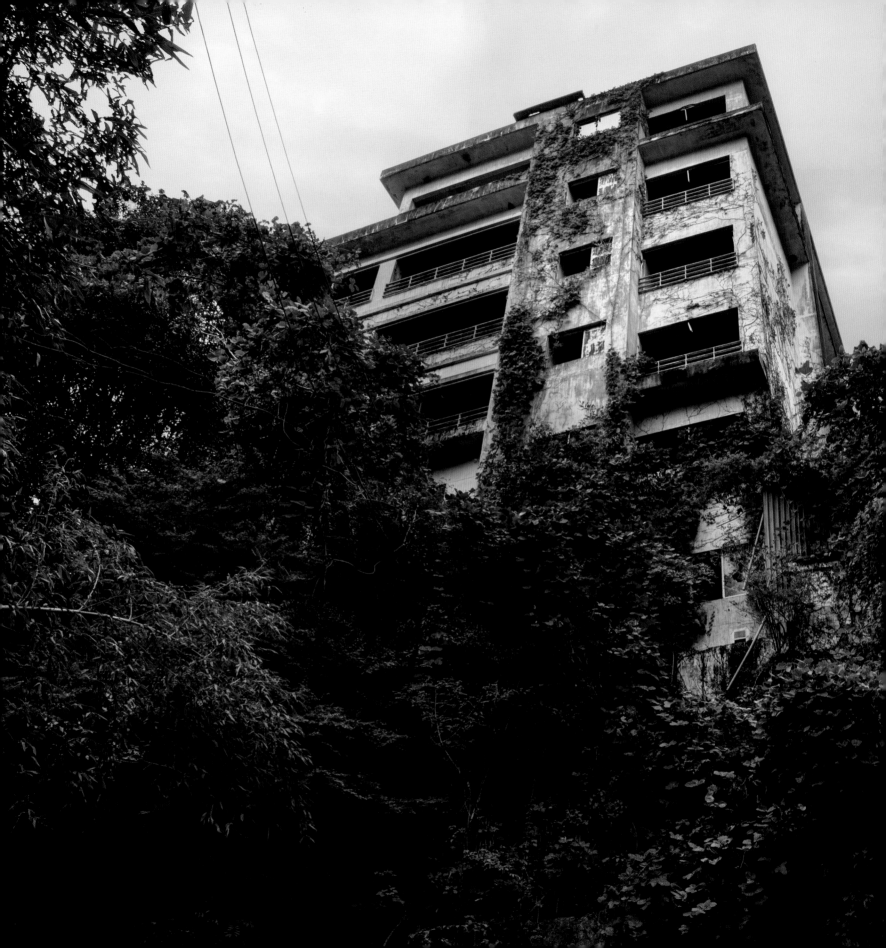

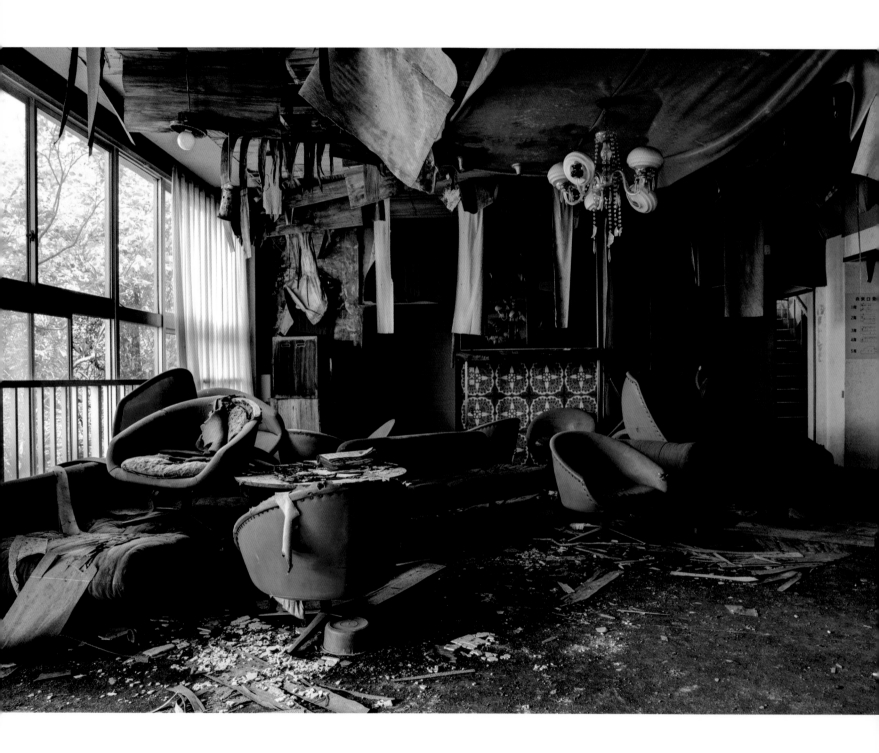

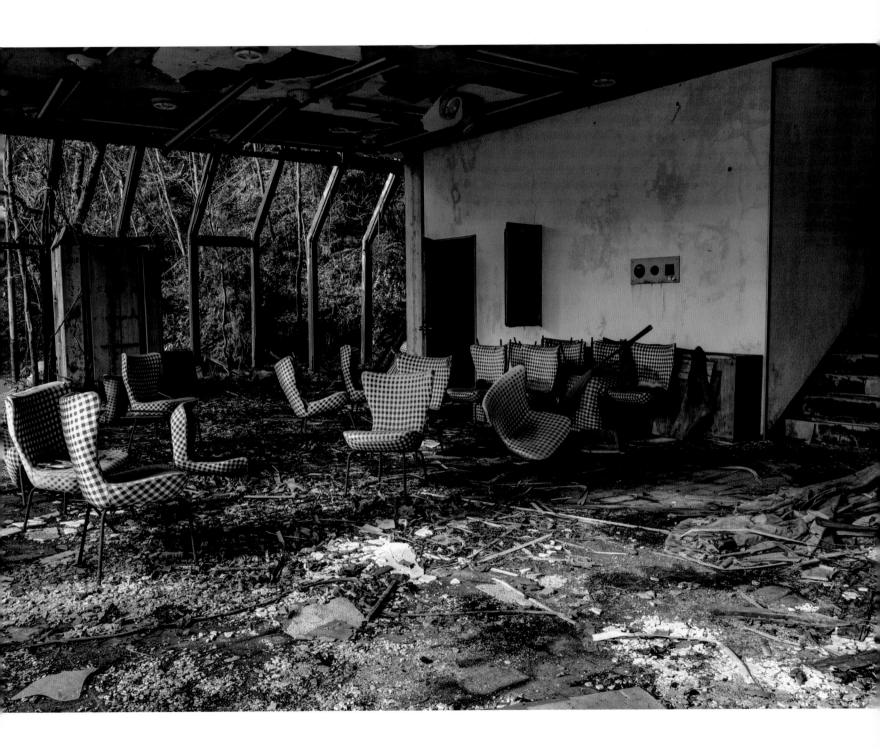

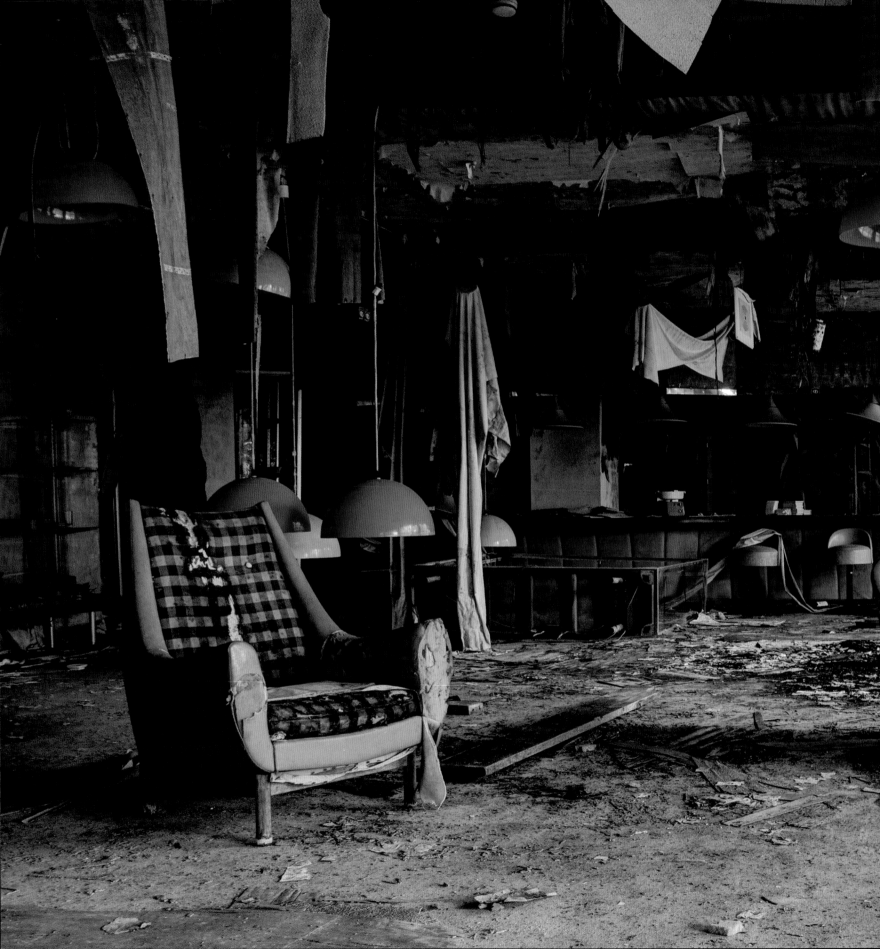

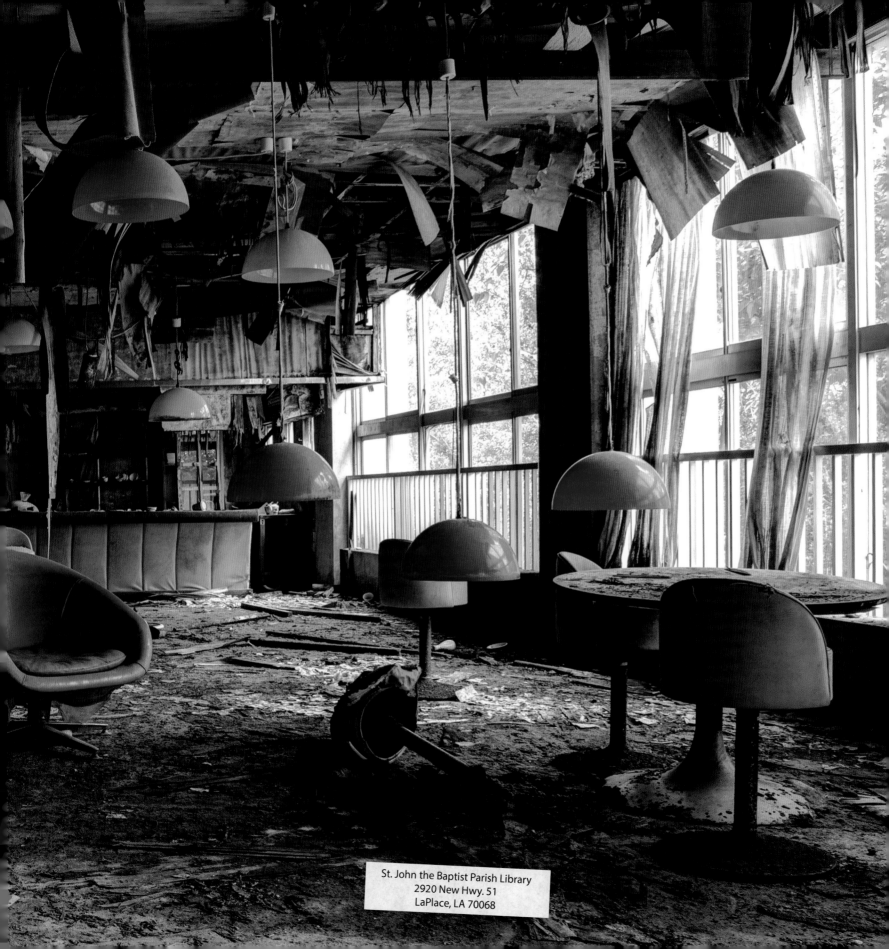

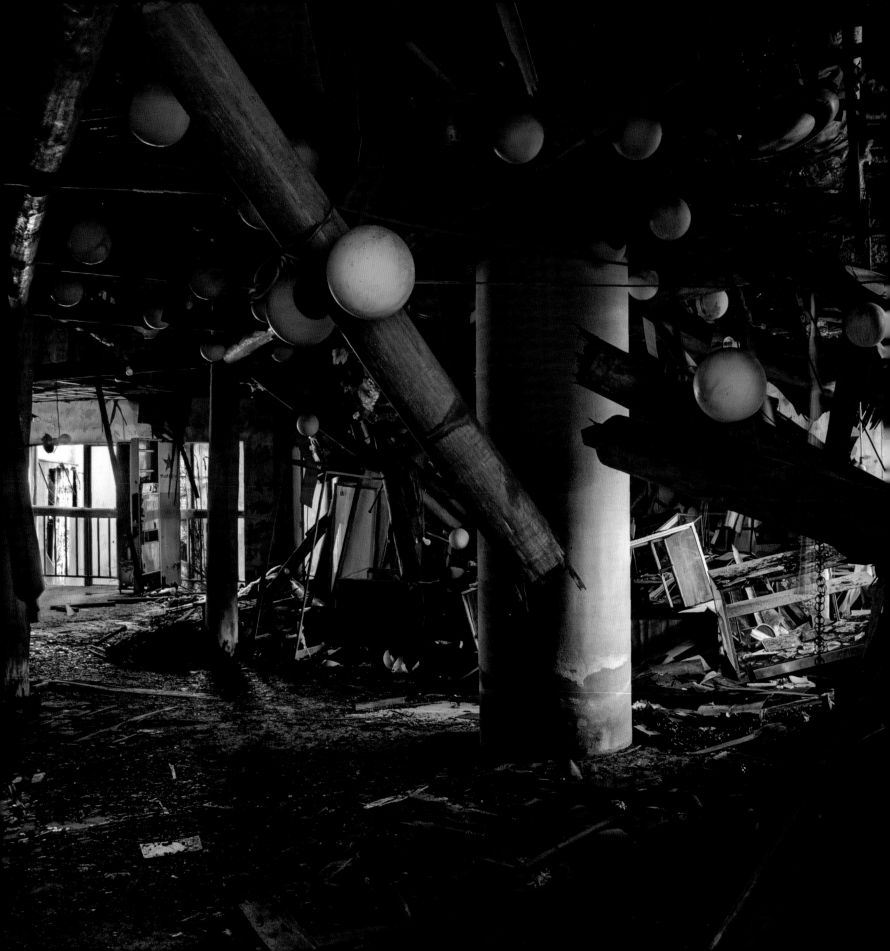

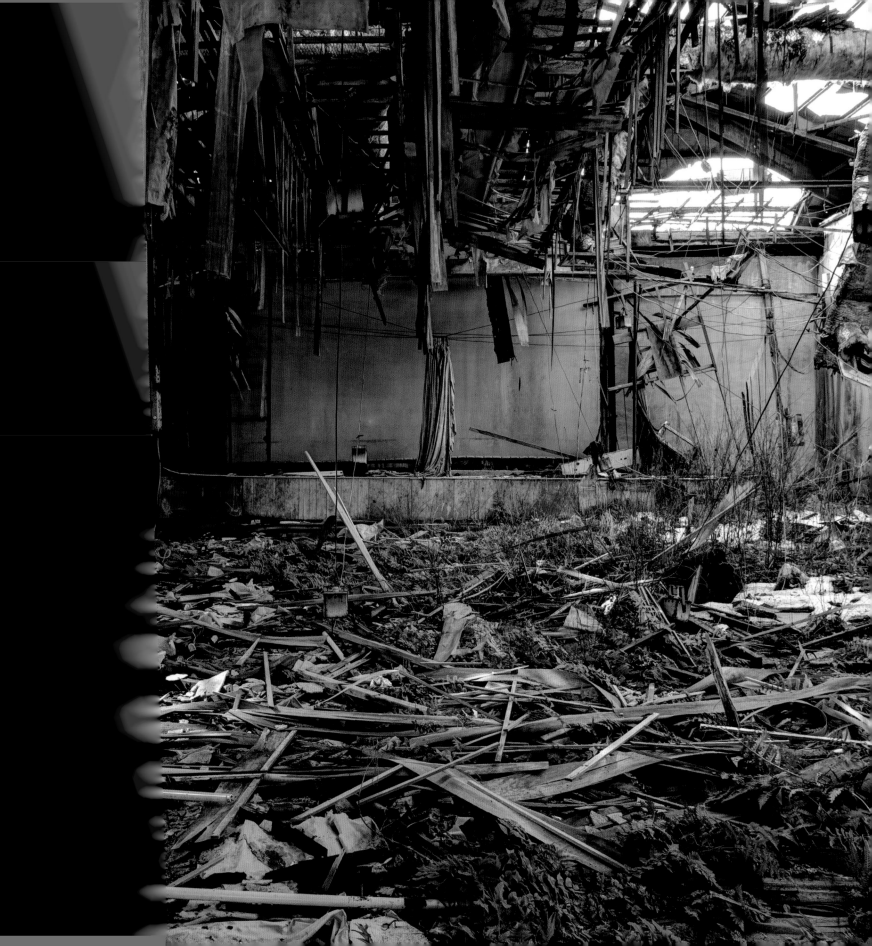

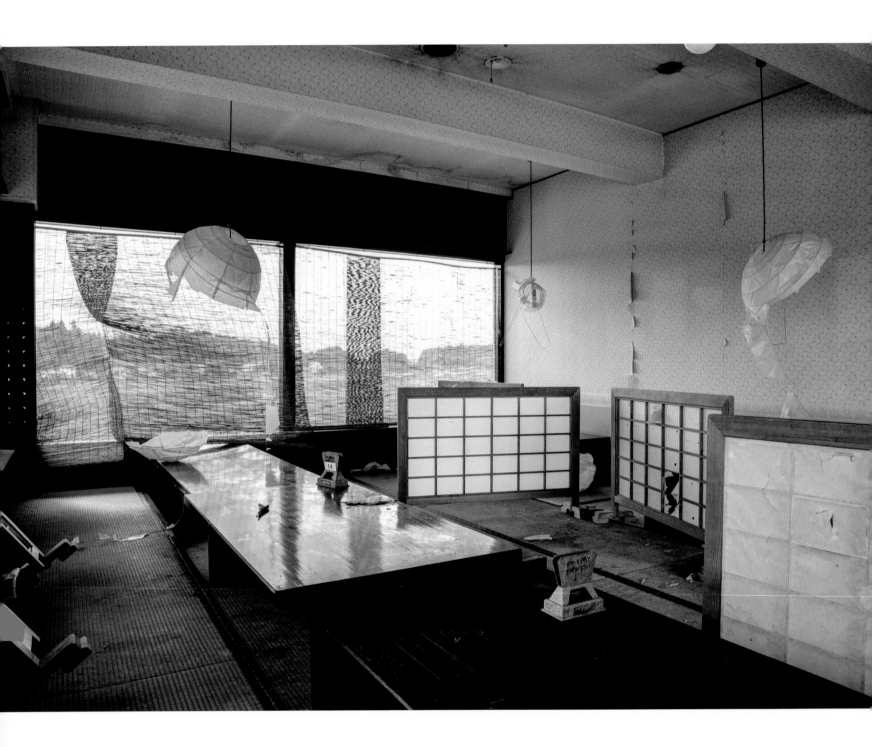

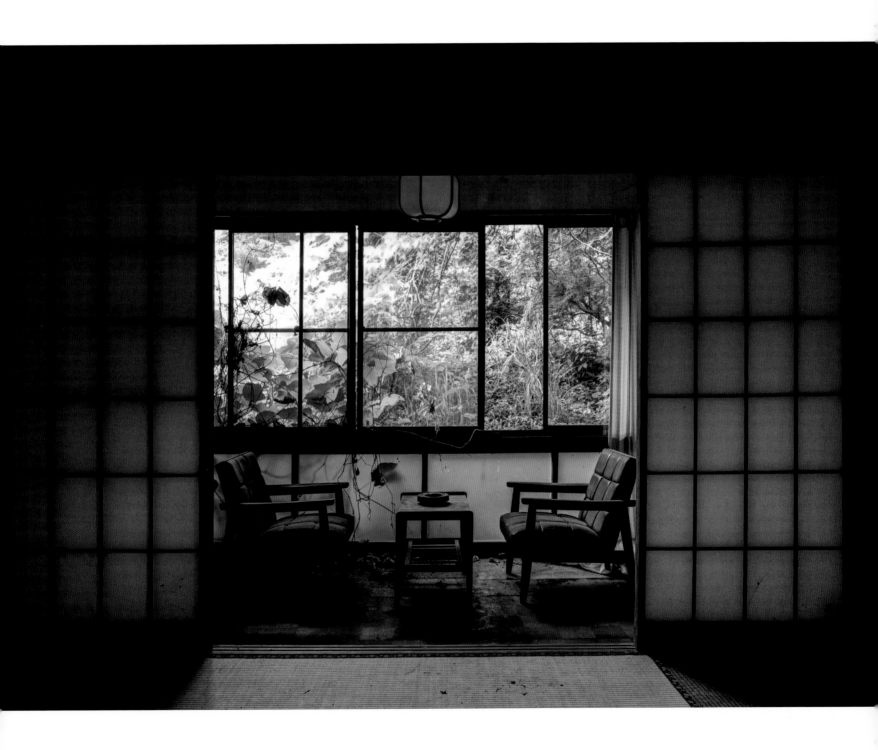

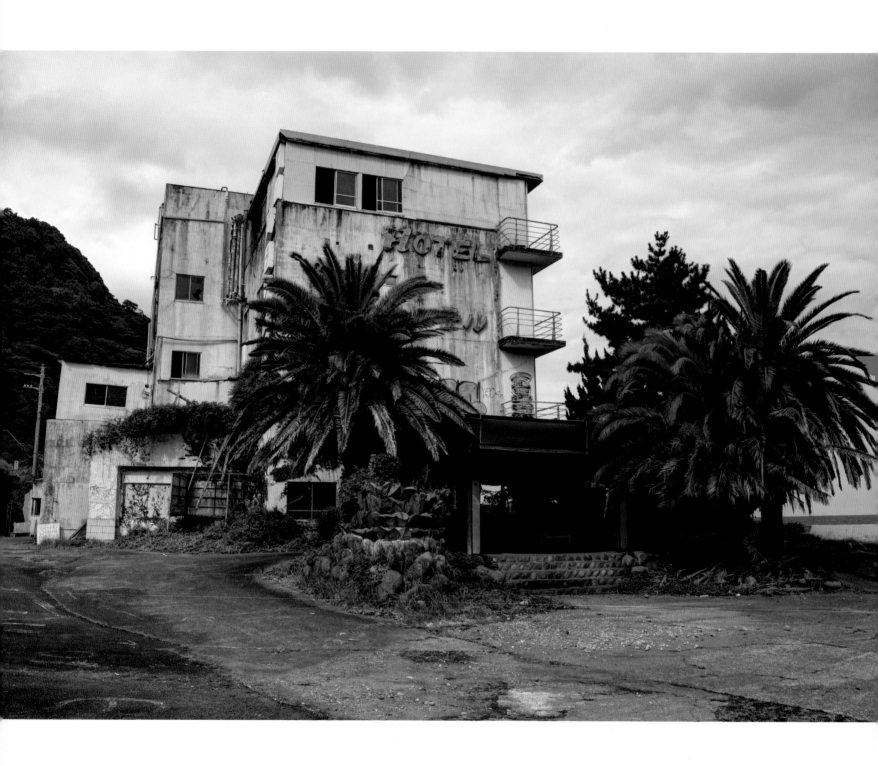

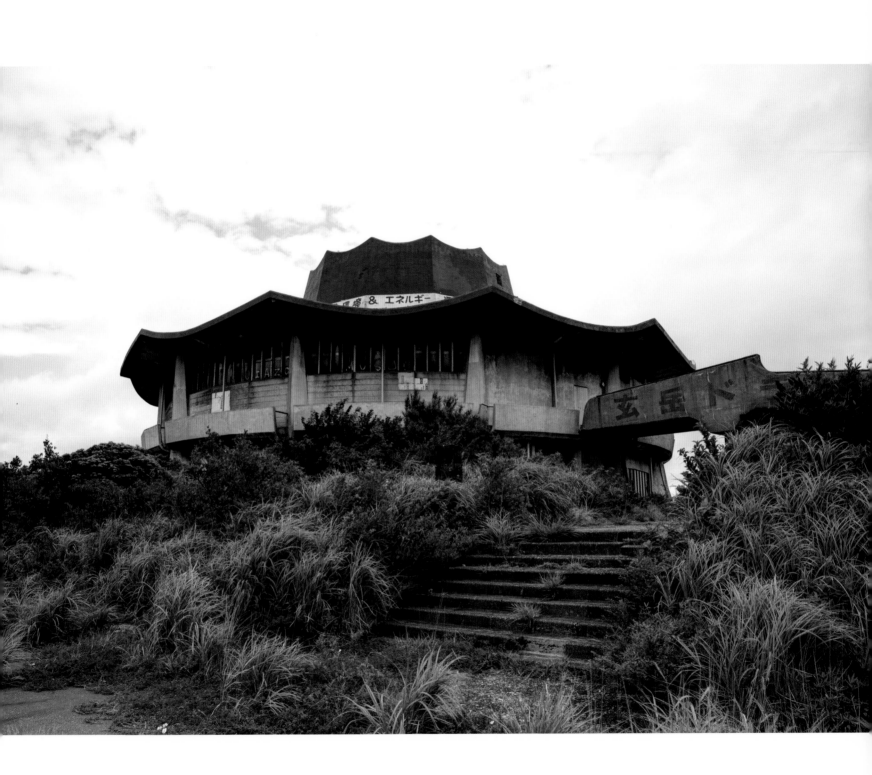

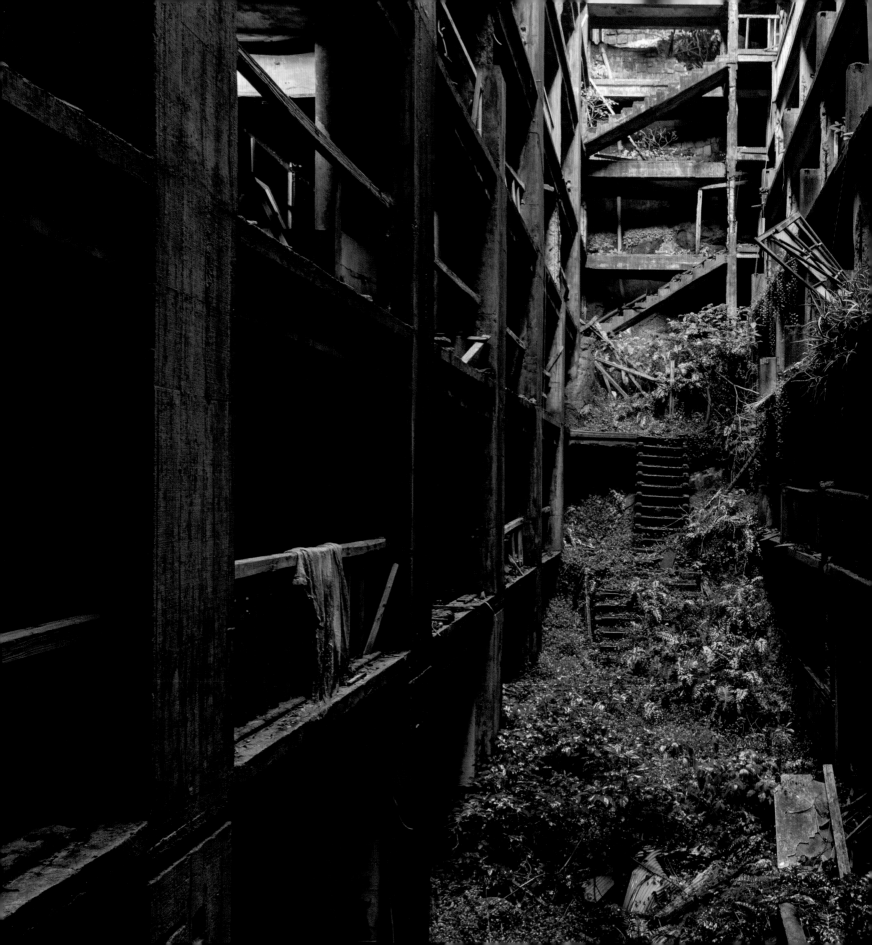

MINES
& INDUSTRY

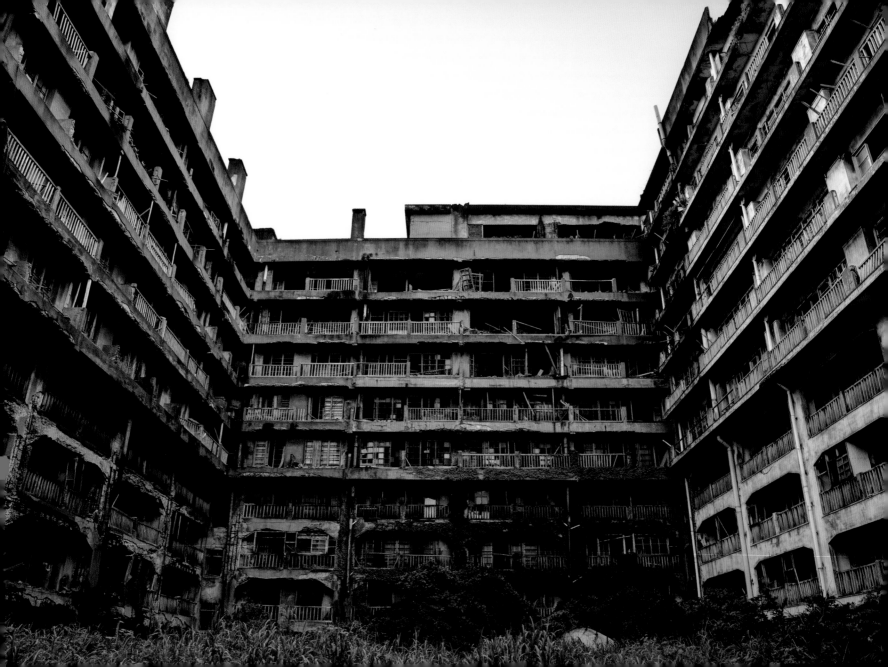

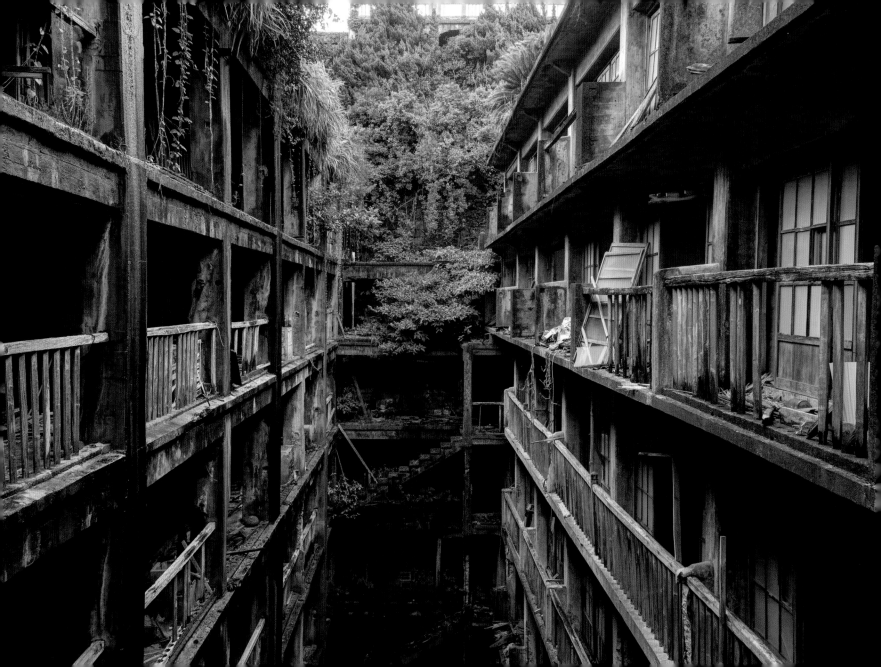

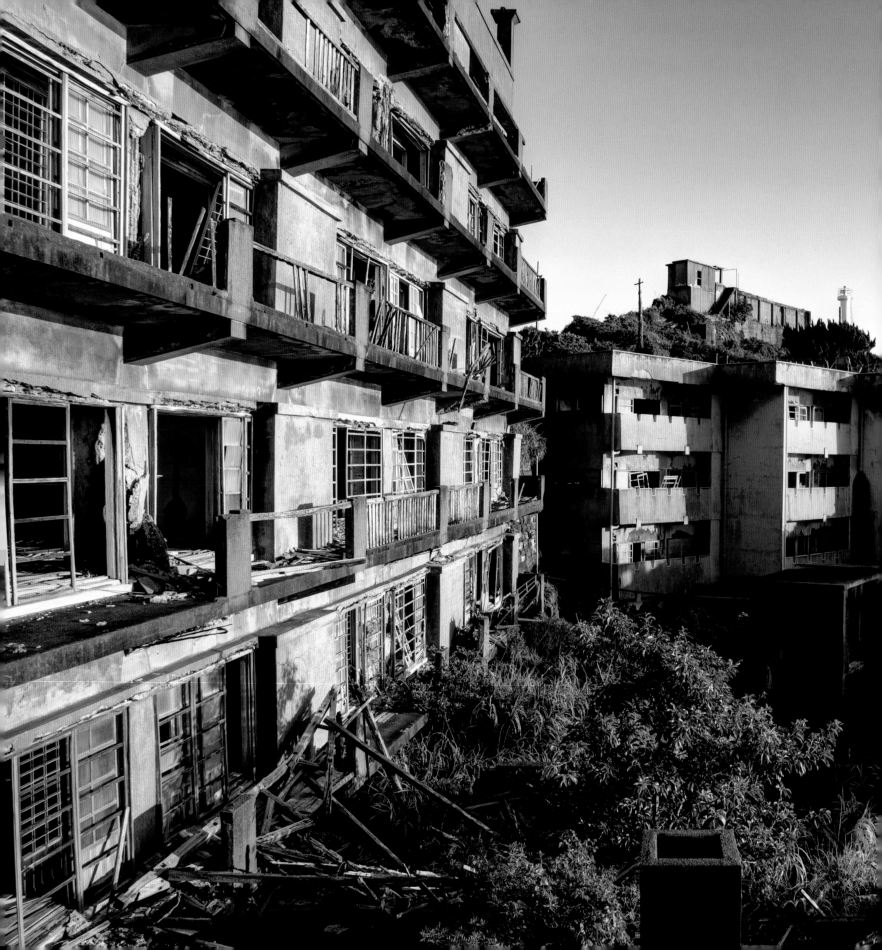

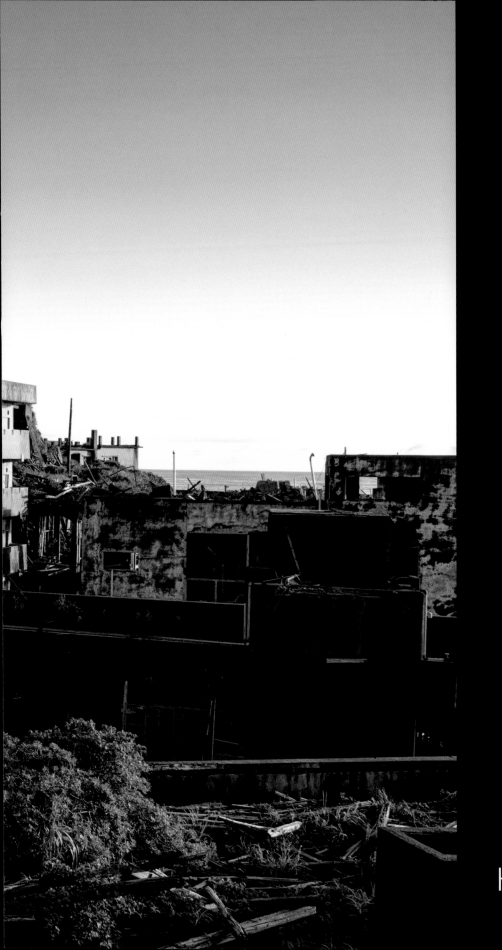

HASHIMA ISLAND

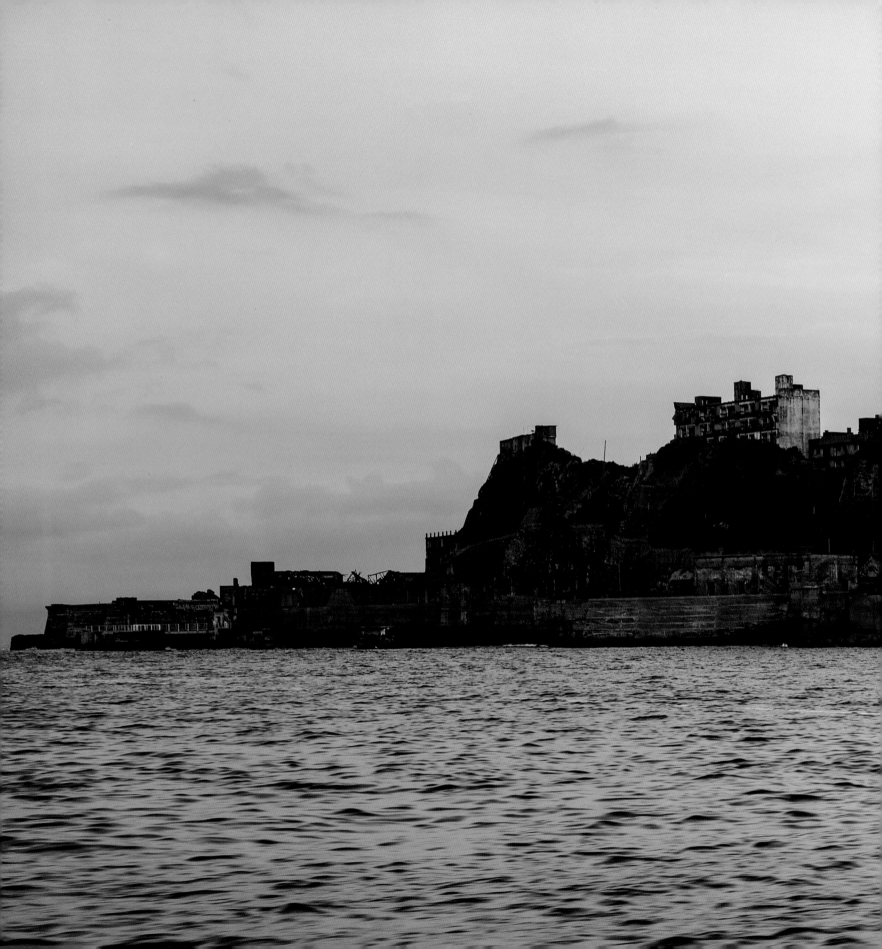

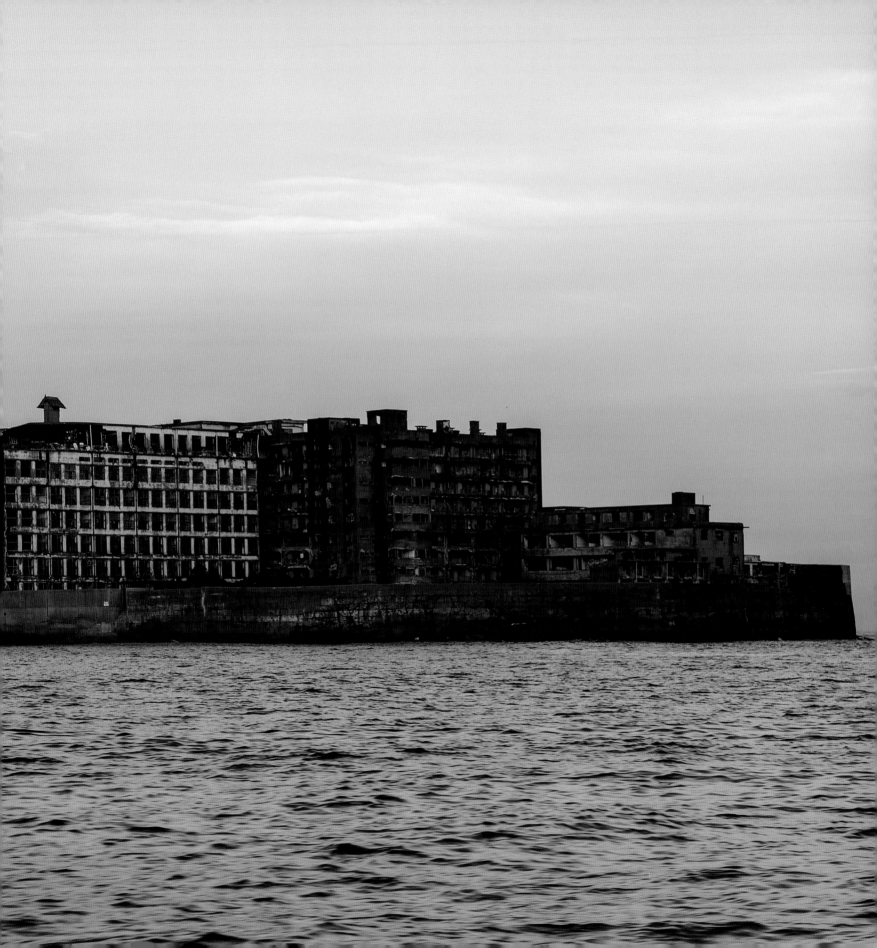

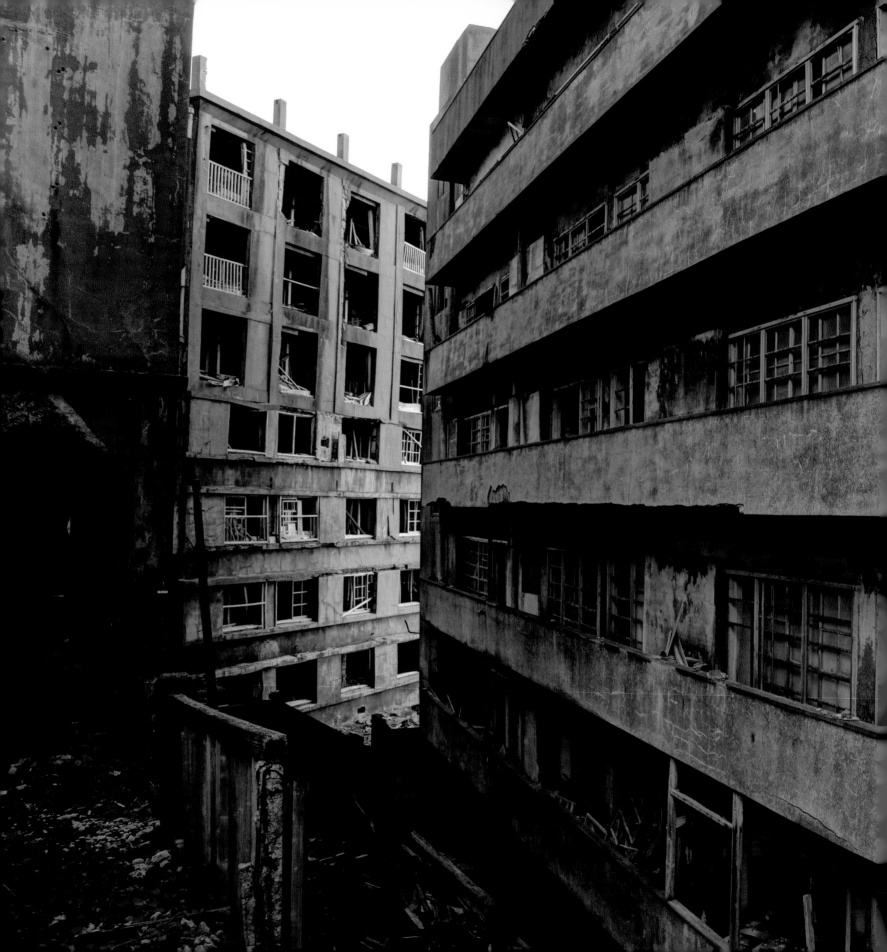

Upon the depletion of its once plentiful underground coal beds combined with a surge in the use of petroleum, Hashima Island, or *Gunkanjima* (meaning 'Battleship Island') ceased its mining operations forever in 1974.

Established in the late 1800s at the height of Japan's industrial revolution, its population peaked in the 1950s with 5,259 residents – most of whom worked deep within the confines of its dangerous mine. Now, in place of what was once a suffocatingly crammed community that lived on top of each other, sits a deserted and enchantingly dark ghost city.

Located 15 kilometres from Nagasaki and far more visually intense than any post-apocalyptic movie set, this isolated labyrinth of crumbling concrete and steel provides a rich and spectacular vision of urban decay.

Squashed within this crammed urban development are former schools, a hospital, kindergarten, town hall, bathhouse, community centre, swimming pool, pachinko parlour and cinema. Deeper within its bowels lies the heavily decayed remains of what was once the island's hairdressing salon - sitting in darkness since 1974, its dusty chairs and hair dryers still remaining moderately intact.

Overgrown vines swallow up its complex network of passageways with most interiors containing only mere fragments of their former furnishings. A labyrinth of narrow decayed concrete alleyways and moss-covered steps weaves through its shadowy spaces, connecting the suffocating buildings.

Concrete sea walls surround the island, keeping it safe from the violent ocean that smashes against its border. Cracking waves send shuddering roars through its fragile structures, many of which stand brittle and skeletal after years of no maintenance. Severe typhoons have also left a number of buildings severely dilapidated with debris strewn over what little ground there is.

A number of its constructions were built during the Taishō (1912-1926) and Shōwa (1926-1989) periods, sparking heritage talks with prospects of a possible restoration. With this in mind, Gunkanjima has a dark and contentious past that is often placed under scrutiny from both Chinese and Korean sides. In the 1930s and '40s, the island housed a number of prisoners, many of whom worked deep in its confines before and during World War II.

Hashima Island is a famous Japanese icon amongst ruins enthusiasts and a much sought after location within the haikyo and wider urban explorer communities. Arousing an abundance of curiosity from adventurers the world over, the island's isolated location combined with rough surrounding waters makes it a very difficult place to reach - but the lucky ones who succeed are treated to a privileged decaying visual that is all at once romantically beautiful yet melancholy.

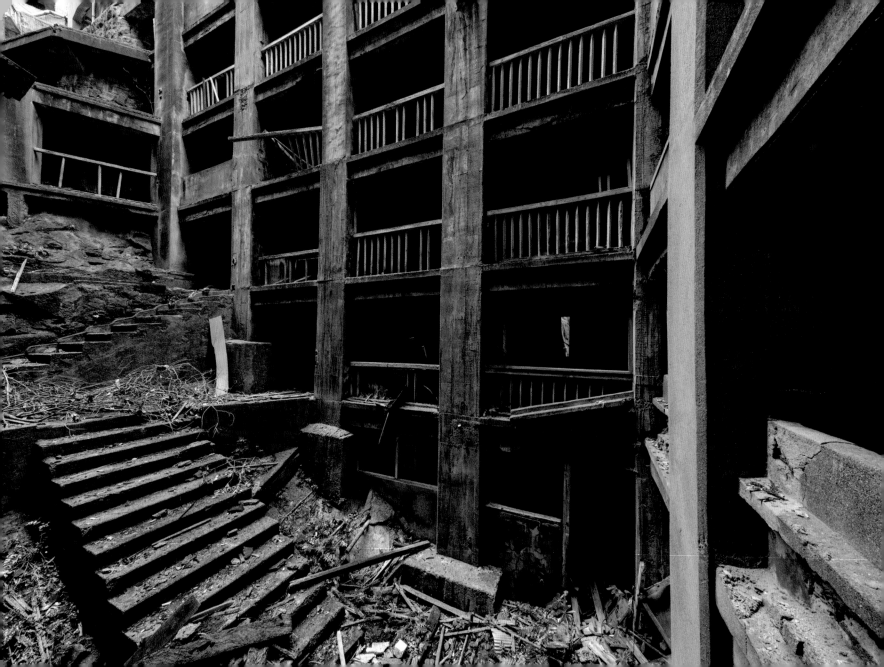

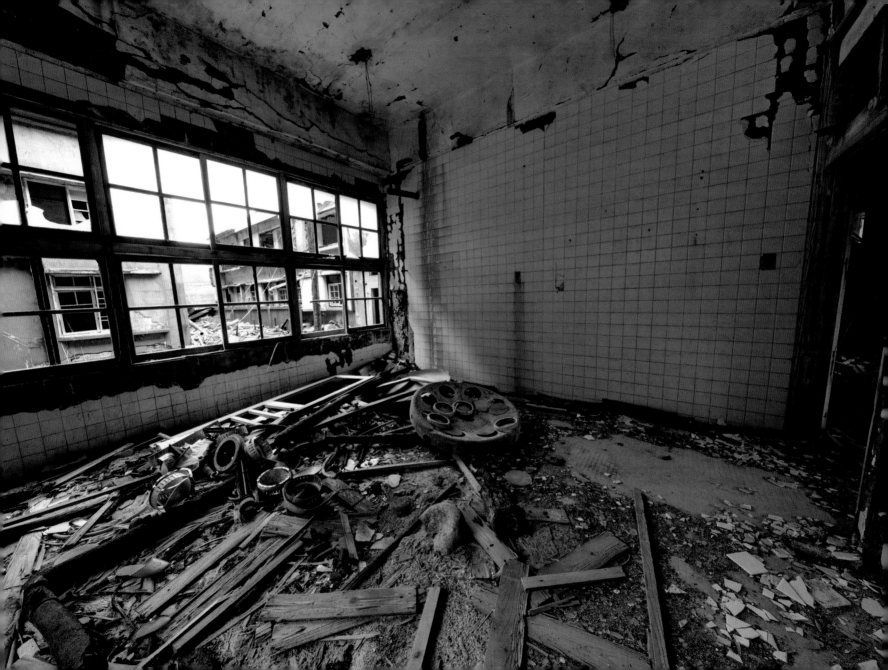

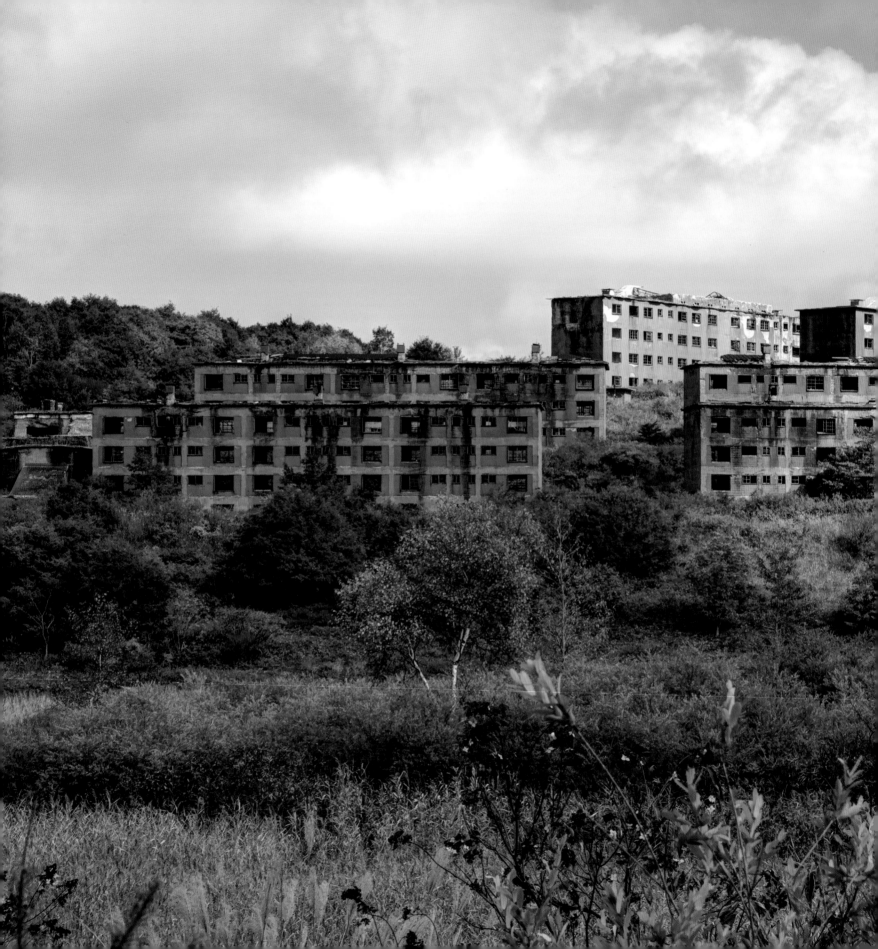

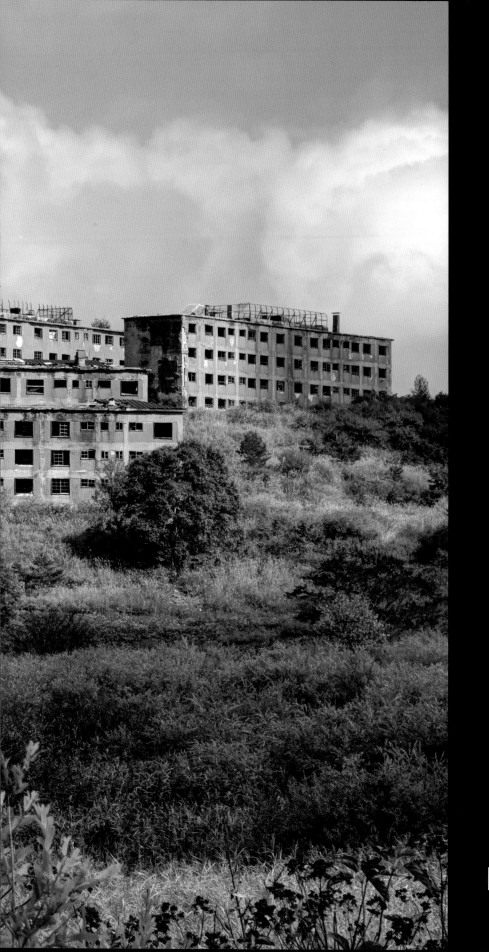

MATSUO MINE

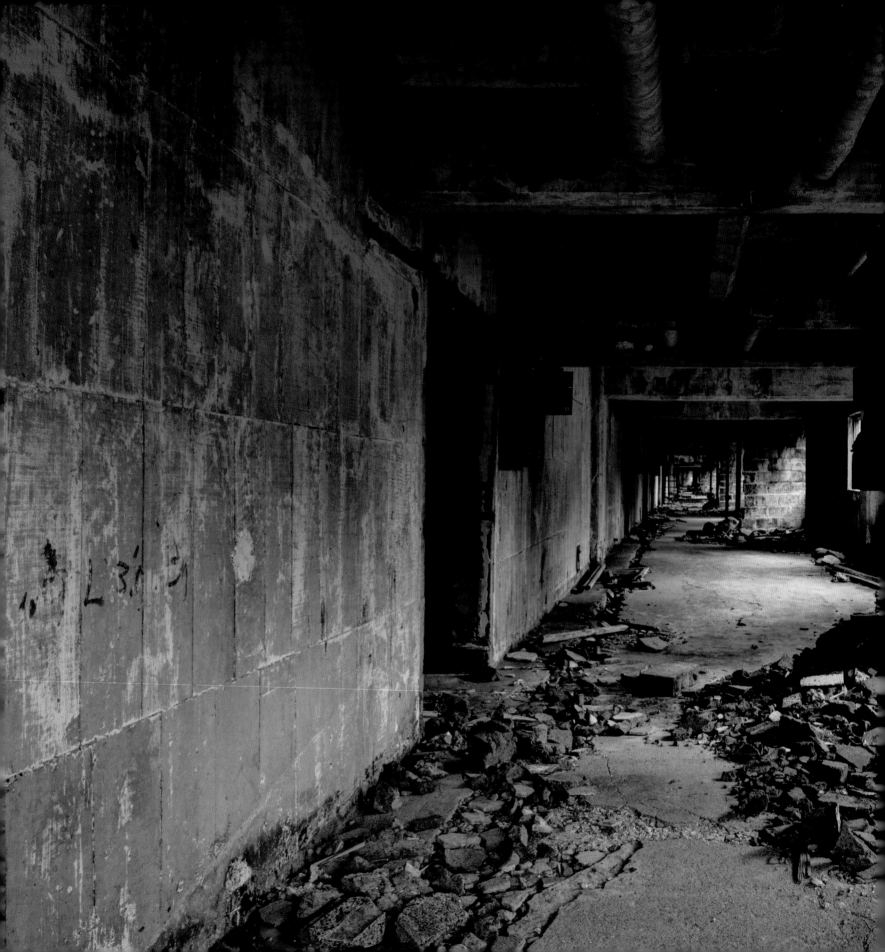

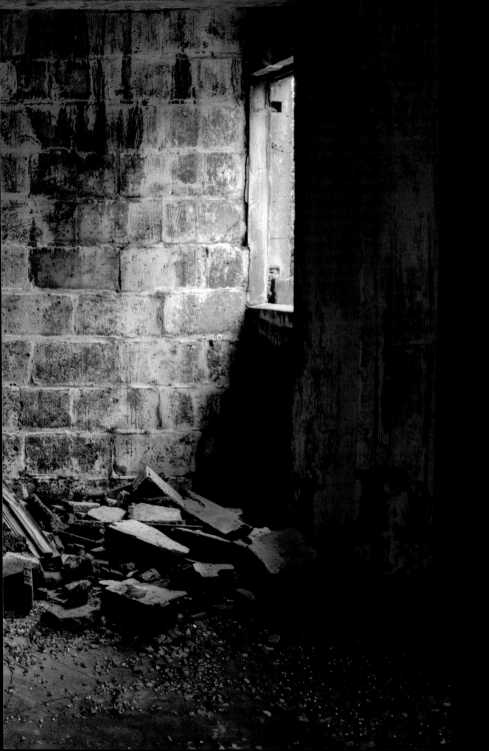

On the site of a previously active mine, these rows of empty, crumbling apartment blocks sit silently in a valley, surrounded by vines and shrubs. Without warning, a fast moving and dense fog descends over the buildings, creating a haunting and eerie ambience.

While the interiors generally offer sparse discovery, the curious explorer may stumble across a bicycle, a decayed mattress or perhaps an empty bottle of Sake, but the majority of its small living spaces remain empty.

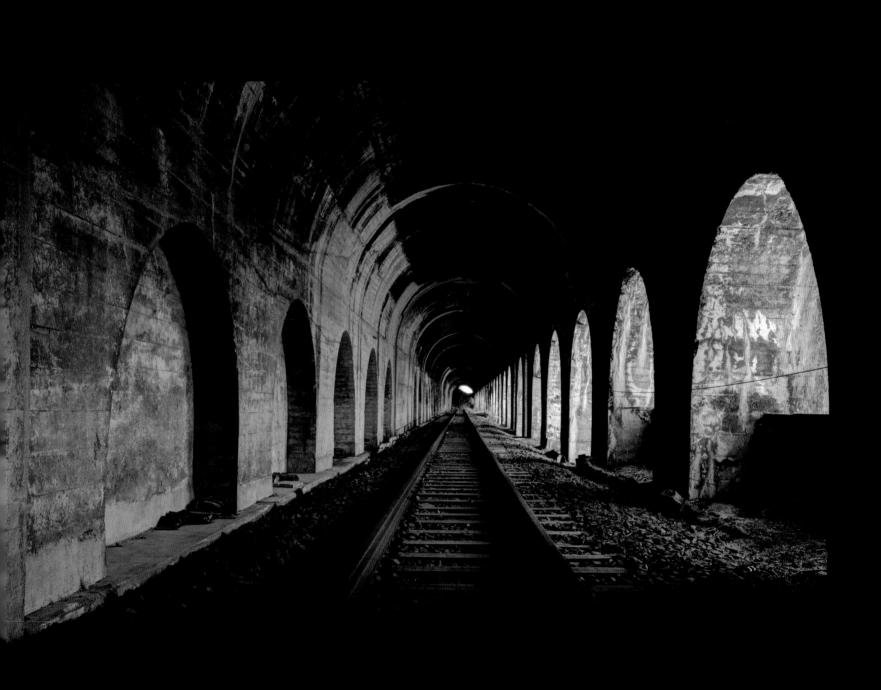

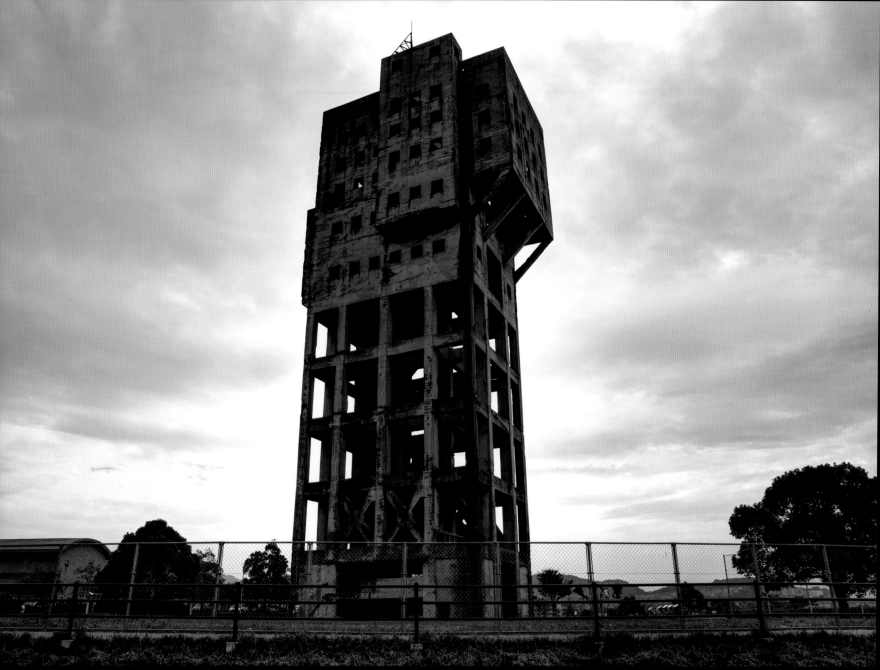

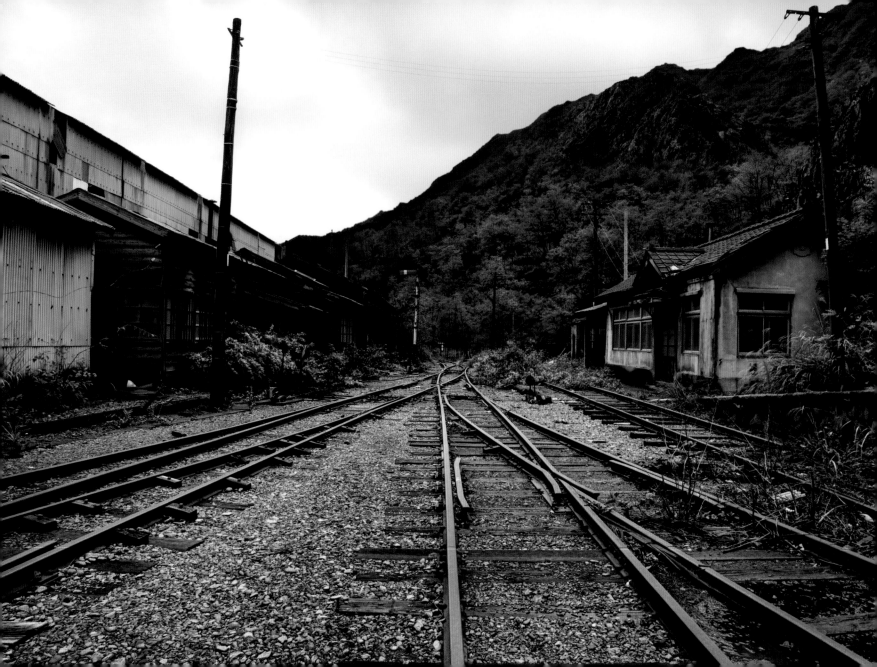

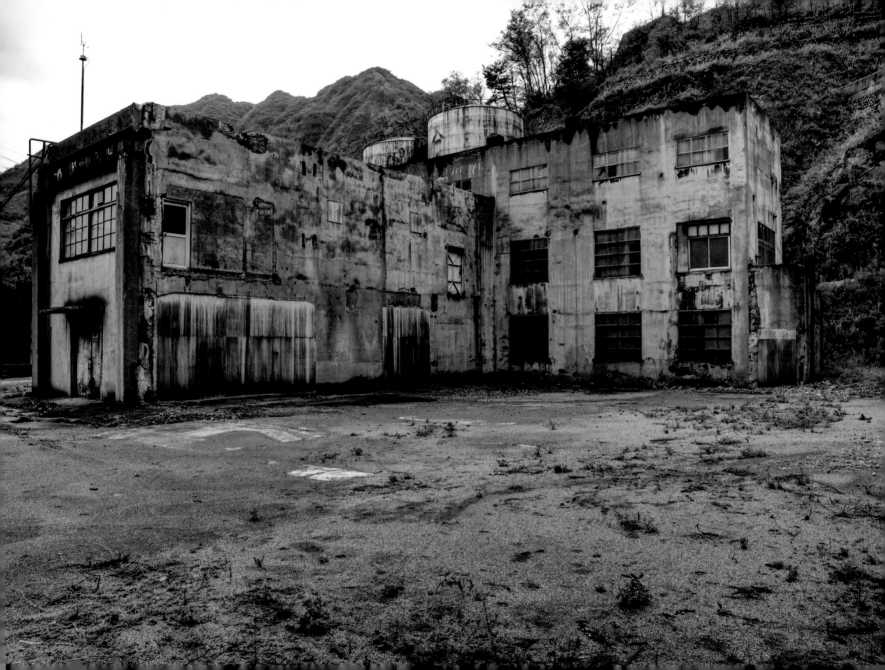

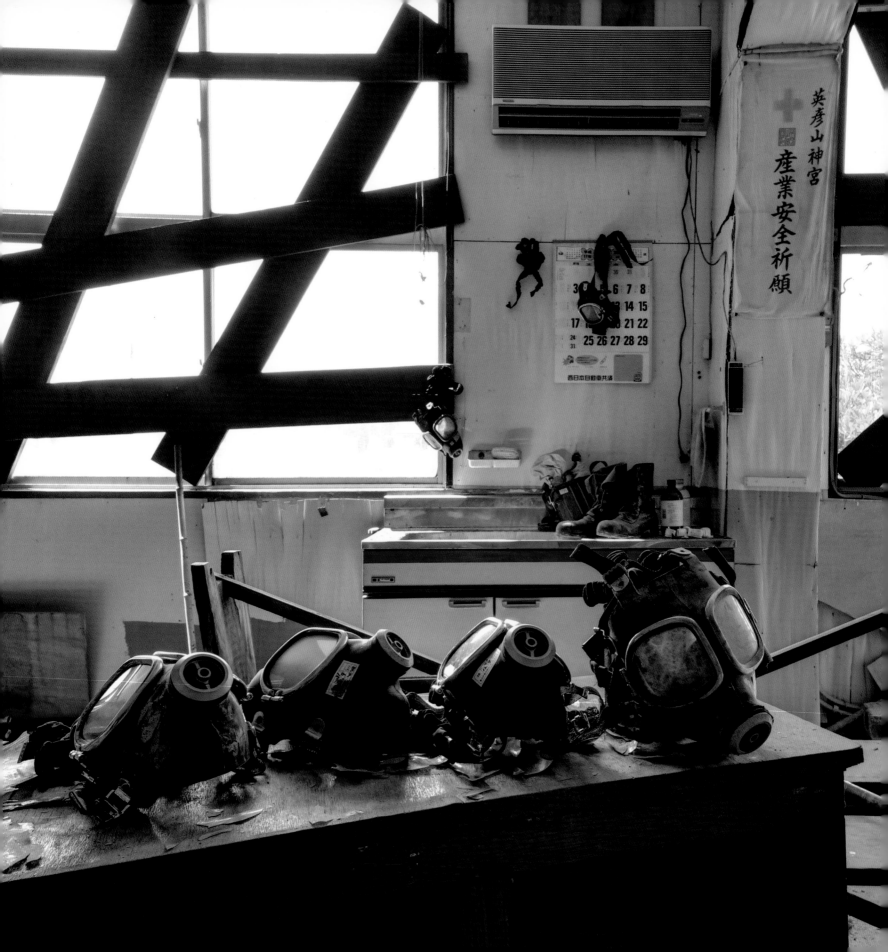

変電設備

係員以外
立入禁止

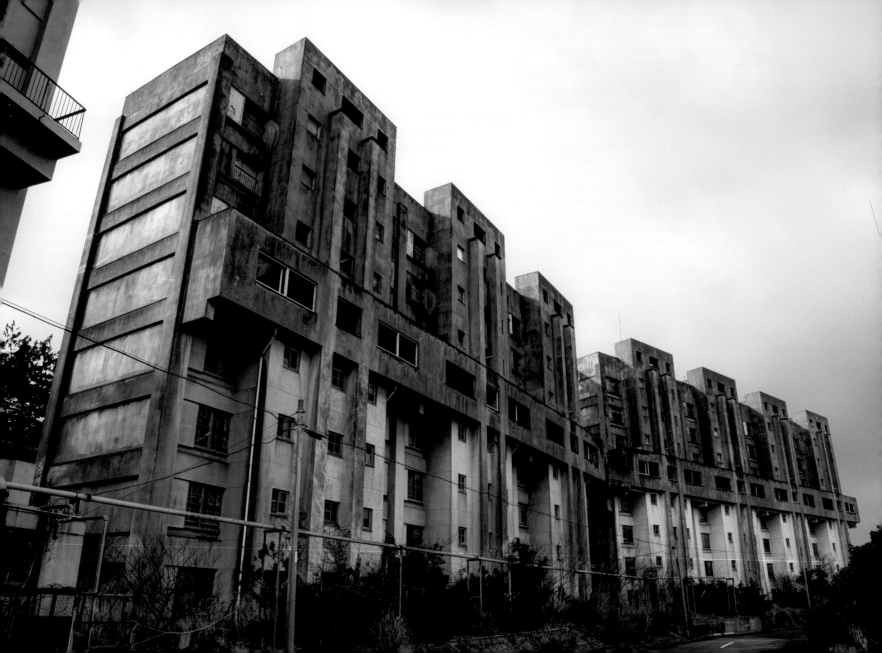

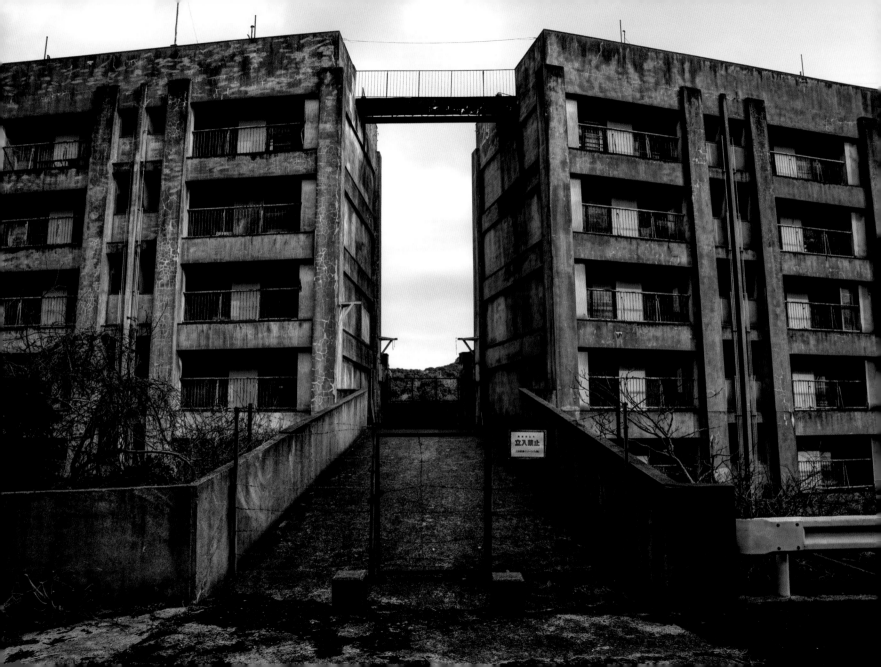

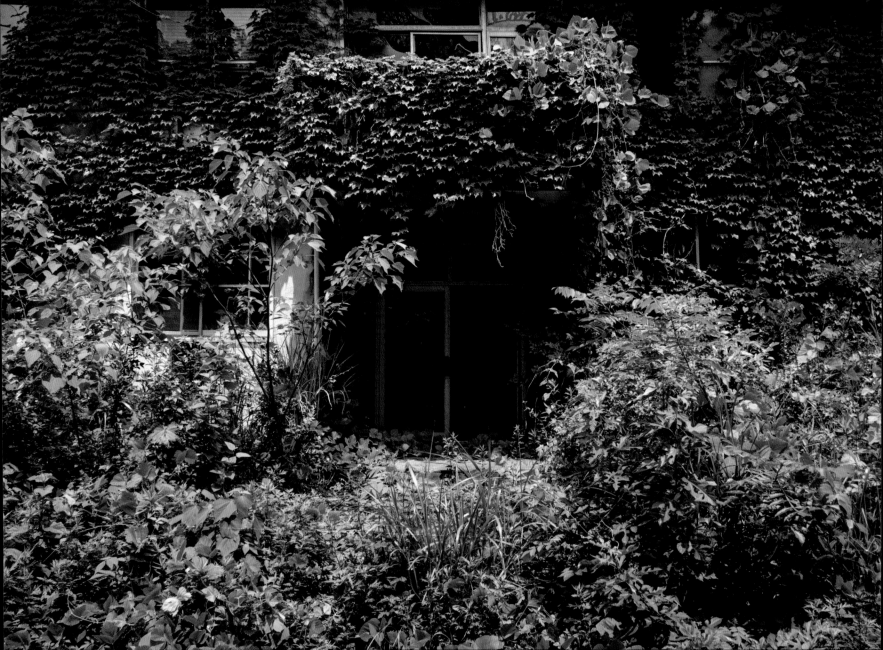

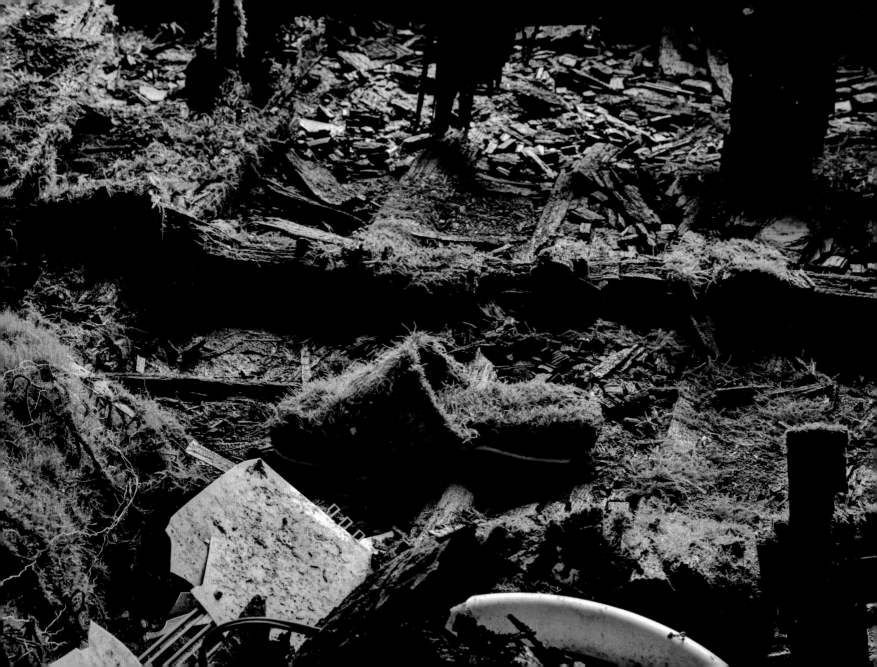

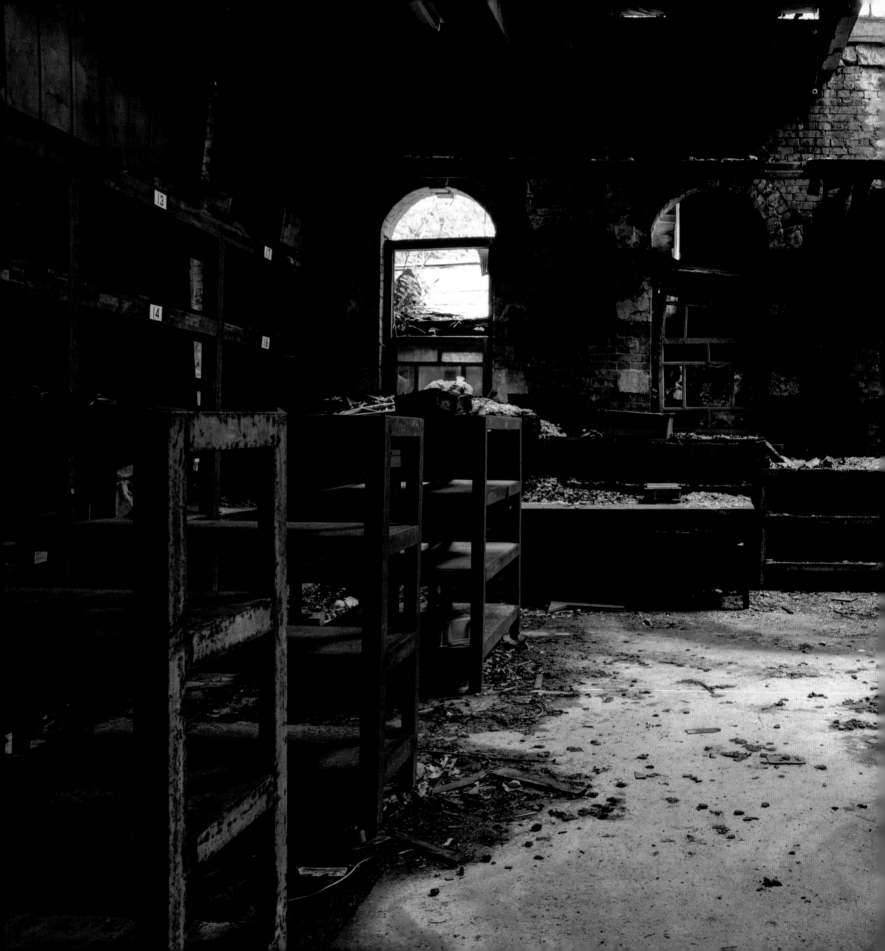

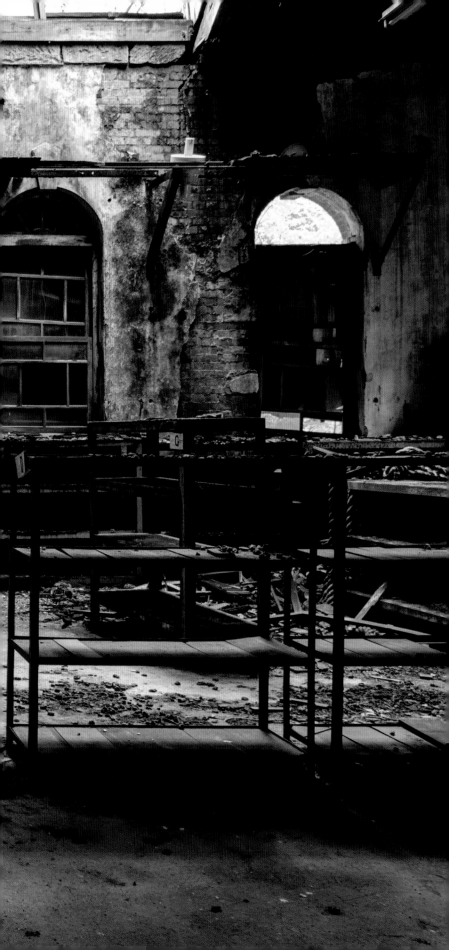

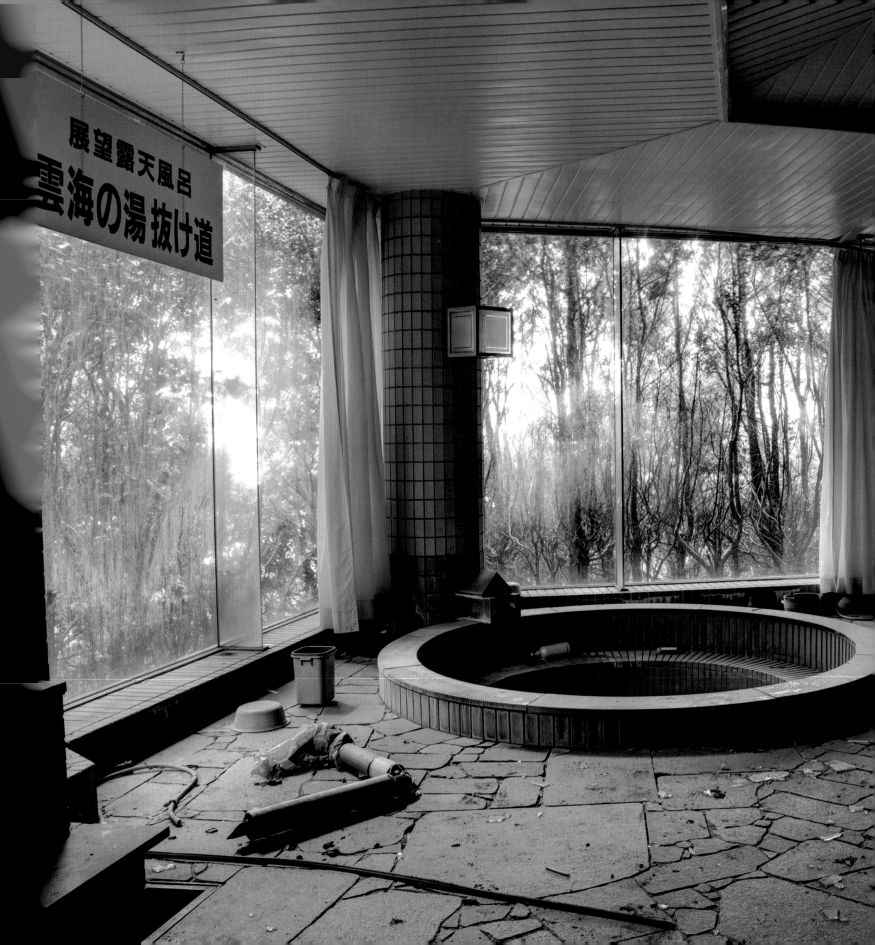

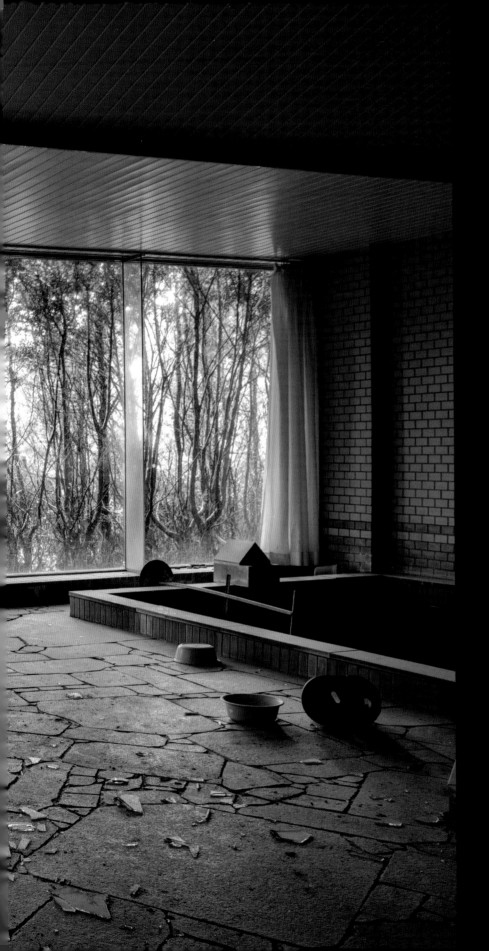

ASO KANKO HOTEL ONSEN

The Onsen is perhaps one of the most defining Japanese cultural icons. Located all over this volcanically active country, these hot, steamy bathhouses are as much a part of Japanese culture as sushi, sake and Sumo wrestling.

Positioned on the side of a semi-active volcano, this onsen resort sits forgotten and dilapidated at the end of a narrow mountain road. Volcanic steam eerily floats through its broken windows and the rich smell of sulfur surrounds its empty halls and guest rooms. On the lower level, an enormous tiled bath house waits in the darkness for bathers who will never arrive. Broken glass, water buckets, soap dispensers and scrubbing brushes lay scattered across its floors. A place where people once cleansed, revived and rejuvenated, now only the dirt, dust and decay remains.

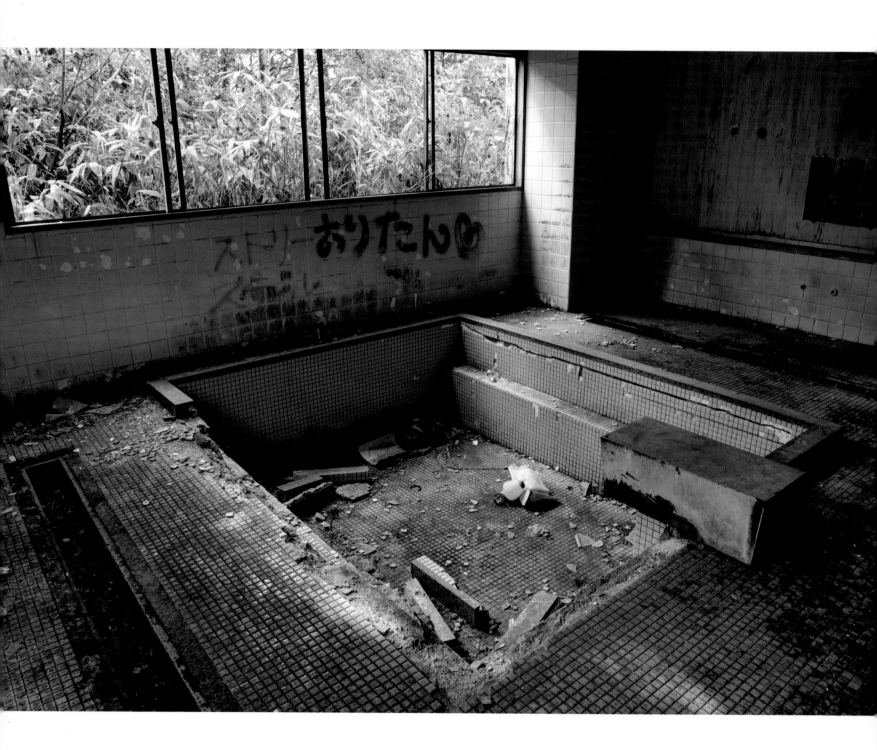

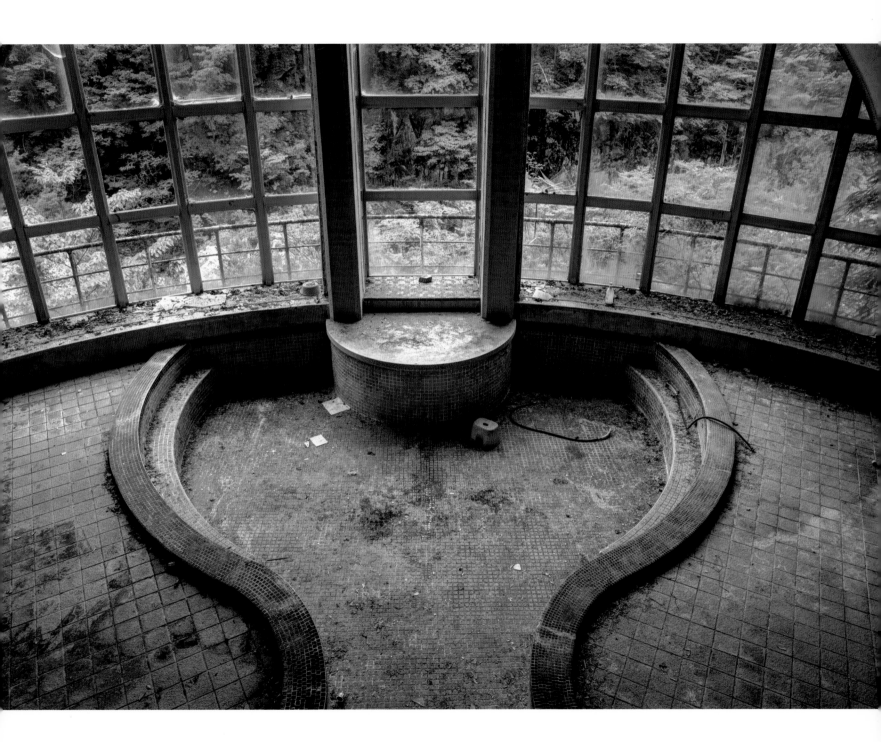

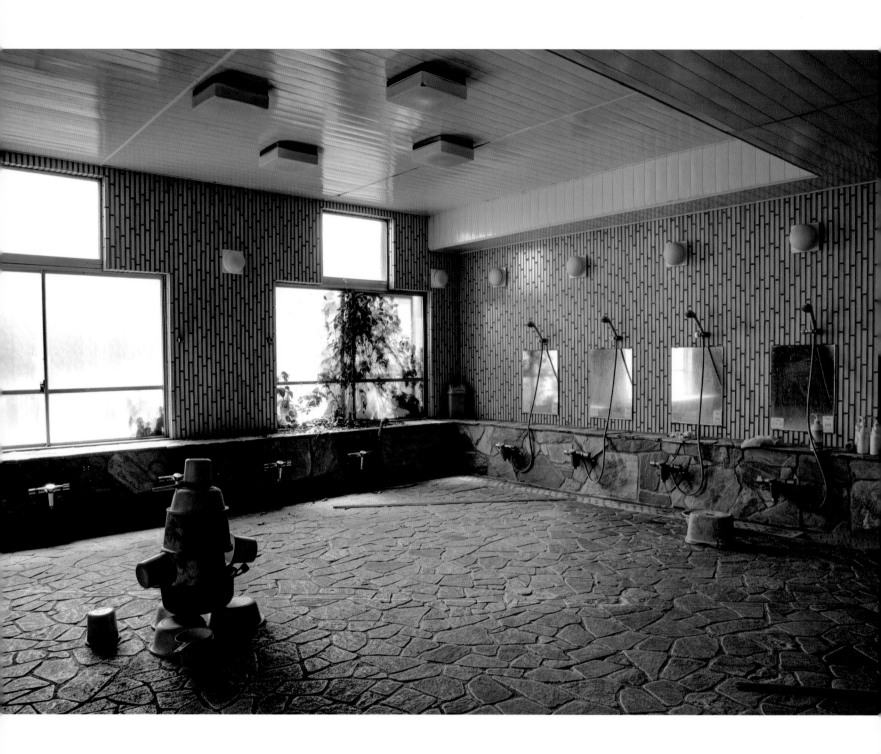

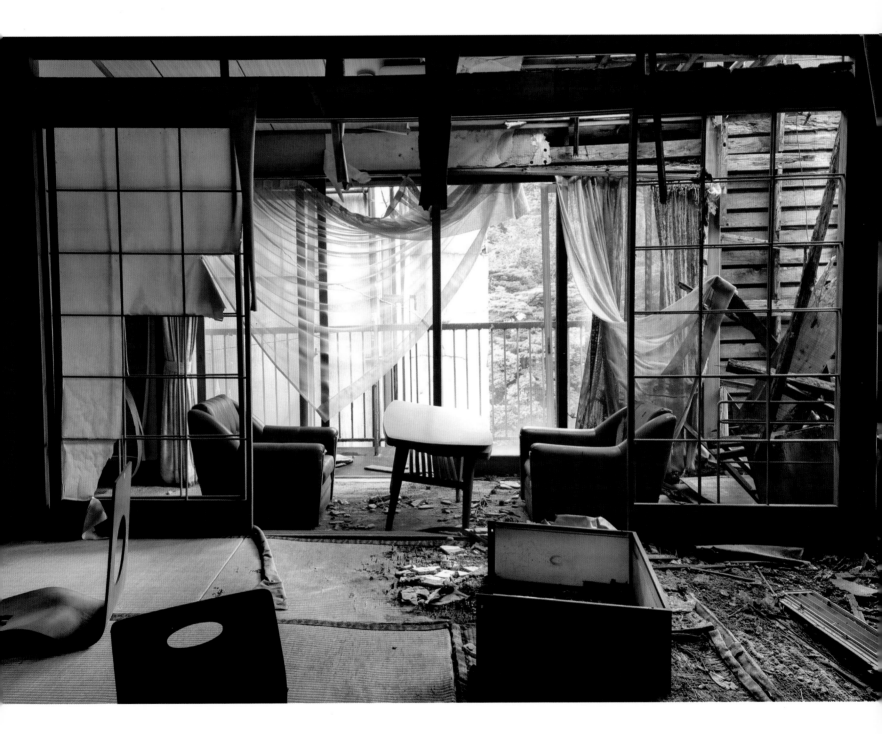

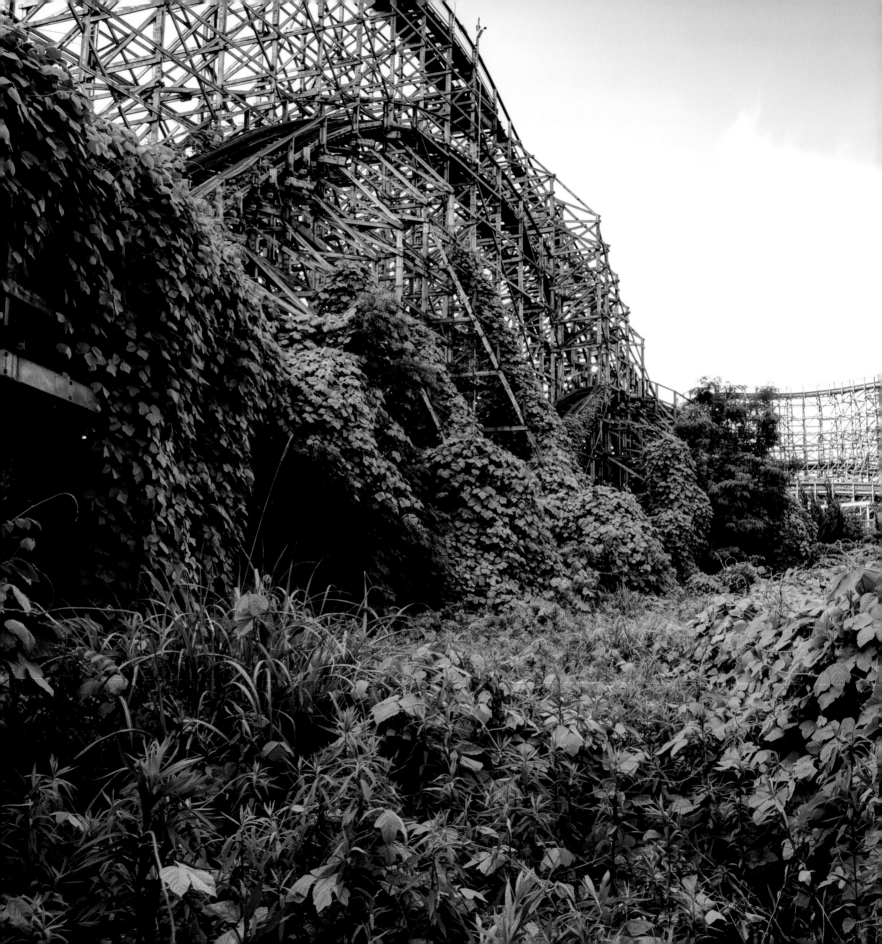

THEME PARKS
& LEISURE

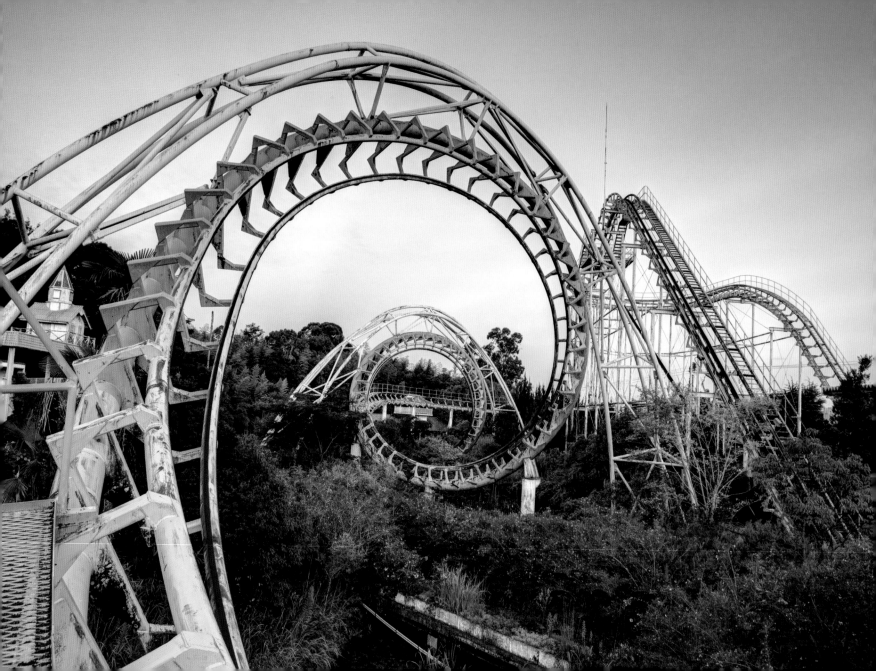

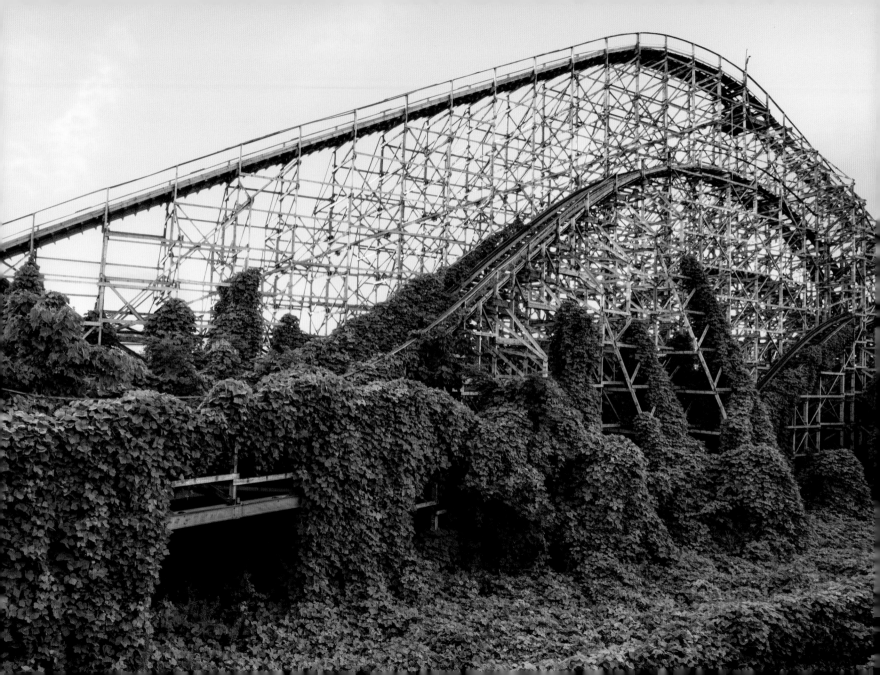

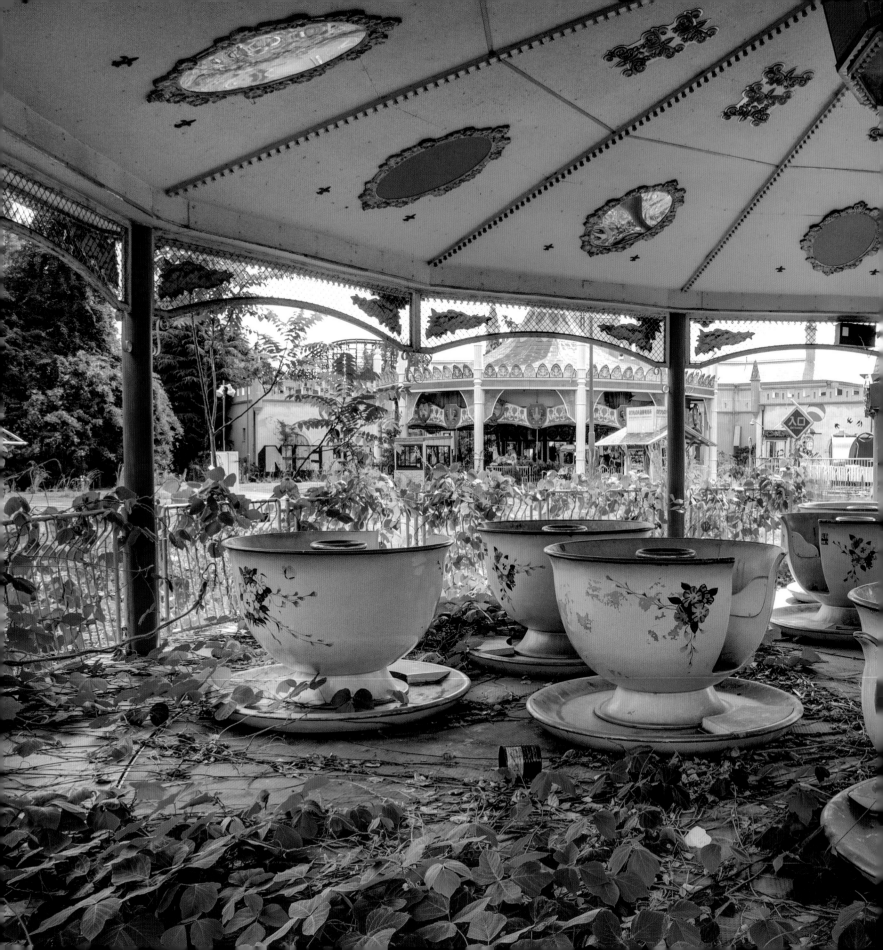

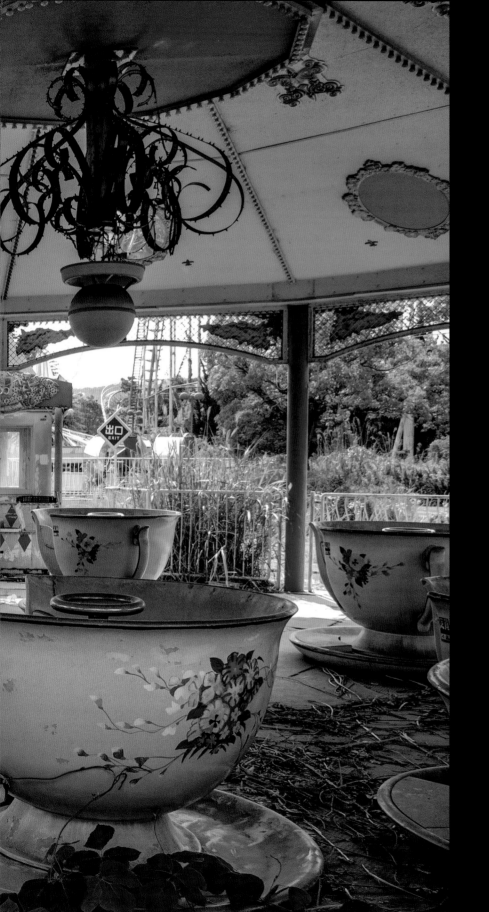

NARA DREAMLAND

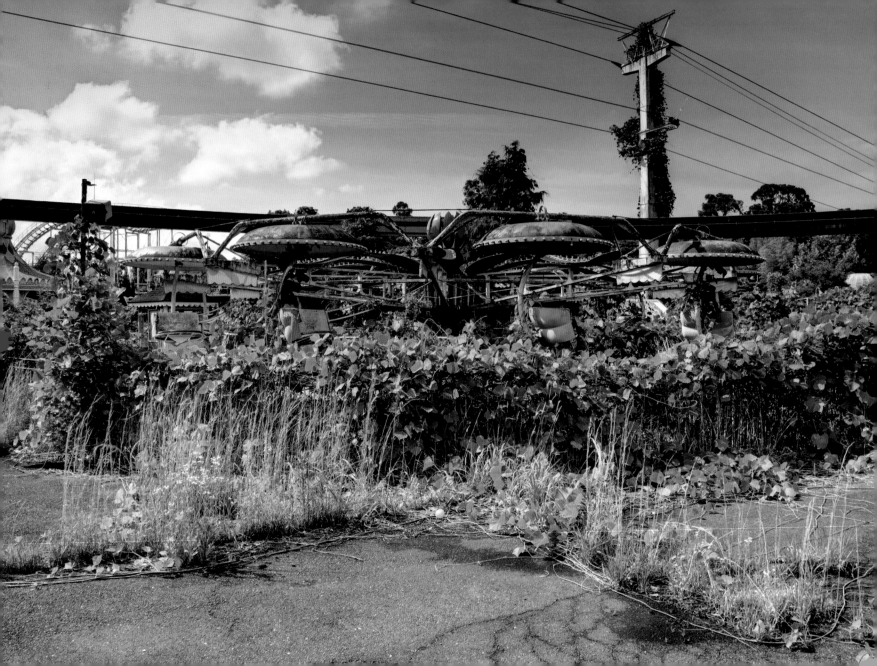

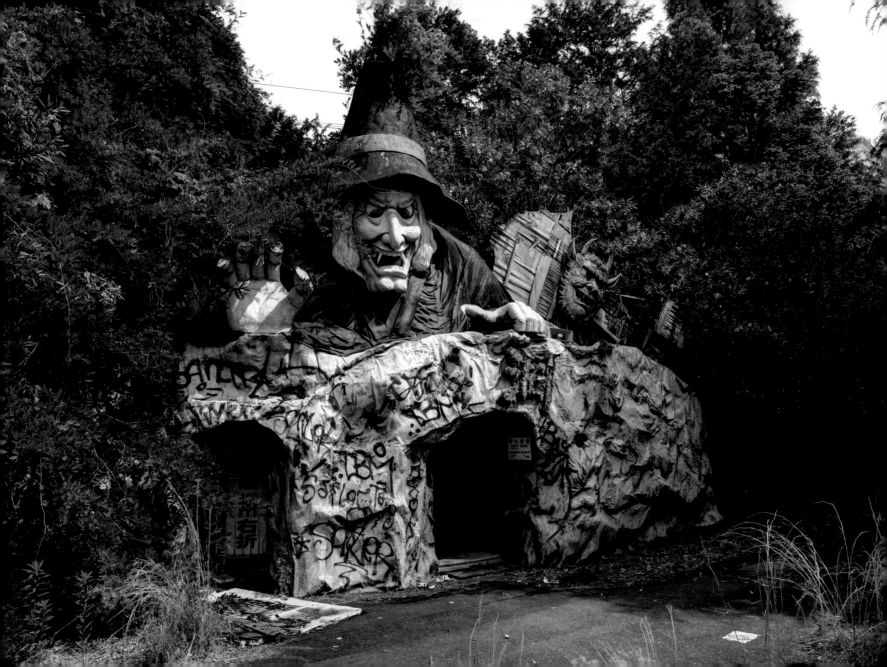

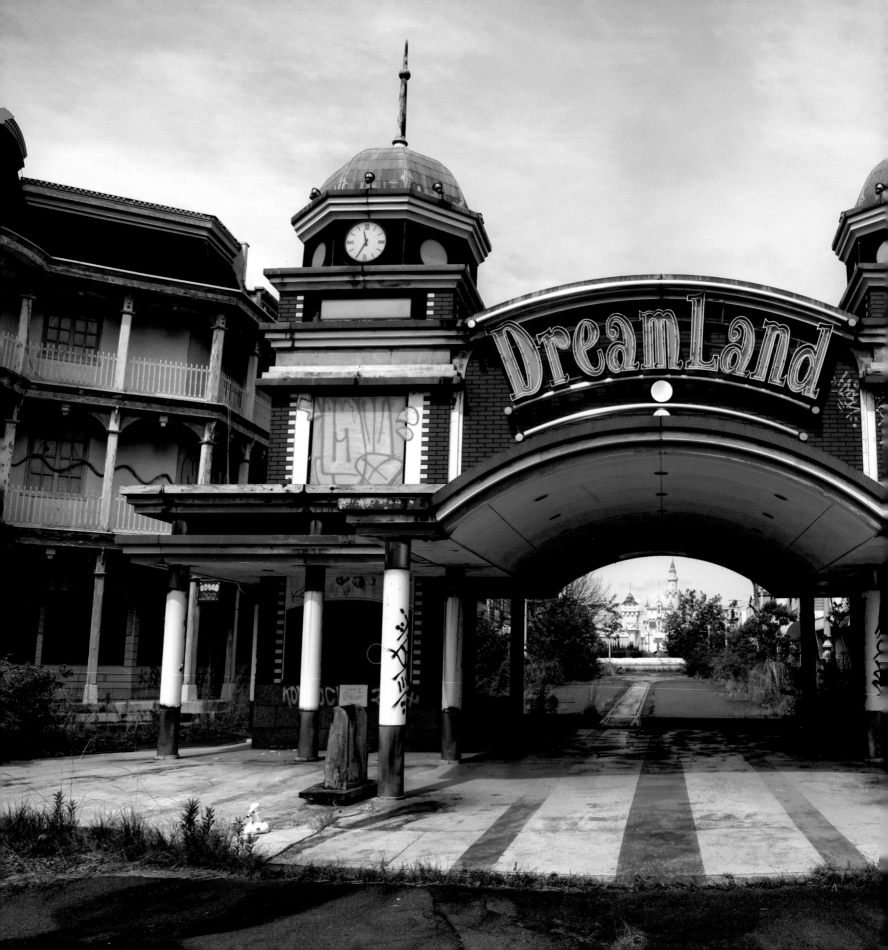

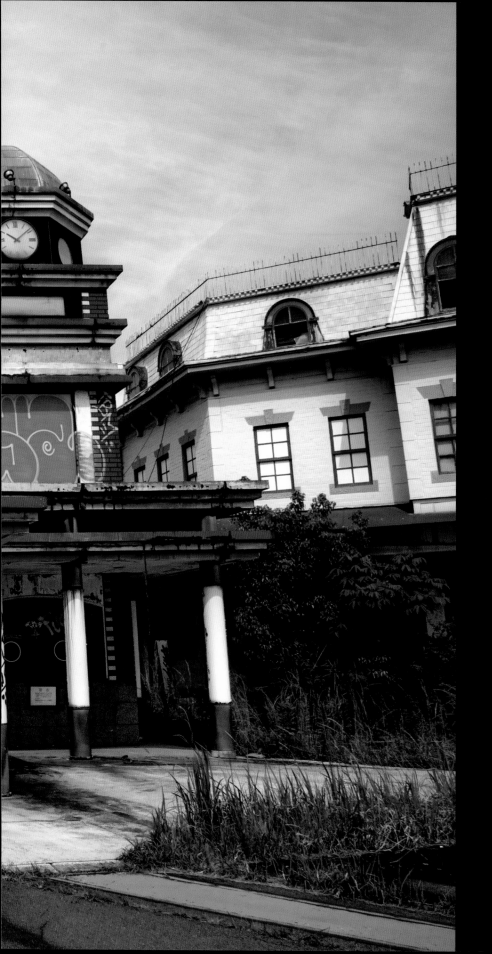

Built in 1961, Nara Dreamland was termed by many as Japans answer to the ever-infamous Disneyland. Initially drawing an abundance of visitors from far and wide, this counterfeit theme park contained replicas of well-known Disney trademarks such as Main Street USA, Adventureland and Tomorrowland. But fierce competition from the 1983 construction of an authentic Tokyo Disney, combined later with a high-tech Disney Sea park resulted in a huge drop in tourist numbers, eventually leading to its closure in 2006.

Filled with rusty rollercoasters and a variety of dilapidated amusements including waterslides, a carousel, teacup ride, mini golf course, haunted house and a monorail, this deserted playground stood proud as one of the most famous haikyo haunts in Japan. Lined with derelict souvenir shops, destroyed restaurants and trashed snack bars - its drab, weed-ridden main street led the entrant to an imitation *Sleeping Beauty Castle* - much paler in comparison to the Anaheim original.

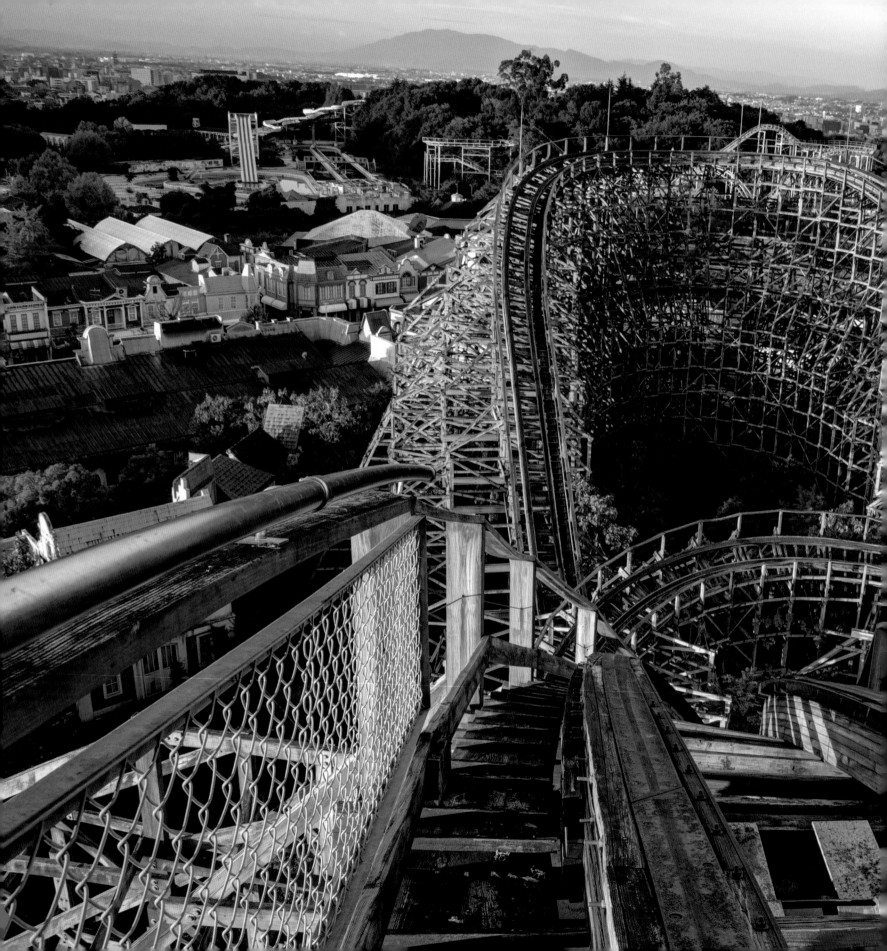

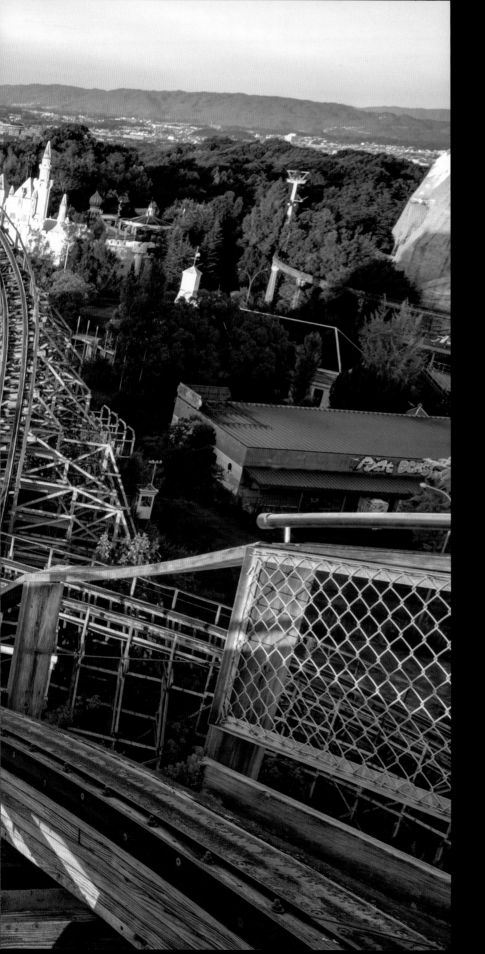

Haunting and eerily nostalgic, the parks gigantic vine covered central coaster provided a spectacular example of nature's ability to reclaim the man-made environment. Towards the back of the complex, time had transformed what was once an underwhelming *Jungle Cruise* into a muddy, mosquito filled swamp full of sunken boats.

Since closure, Nara Dreamland always had an anxious sense of impending demolition. In 2016, its final card was dealt when a purchaser commenced the huge dismantling process, slowly reducing it piece by piece to a heart breaking pile of rubble and dust.

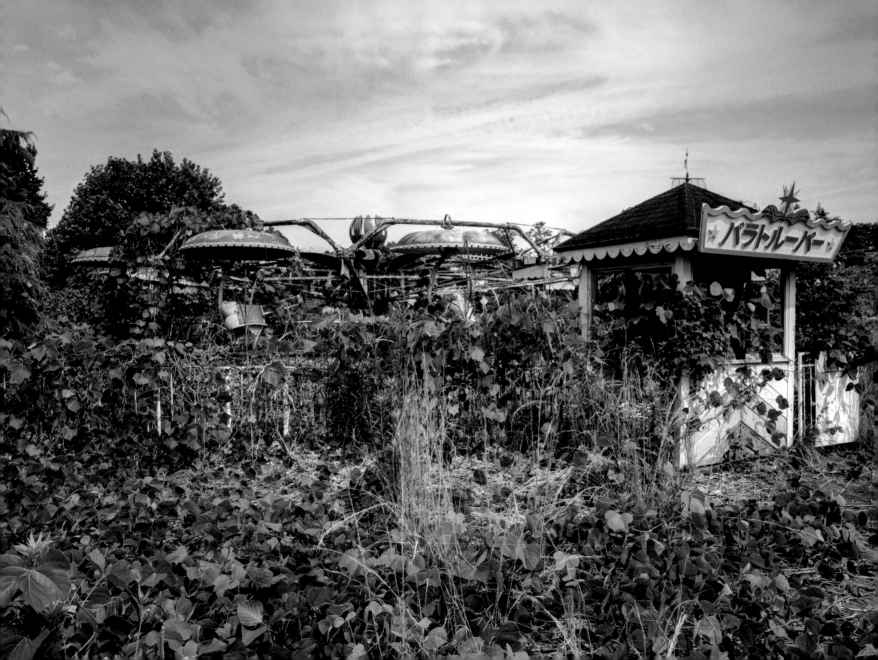

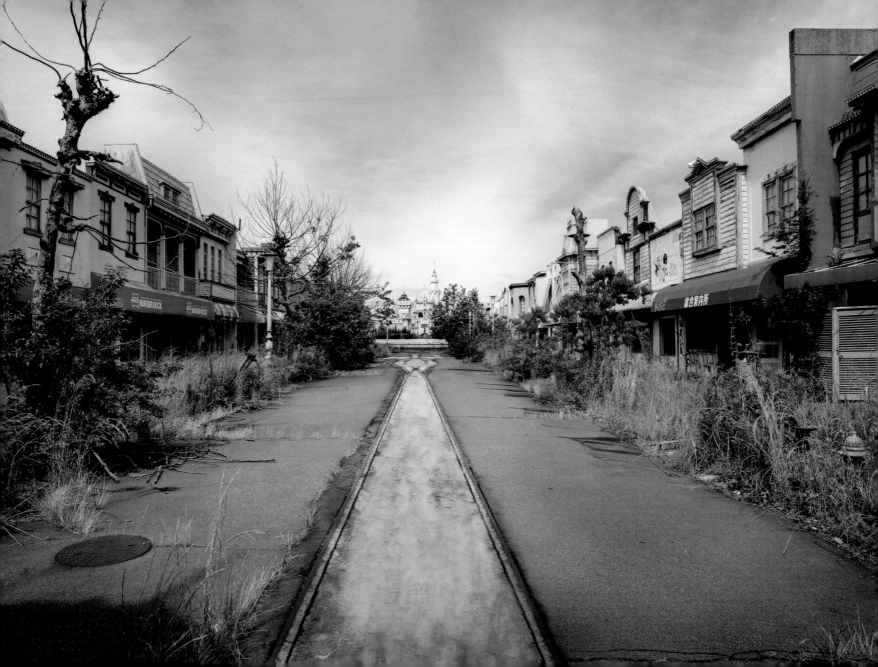

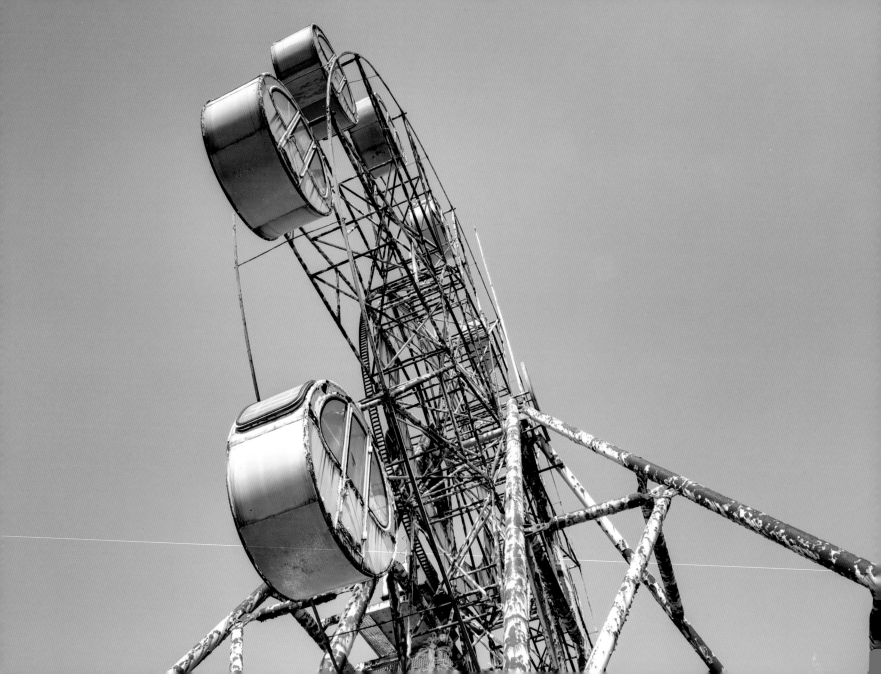

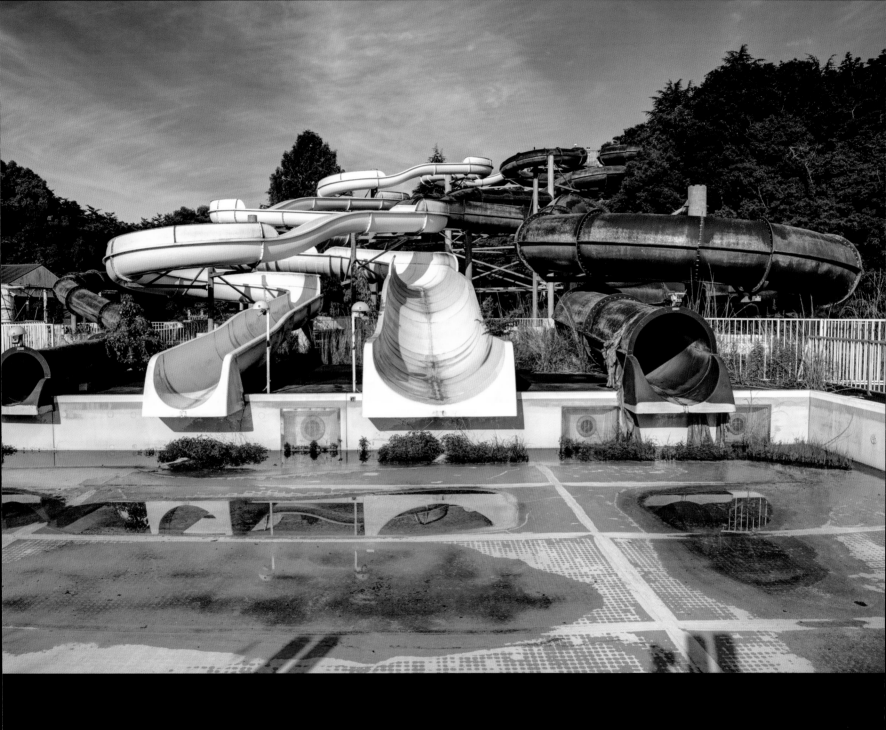

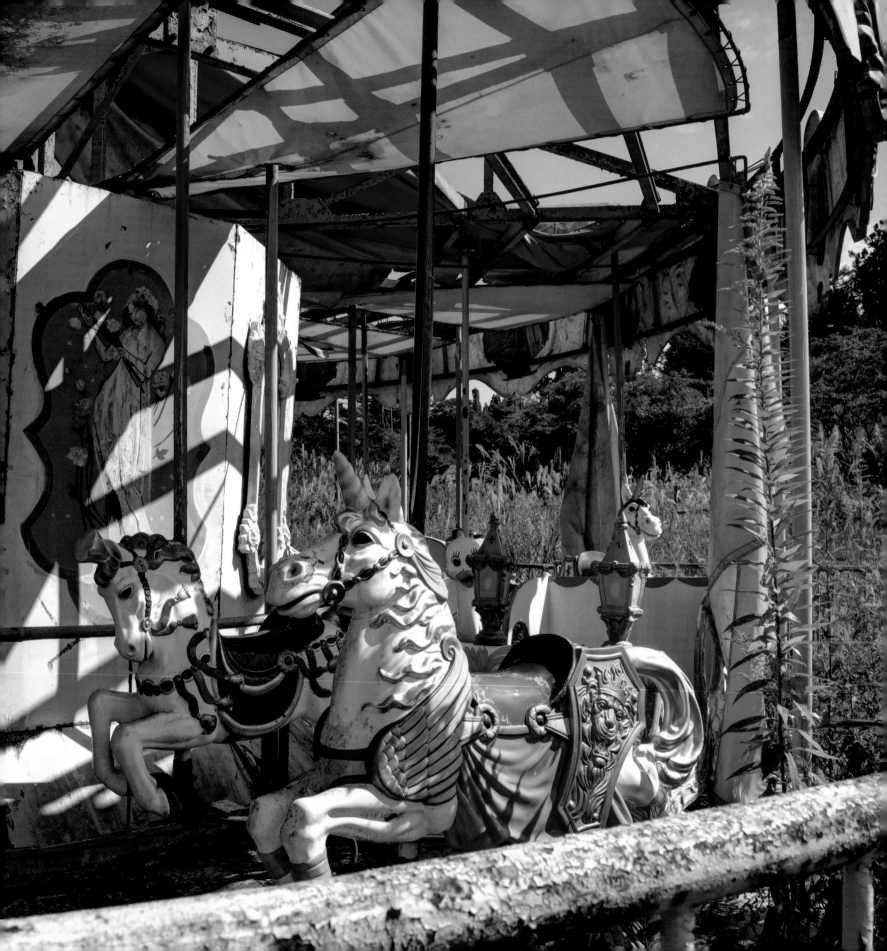

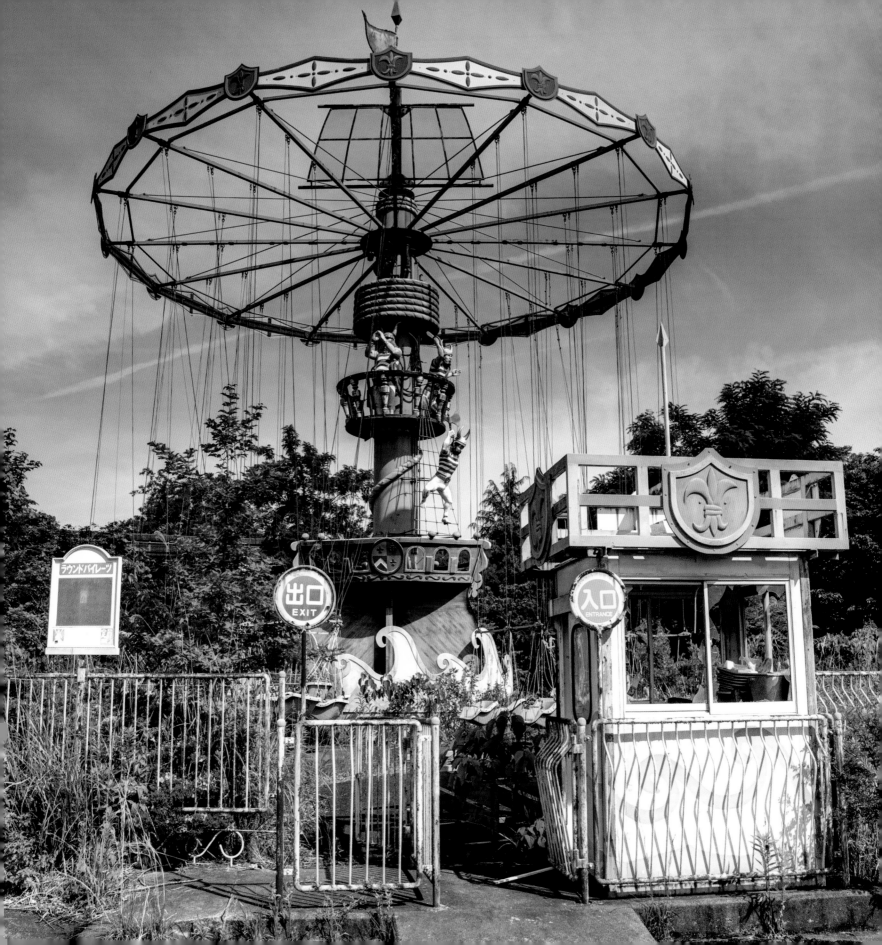

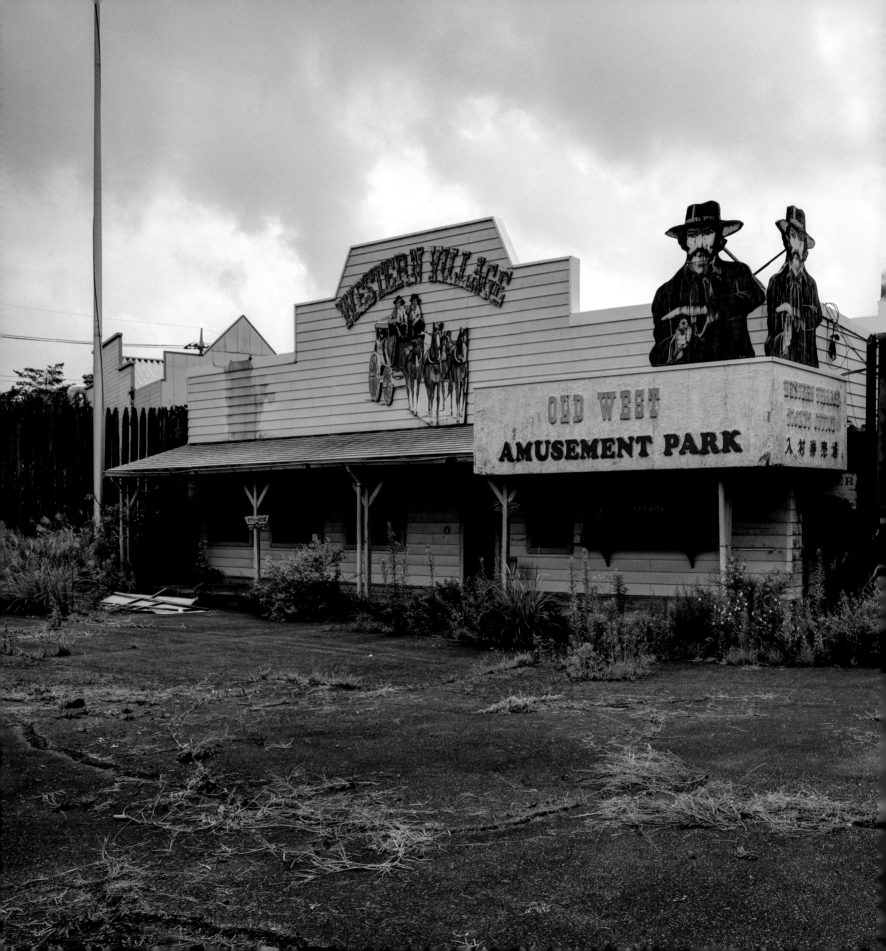

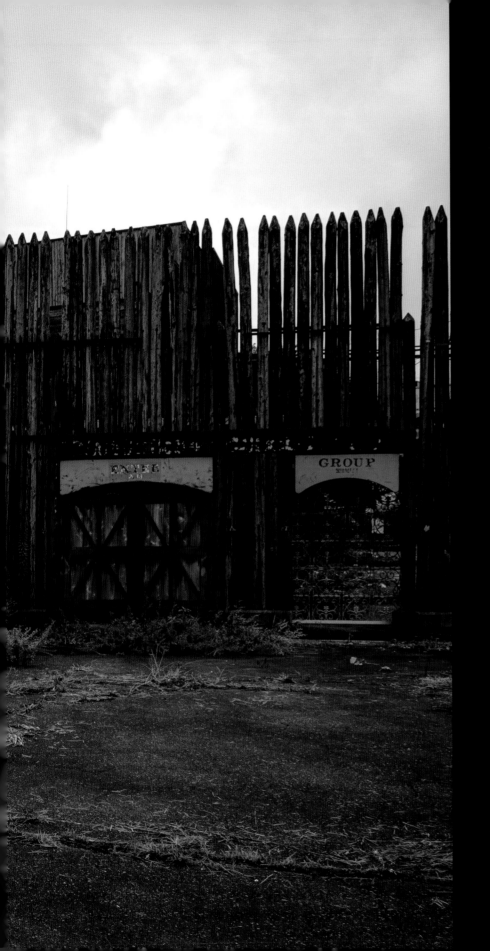

WESTERN VILLAGE
AMUSEMENT PARK

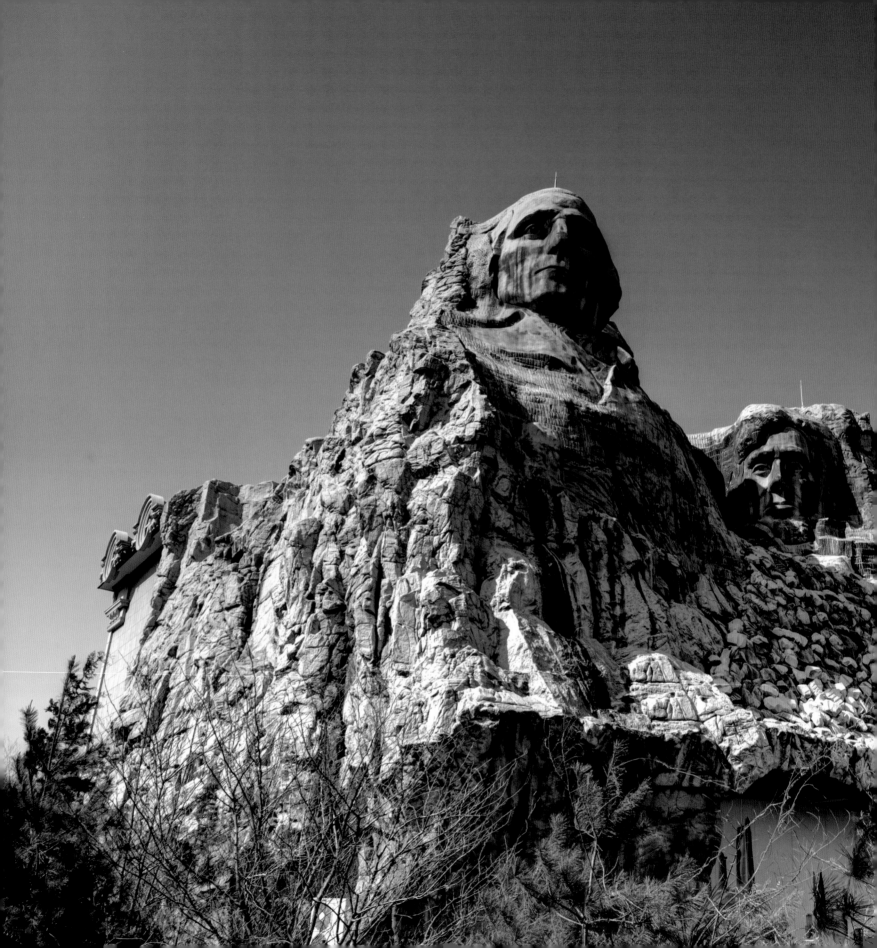

This American colonial style cowboy theme park sits on the edge of a quiet country town. Its many amusements and buildings were left to decay after its permanent closure in 2007.

Dust covered mannequins, furniture and games fill its eerie, dilapidated film set style buildings. Crockery, cutlery and glassware remain on restaurant tables and large, tattered American flags hang on the walls of empty eating halls. A shooting gallery stands frozen in time in an arcade once filled with the sounds of laughter while at the back of the park, the faces of four American presidents stare gloomily down from a huge, fake and weather-beaten Mount Rushmore.

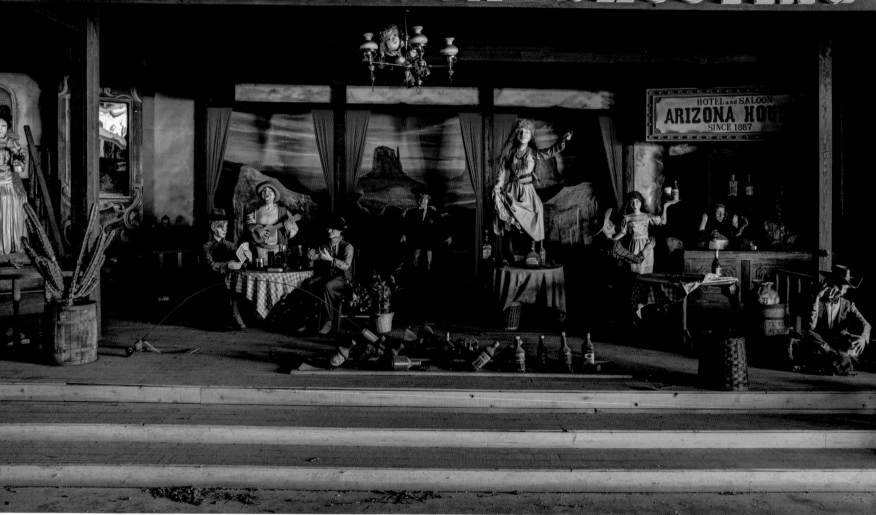

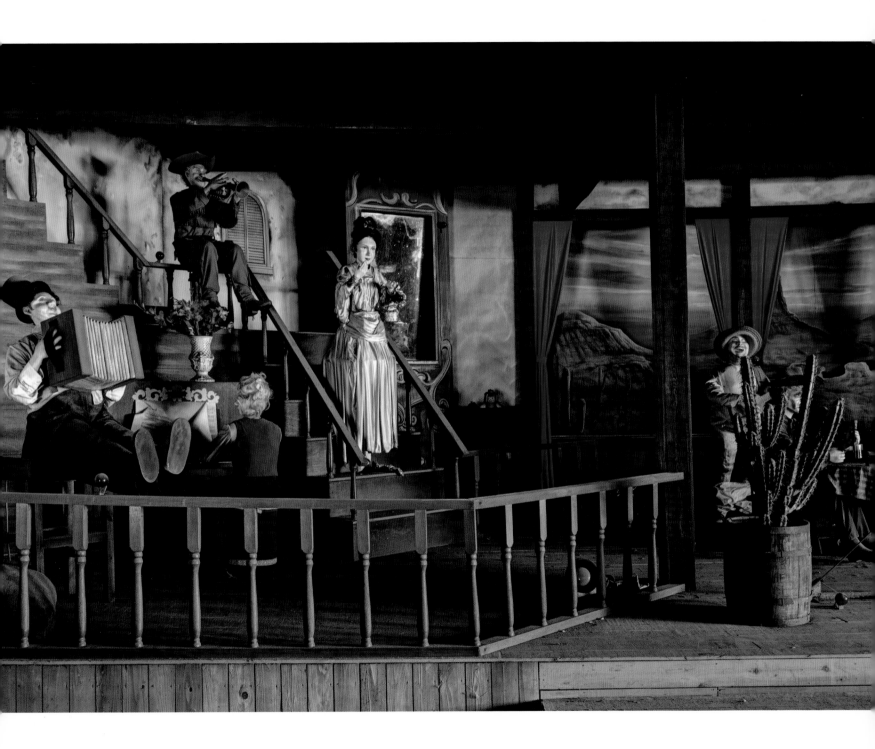

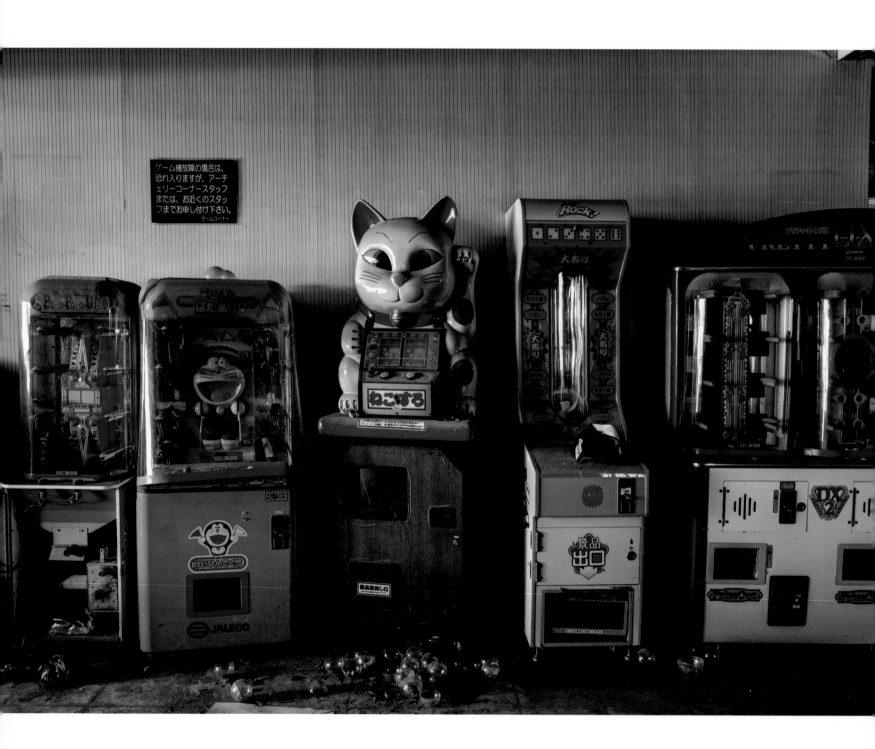

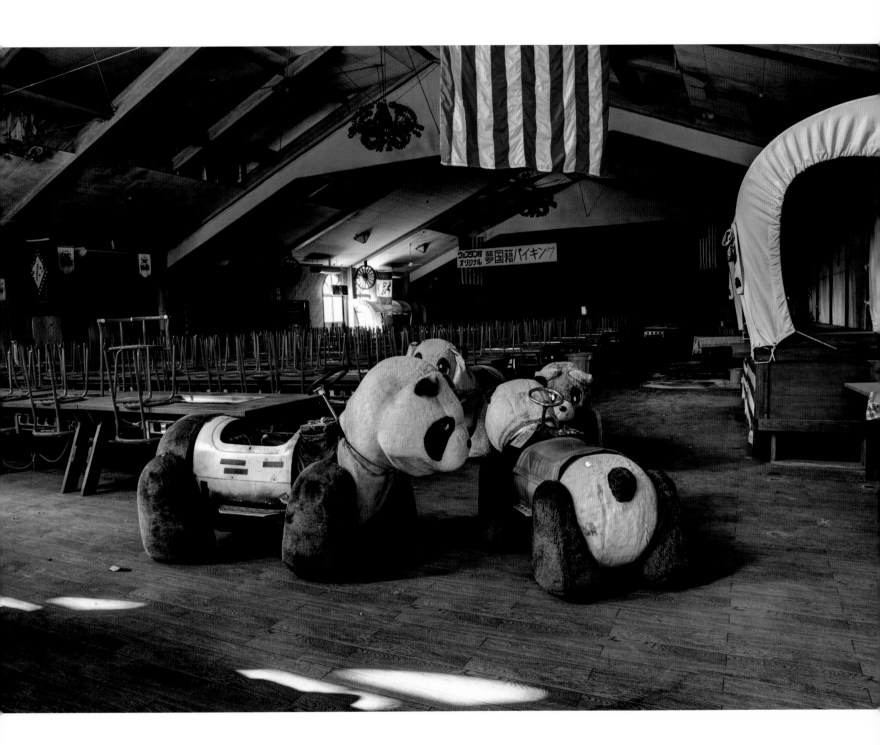

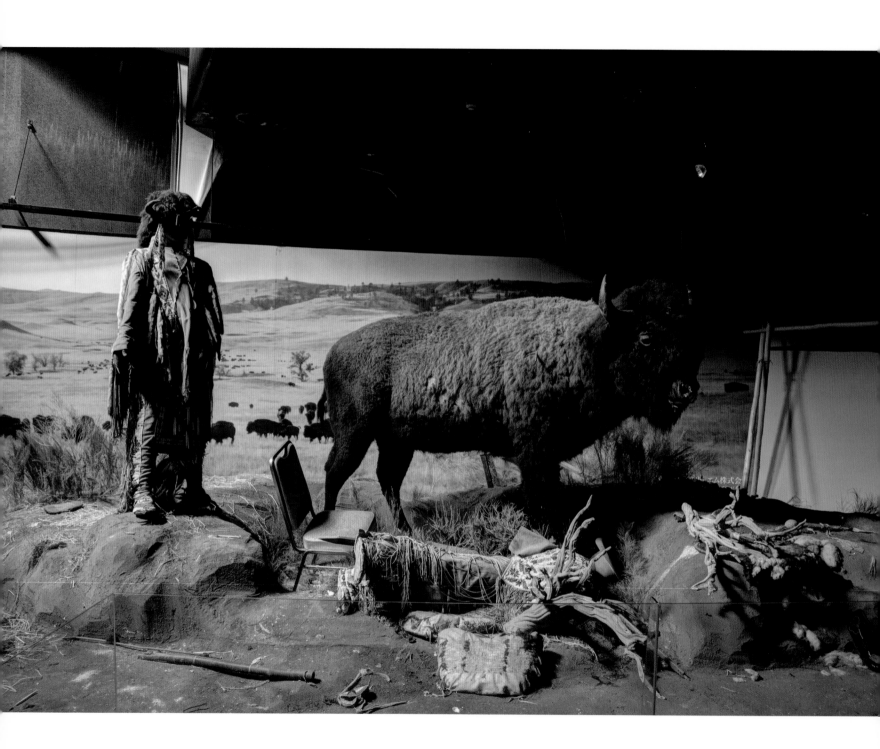

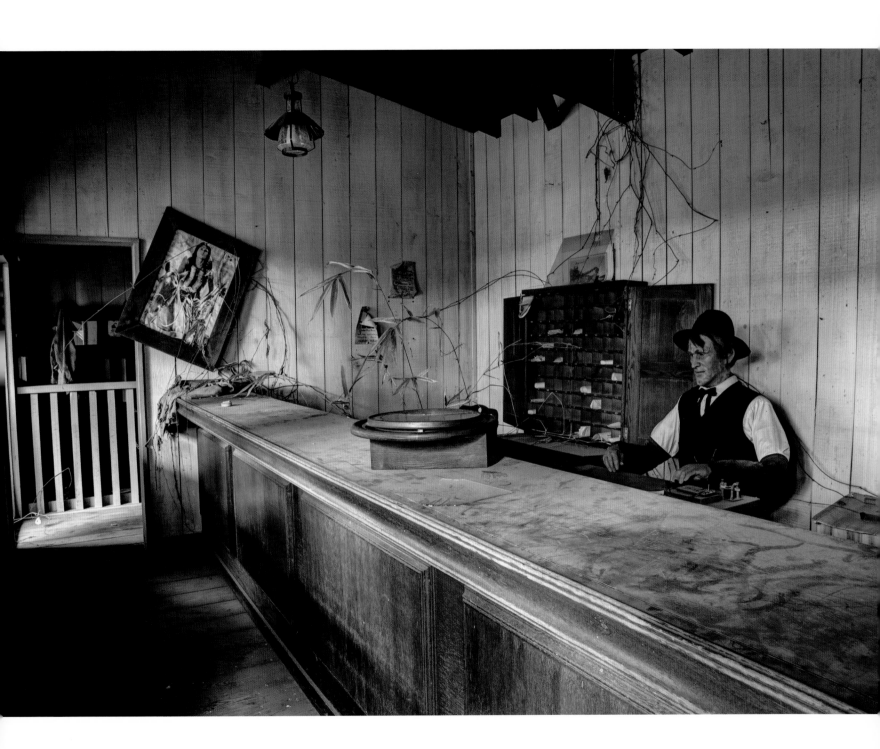

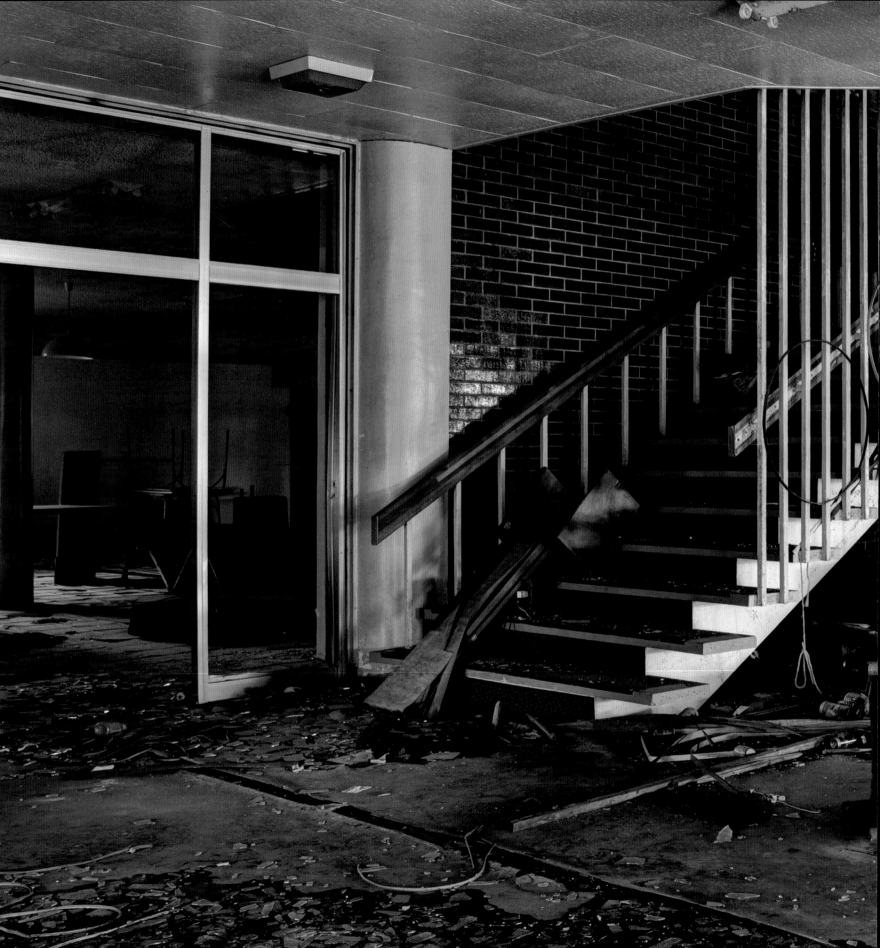

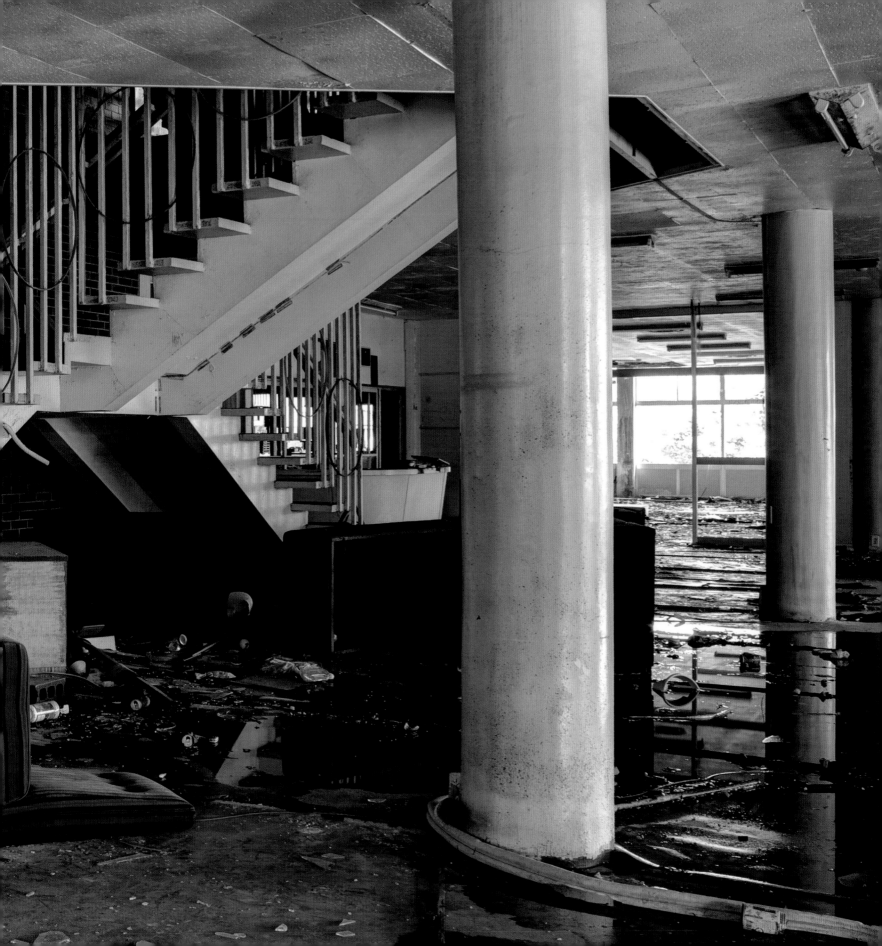

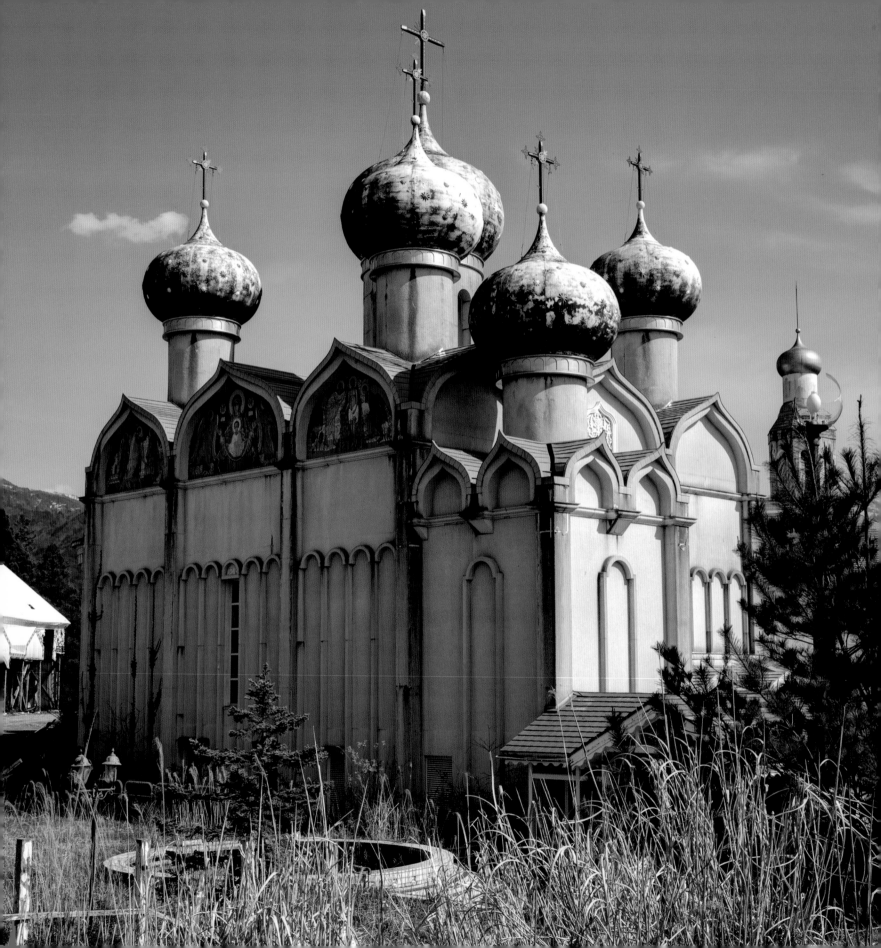

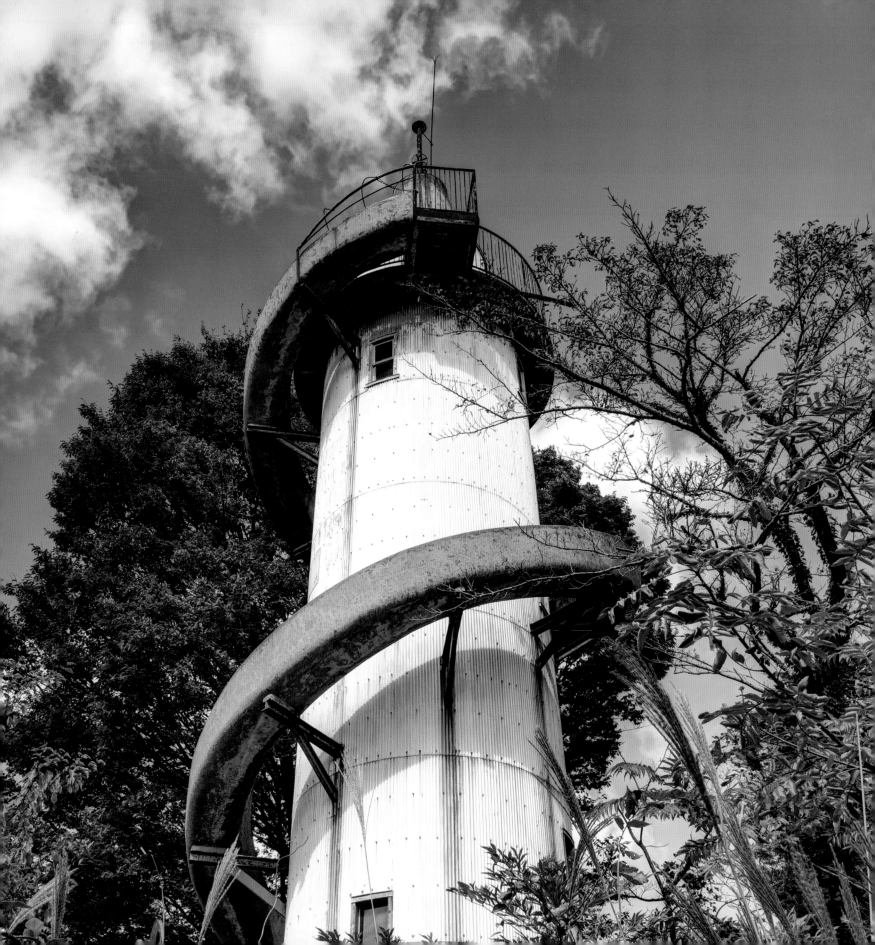

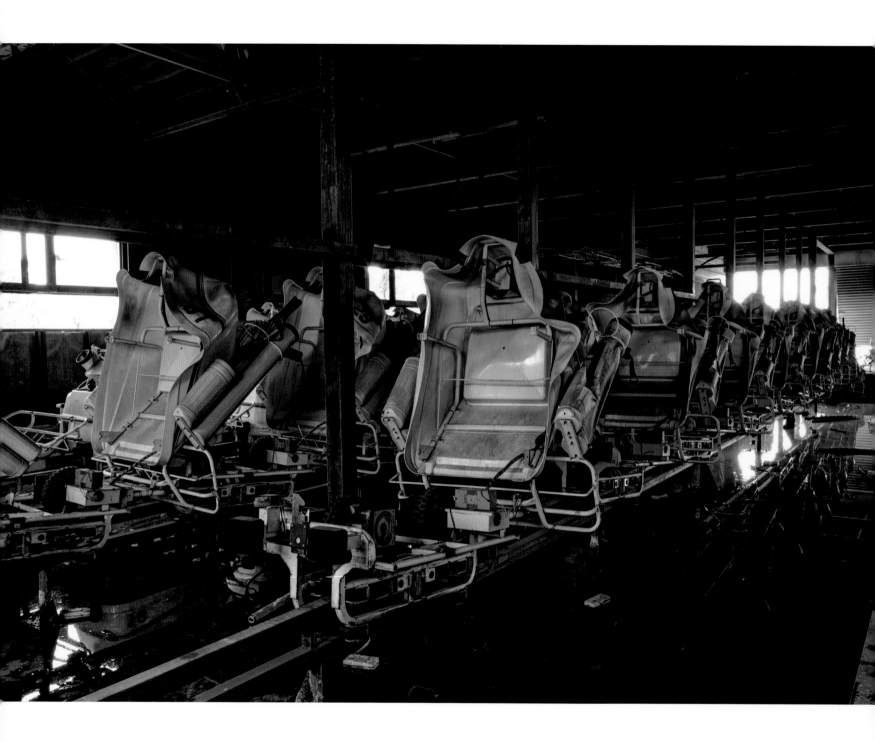

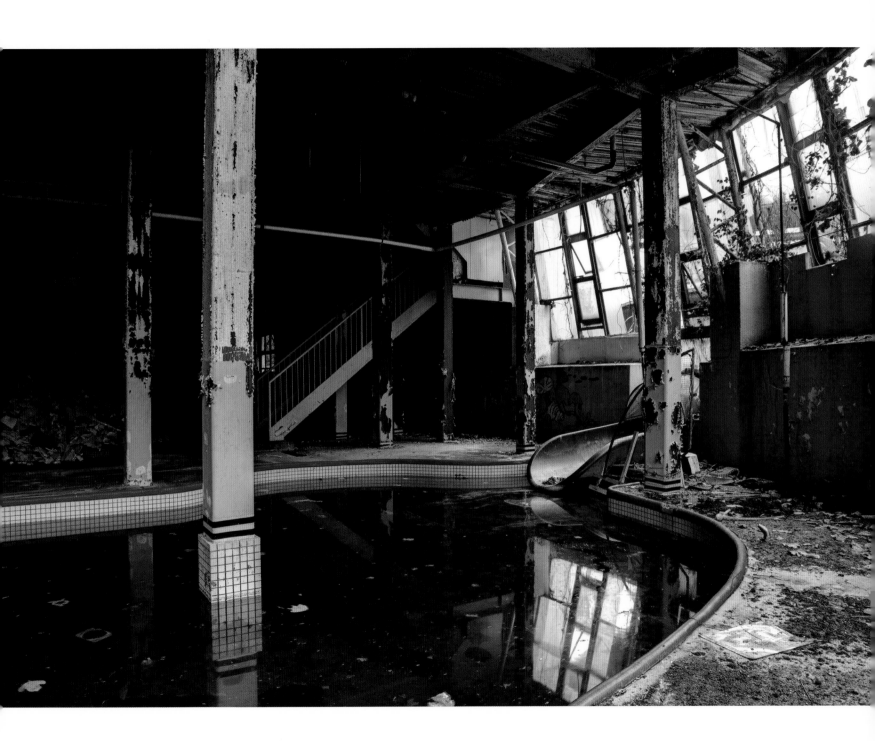

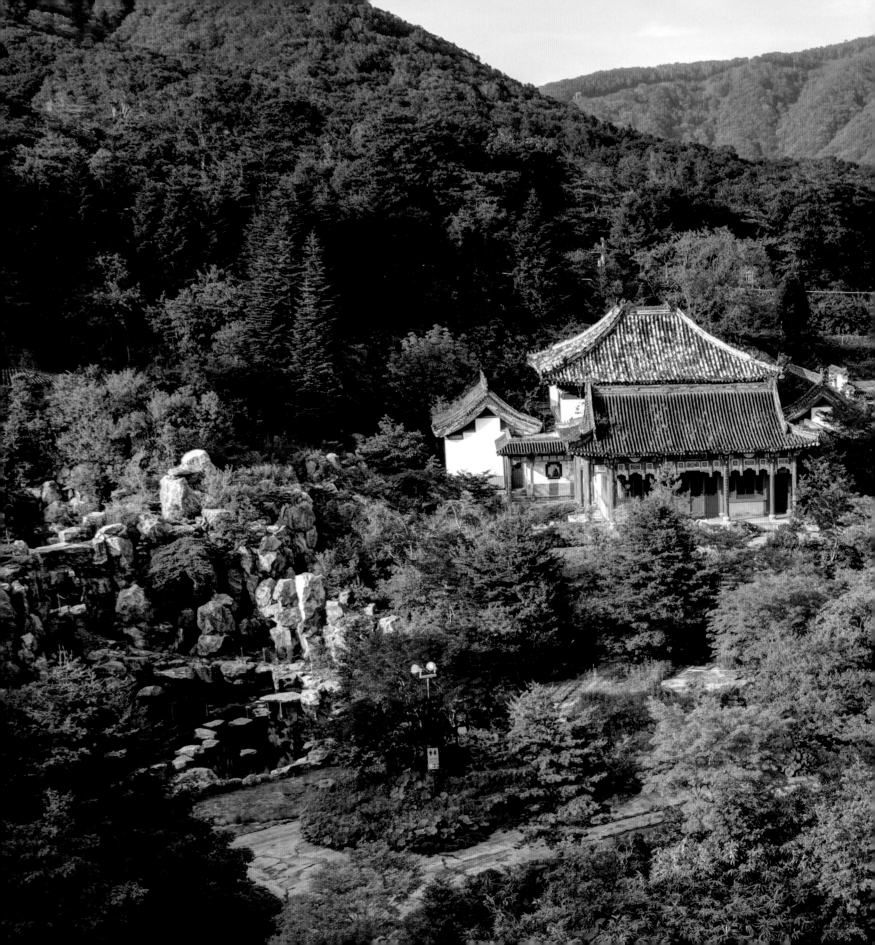

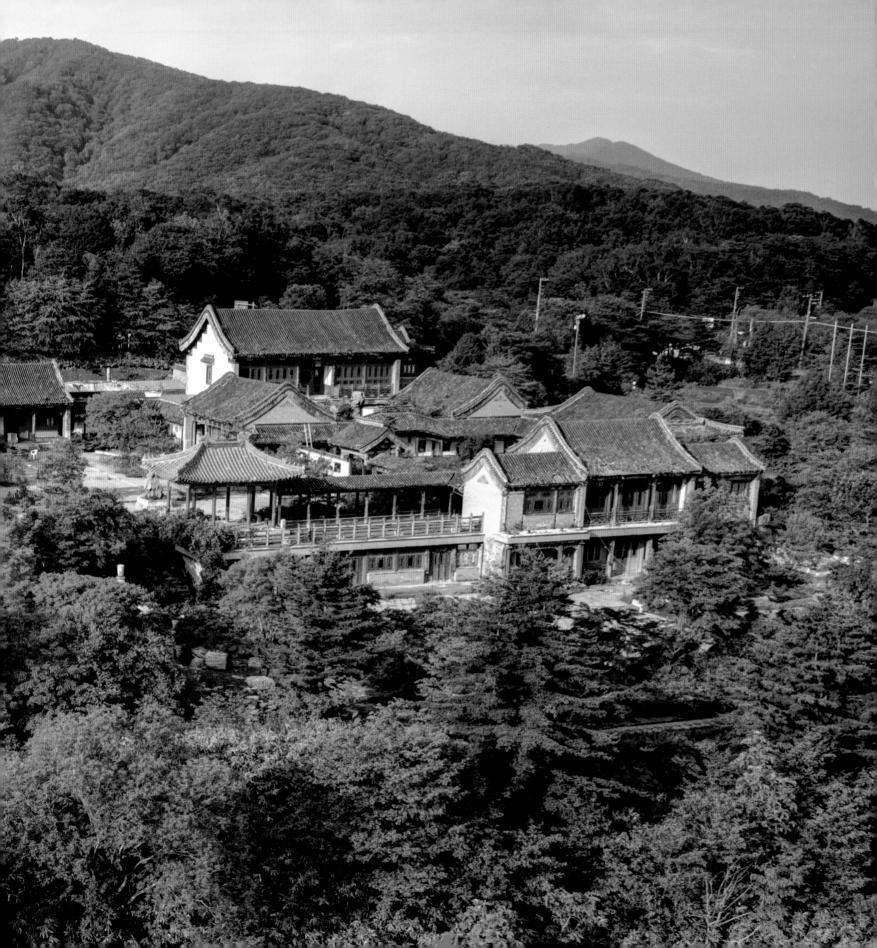

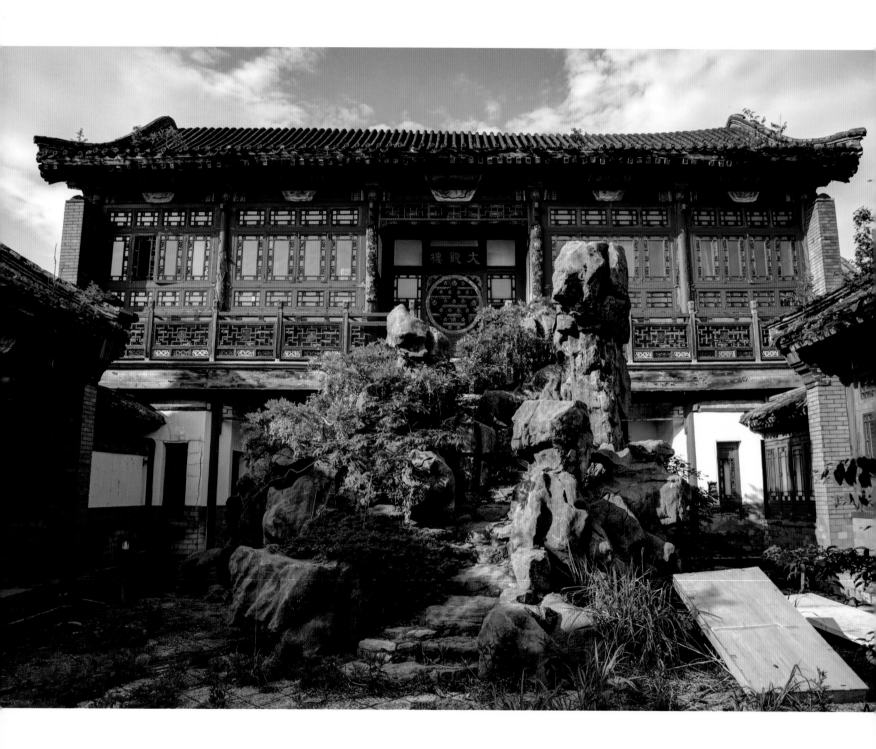

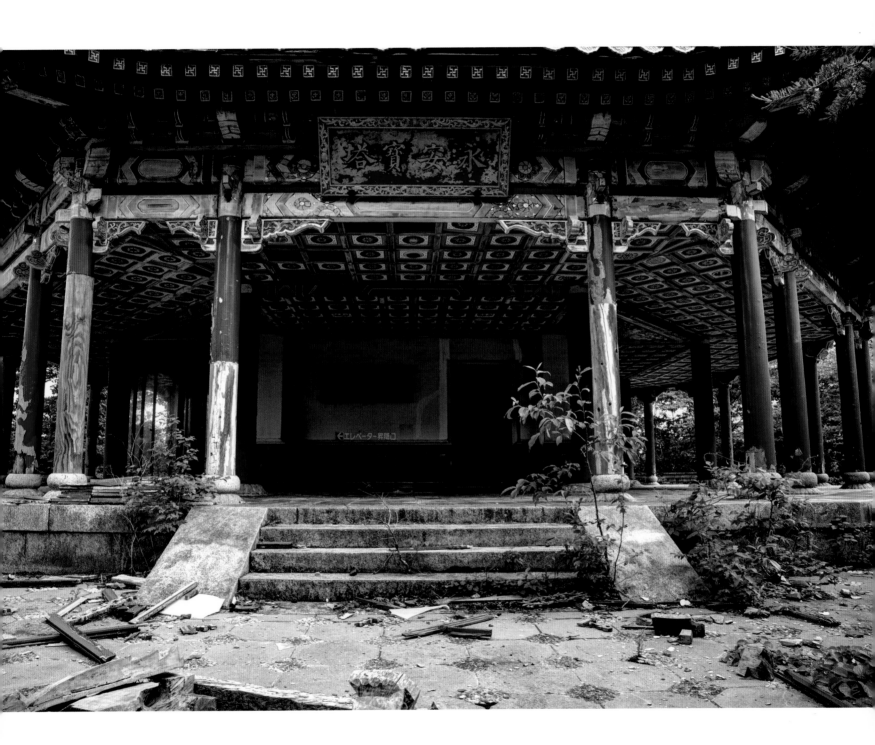

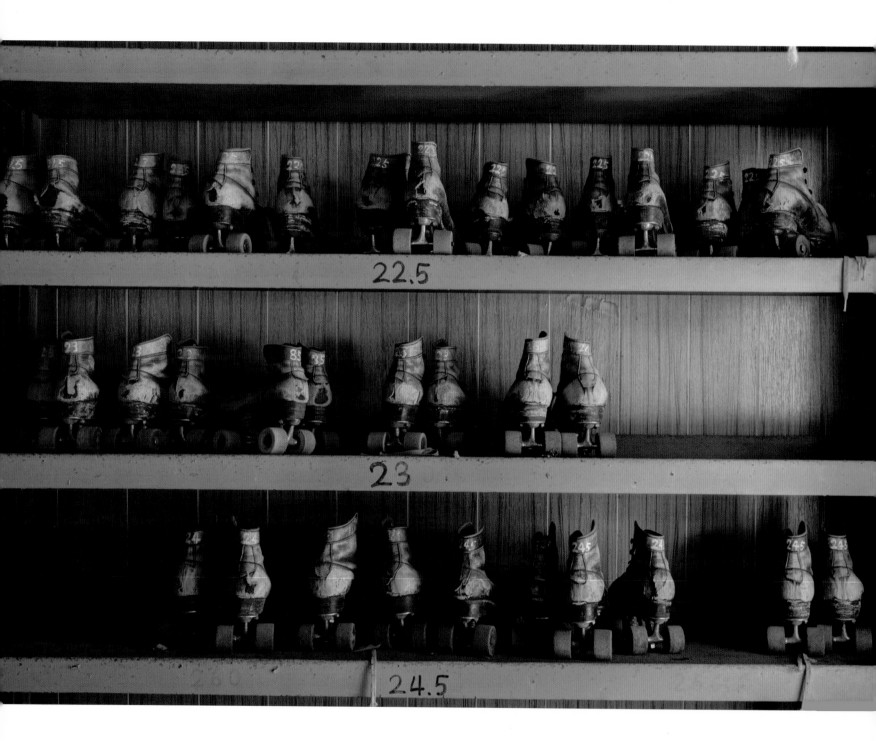

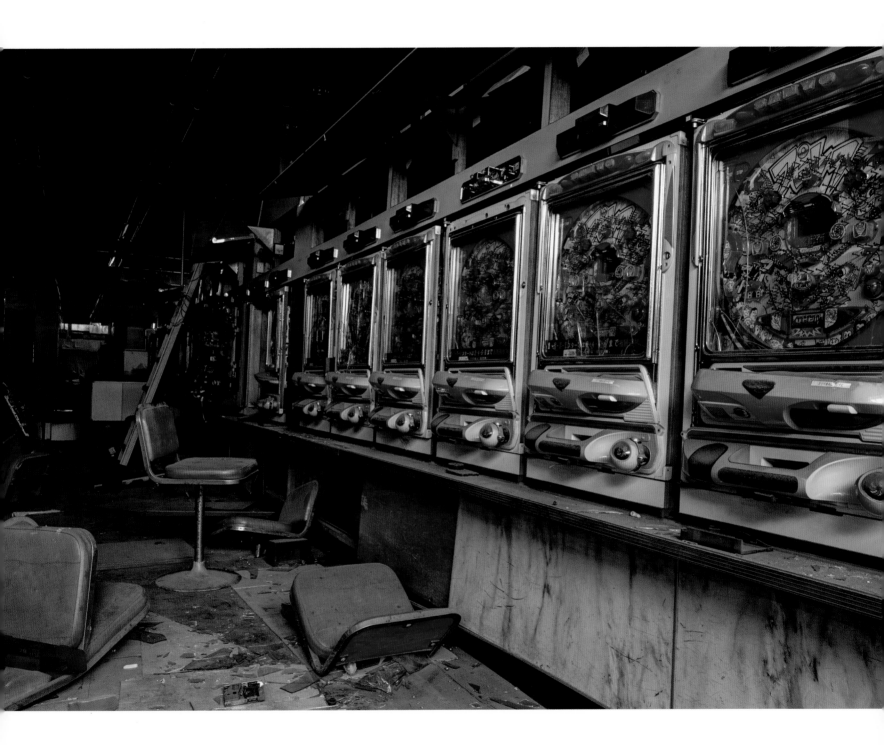

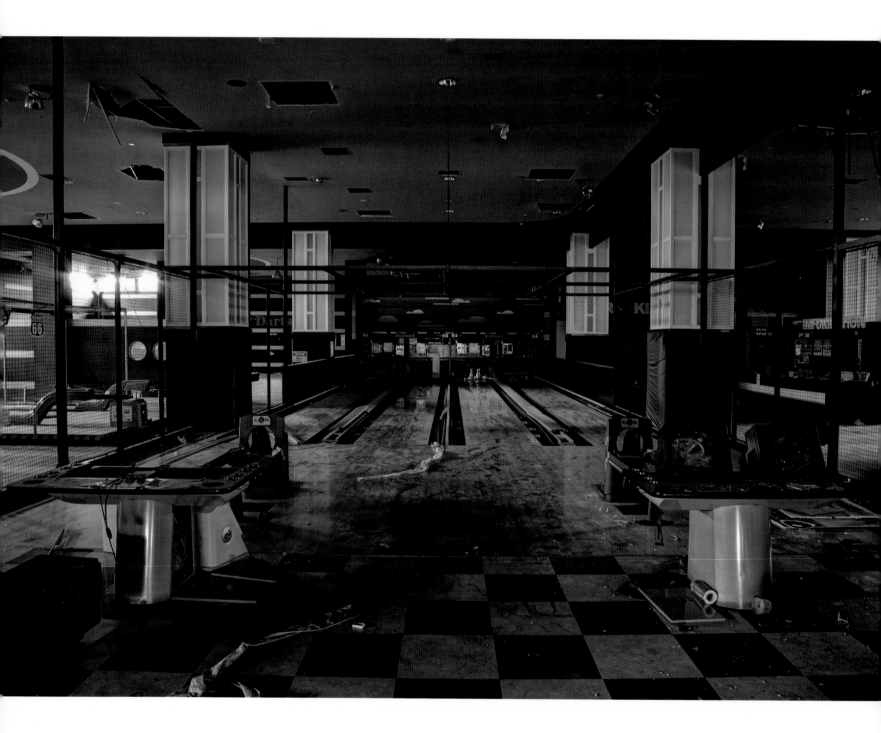

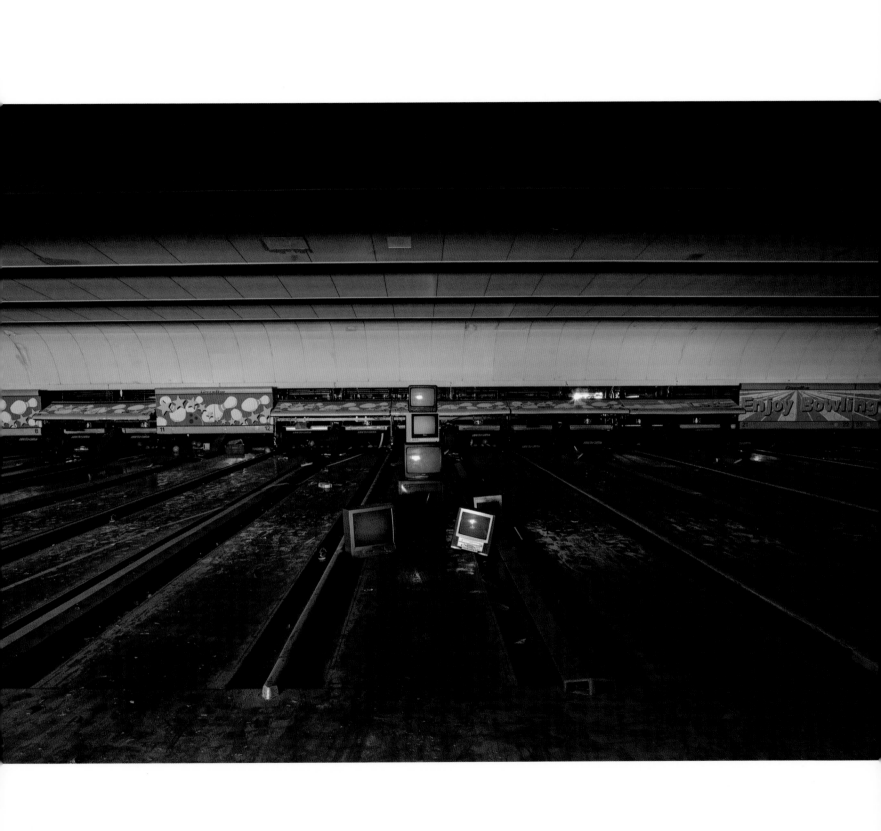

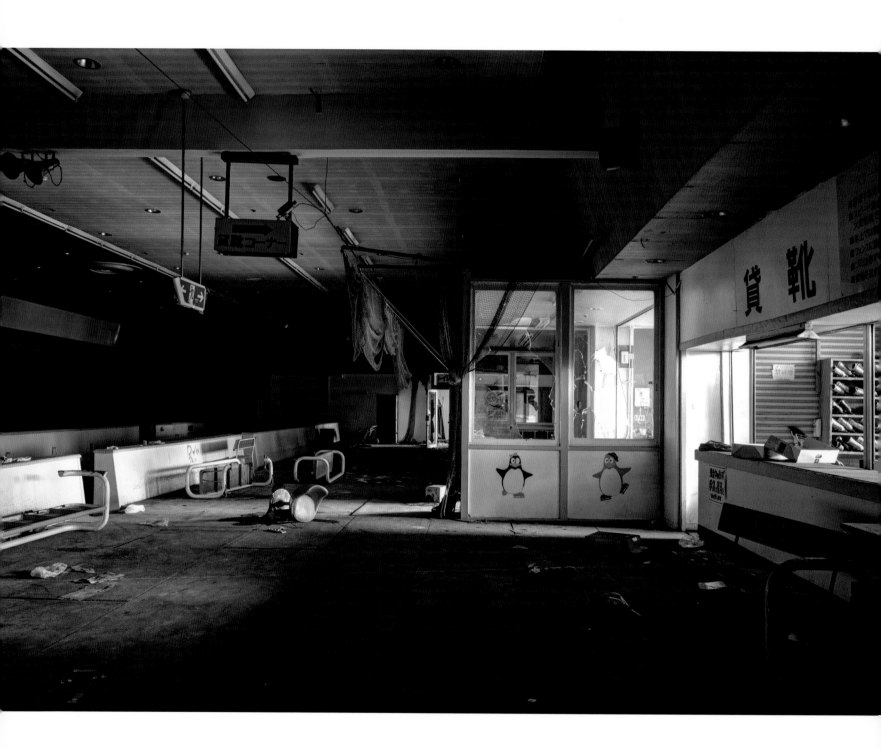

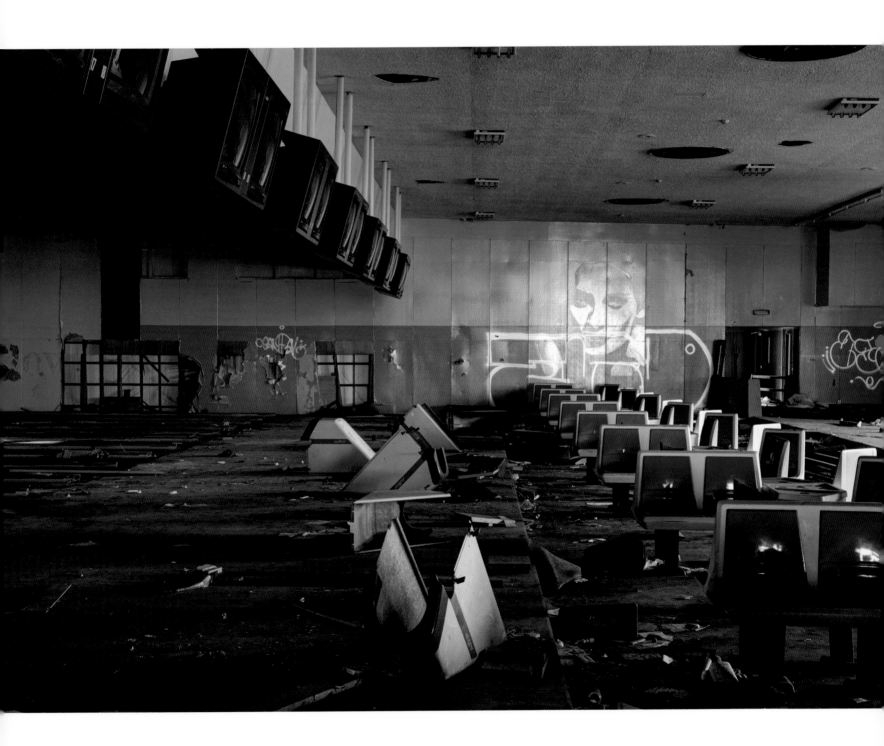

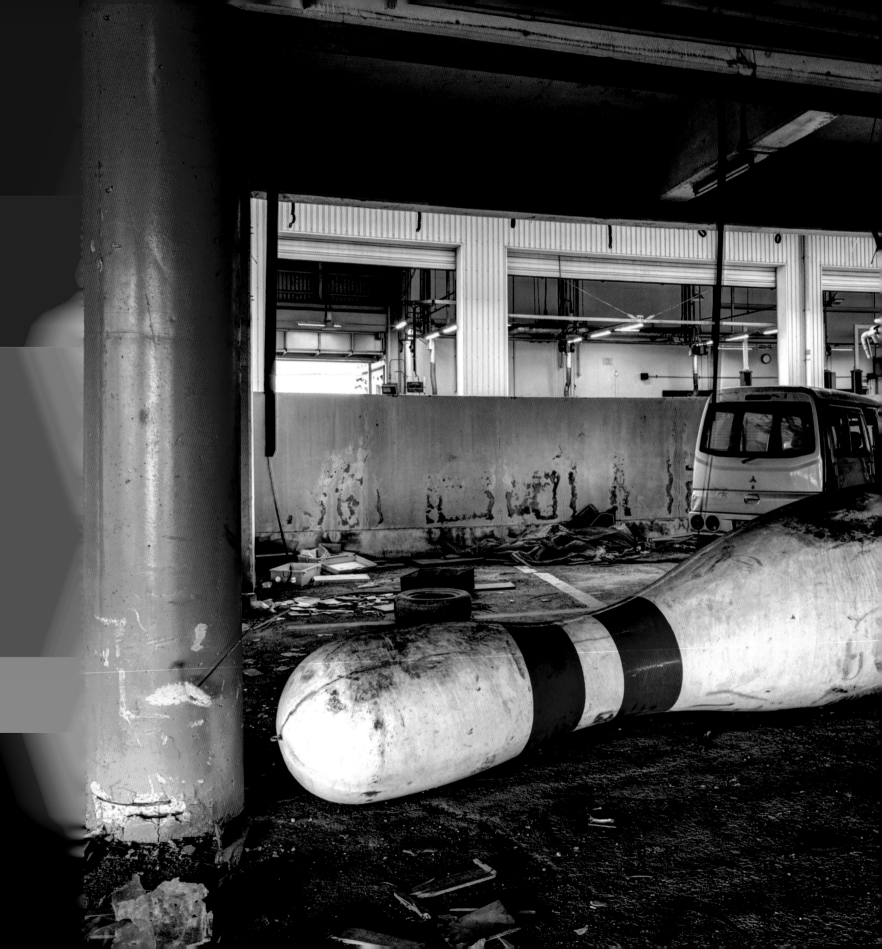

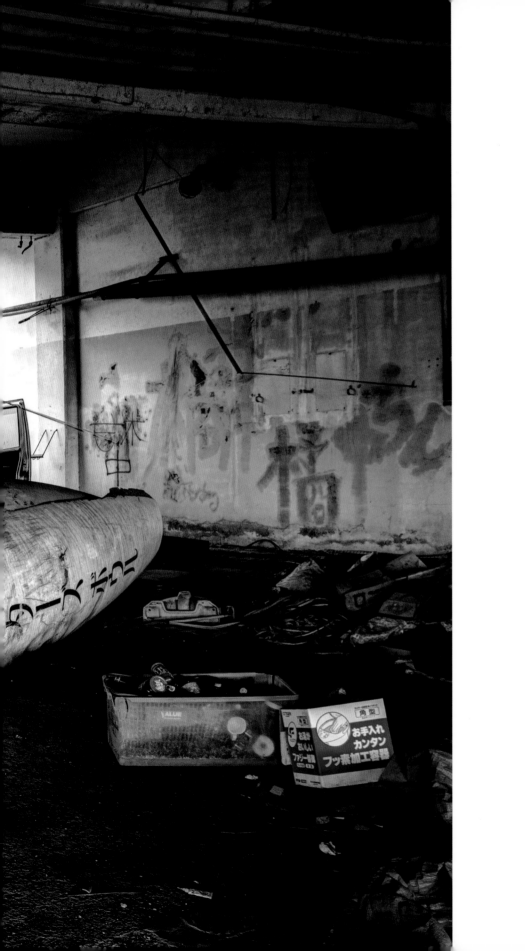

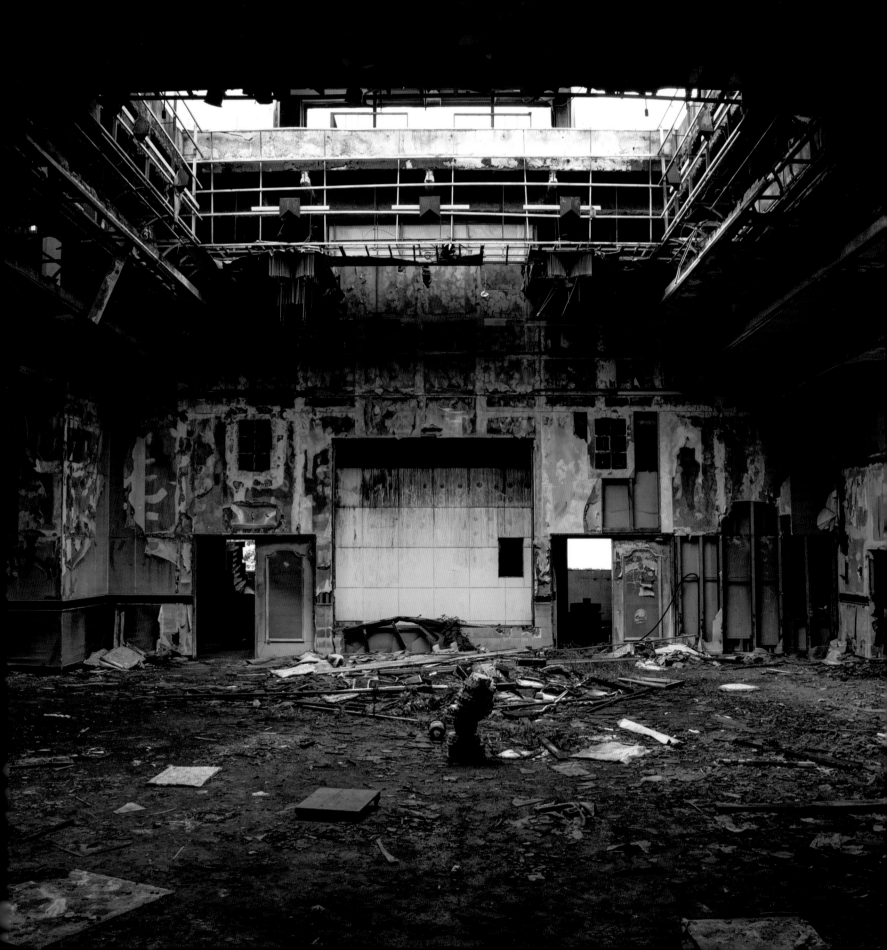

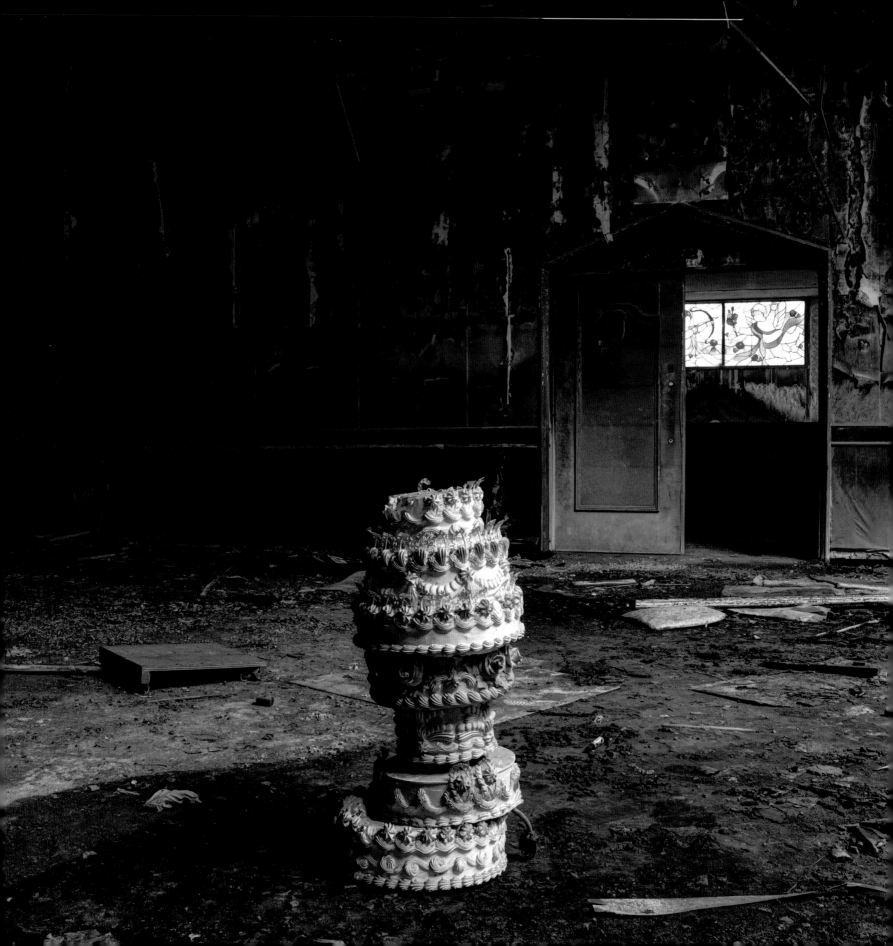

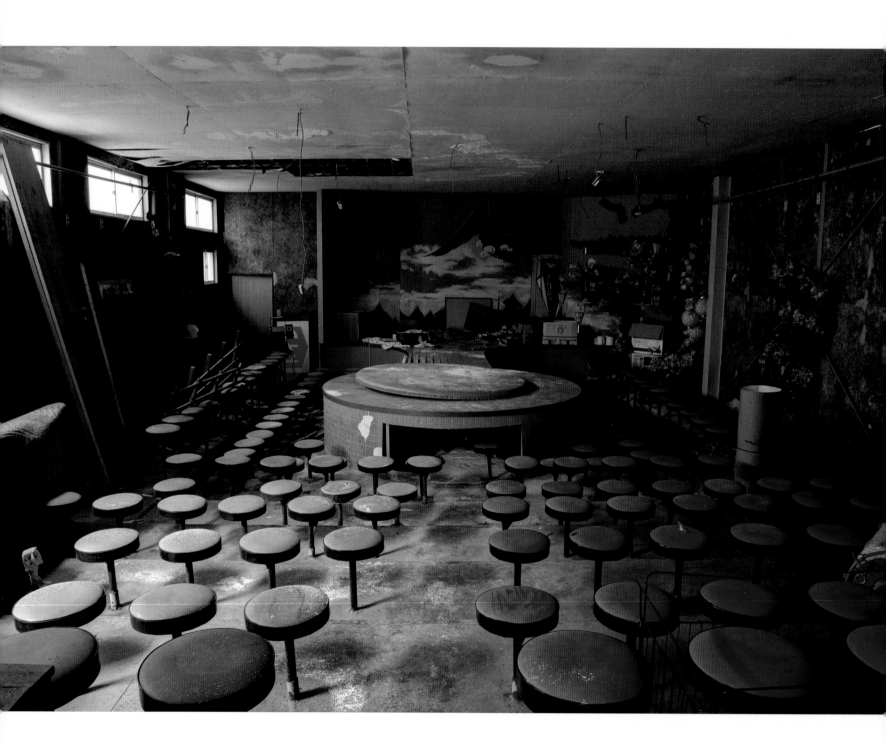

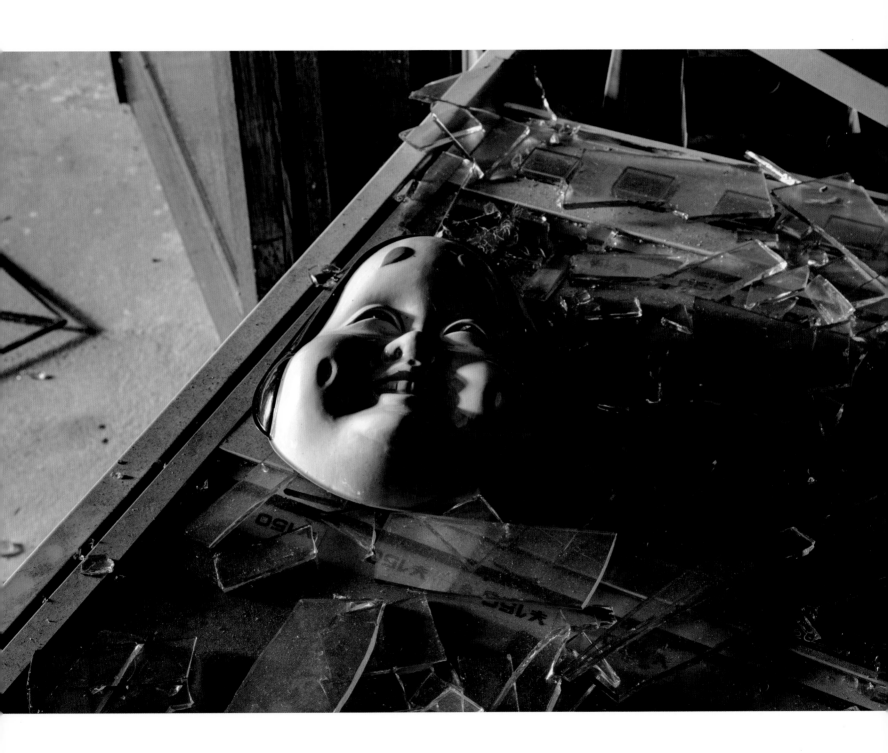

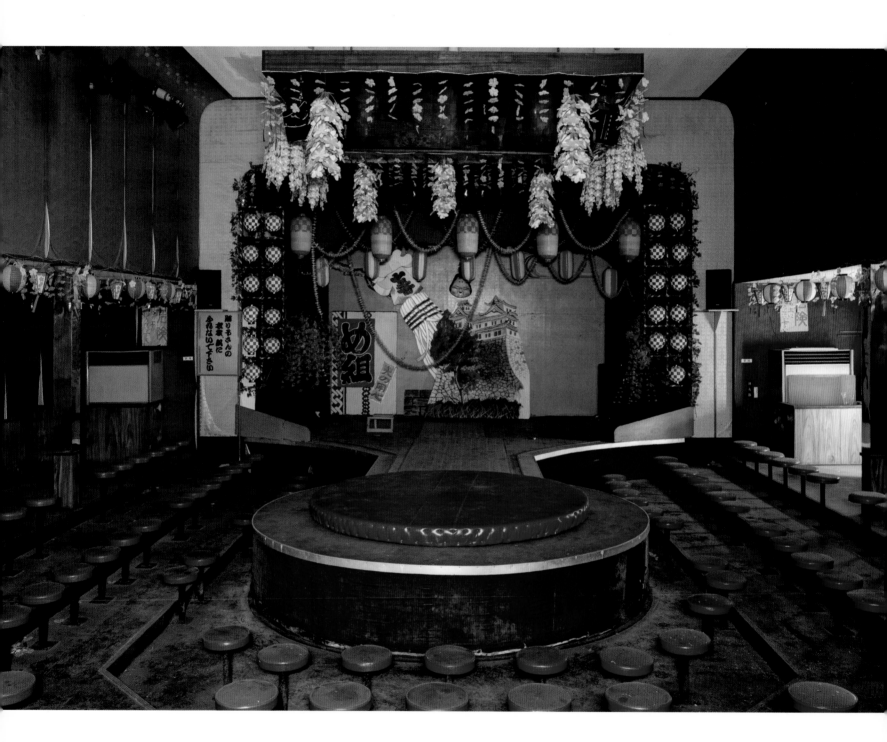

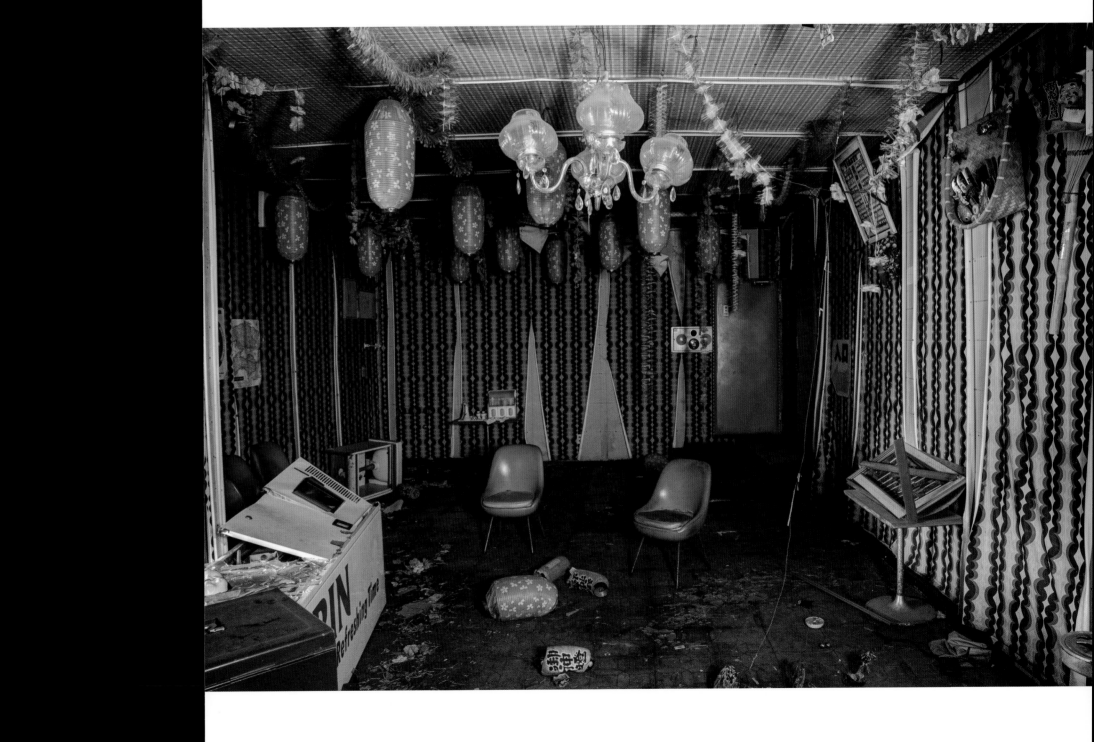

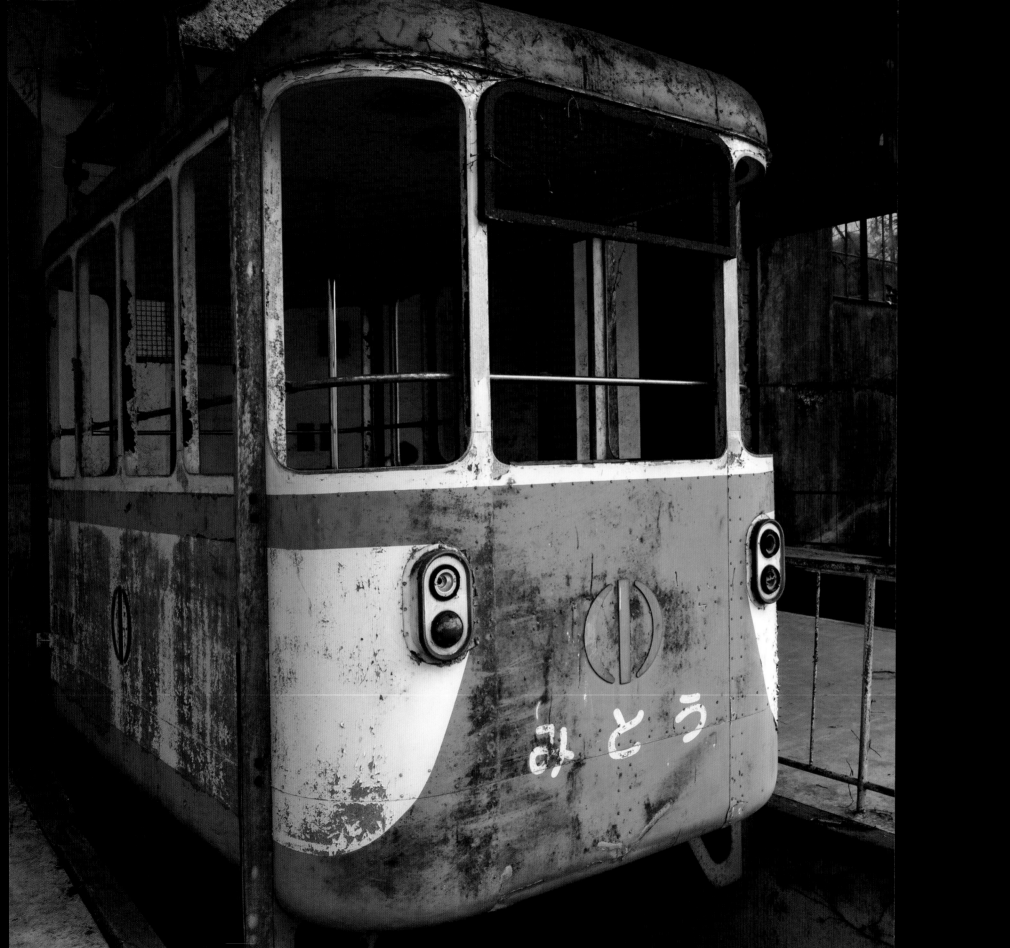

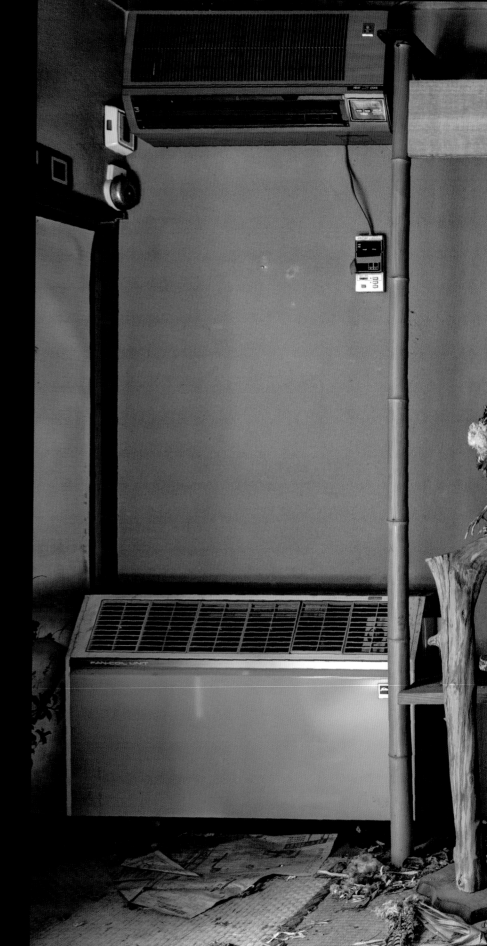

FUU LOVE MOTEL

Love Motels are dotted all over Japan. They operate as short stay establishments where couples can play in the privacy of an intimate space for a few hours, or maybe an entire night. Most tend to adopt a fun theme to attract prospective punters and a lot of effort is put into their interior and exterior style. These hotels are extremely popular all over Japan and receive an abundance of business.

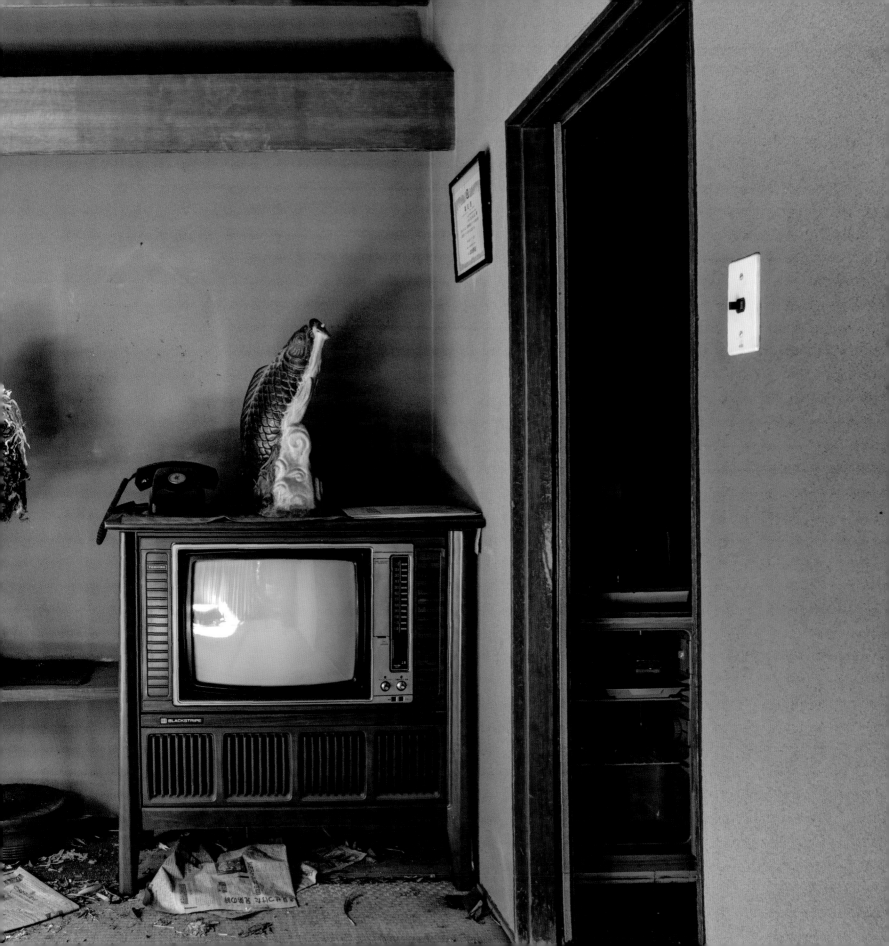

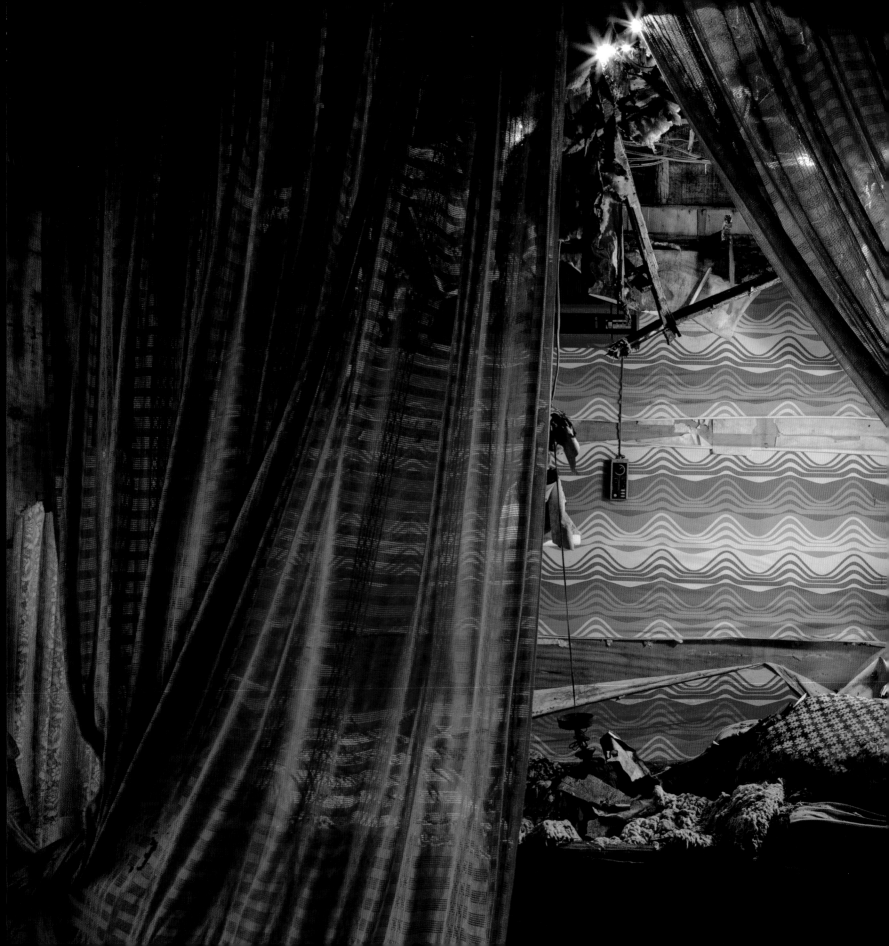

Once a popular place for lovers, this particular motel lies boarded and abandoned on the outskirts of a small country town. It's theme presents a variety of eclectic styles with each room having it's own specific interior, catering to the various sexual tastes of its former clientele. Inside, imitation concrete Grecian mosaics hang on dilapidated walls and broken lights dangle from its weather beaten ceilings. Bamboo invades through broken windows and, within other rooms, deep water covers the floors. Plastic plants hang from the walls surrounding a mini outdoor traditional Japanese garden and, stretching off this space is a tiny nautical pirate themed love making room, fully equipped with a boat-shaped bed. Another room offers heavily decayed Middle Eastern decor including a waterlogged bed

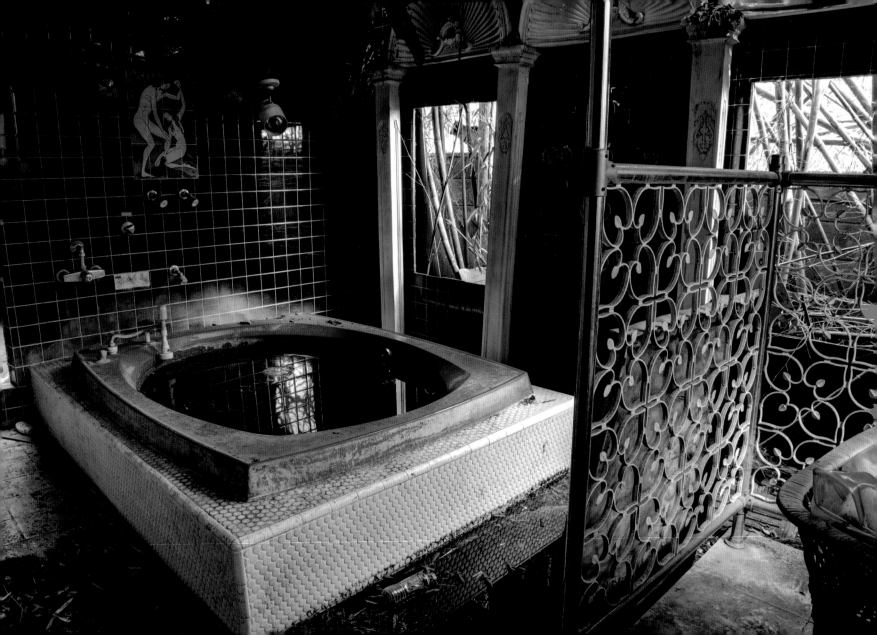

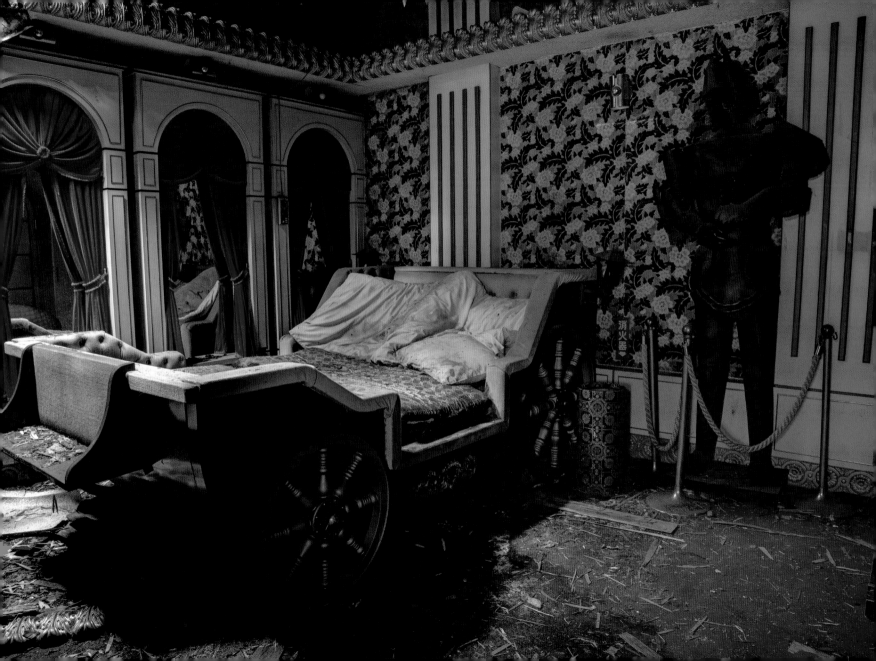

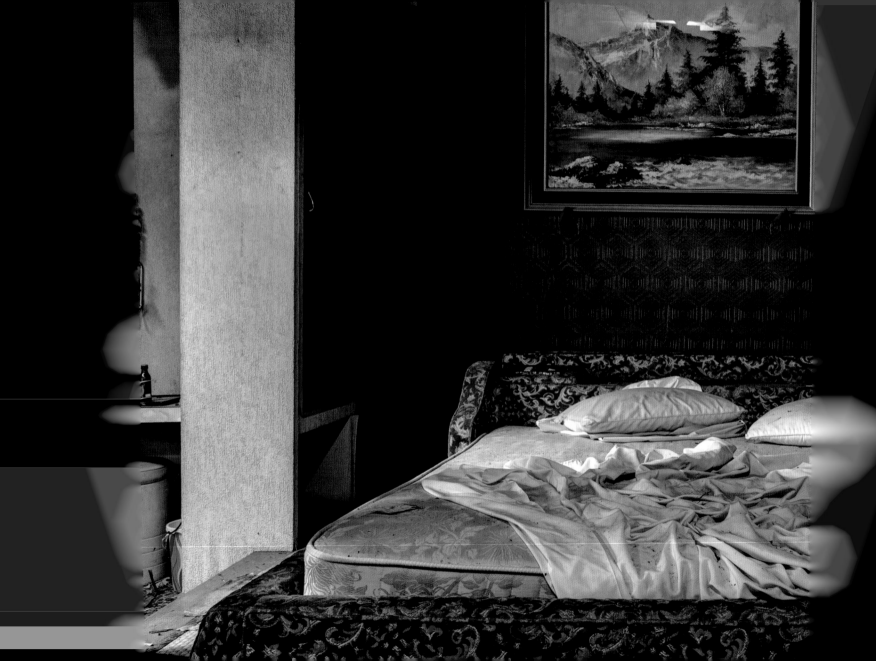

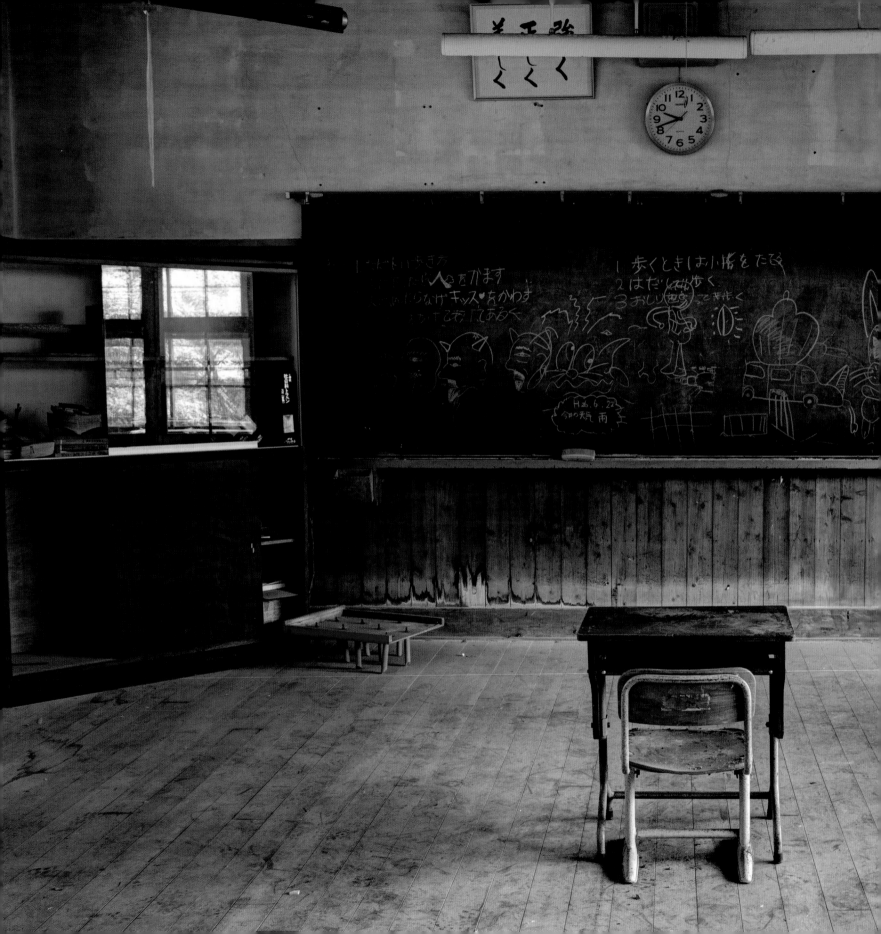

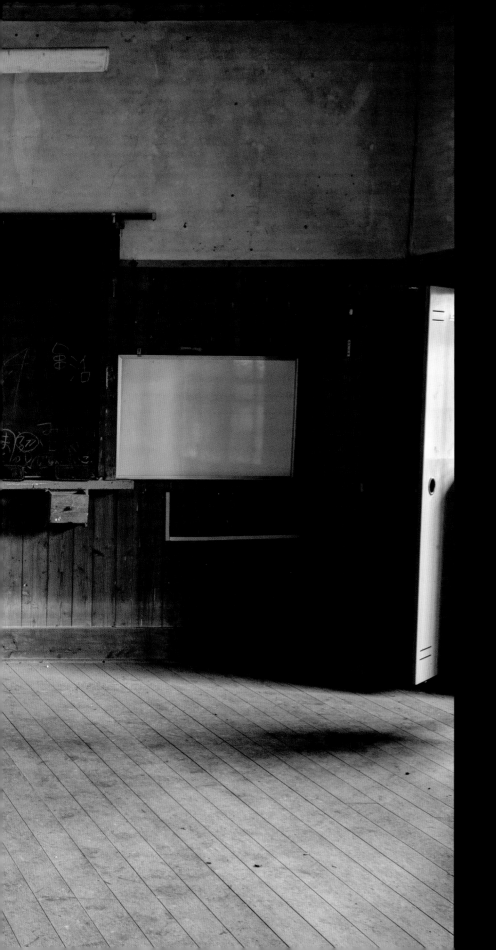

SCHOOLS

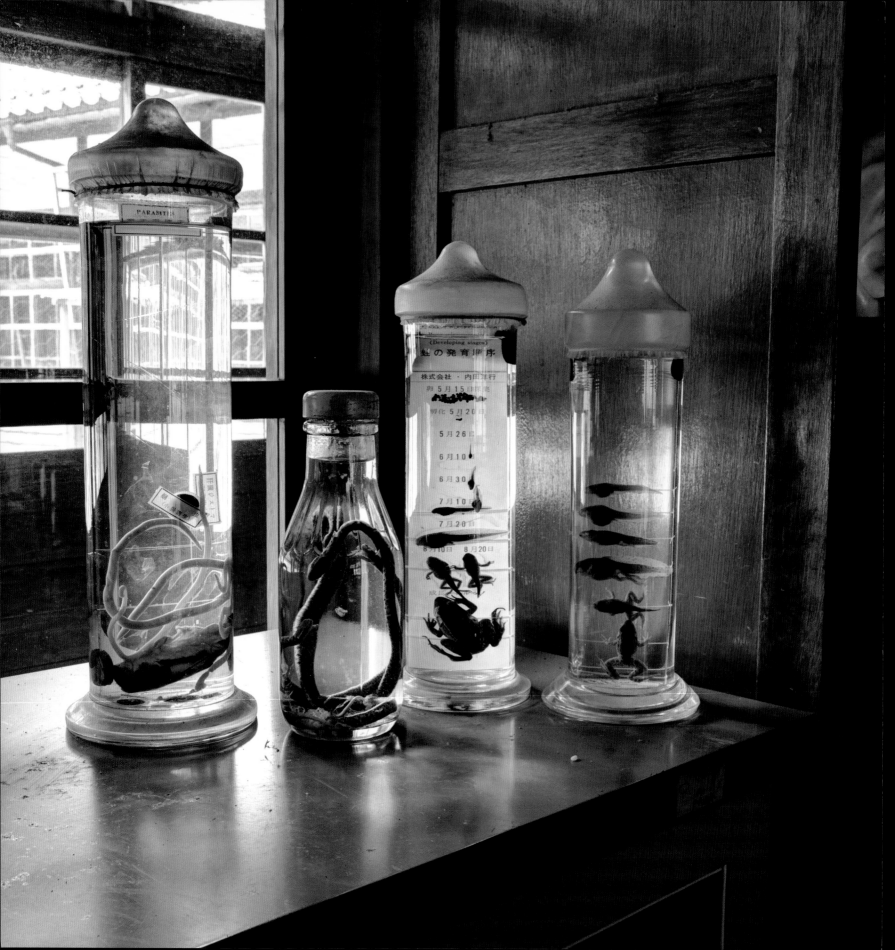

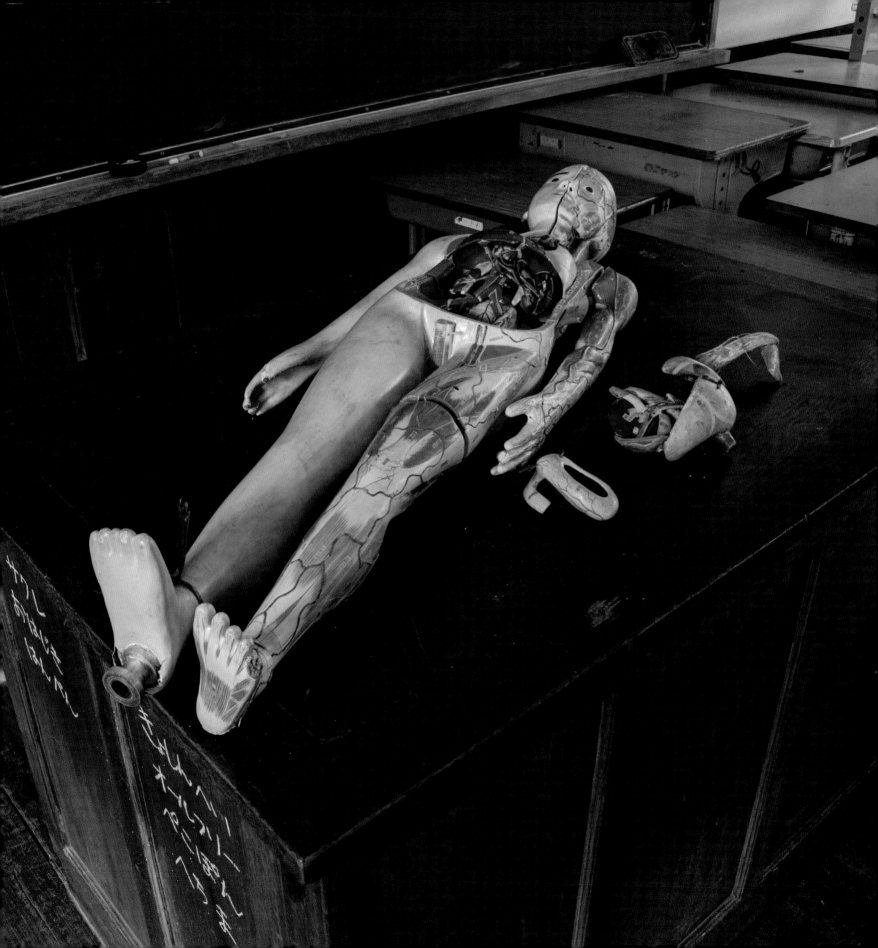

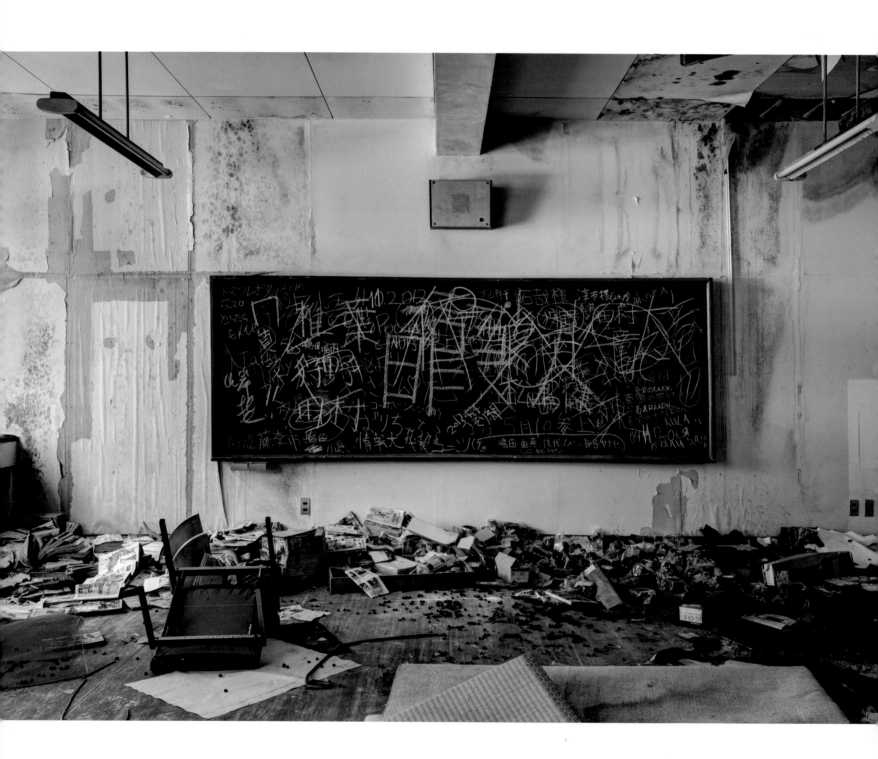

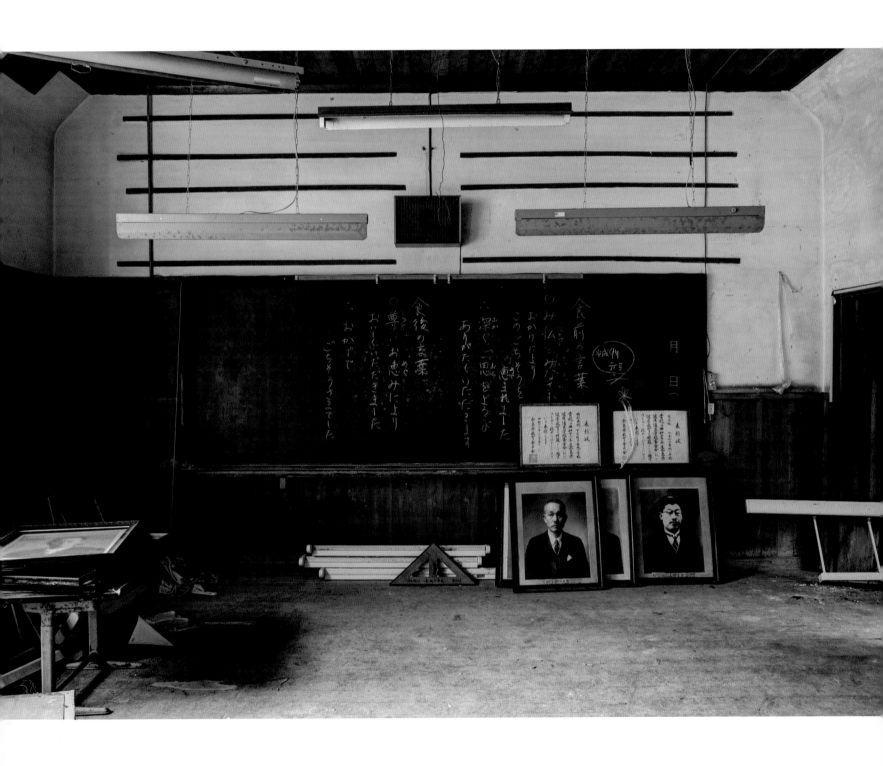

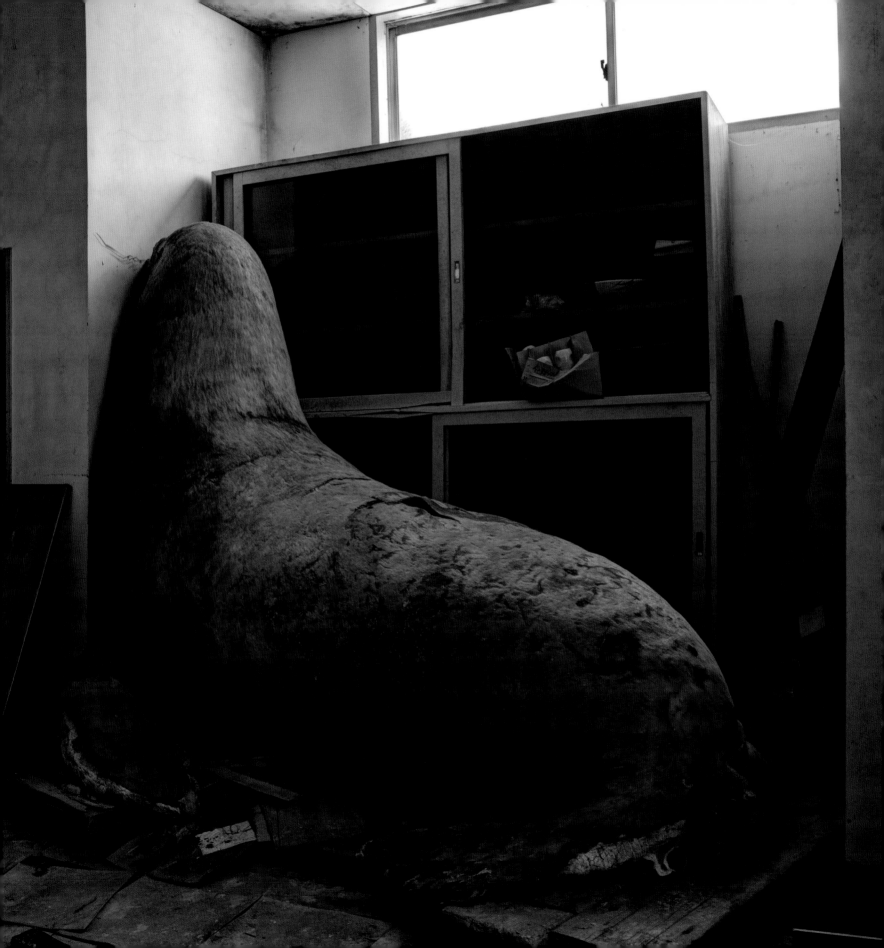

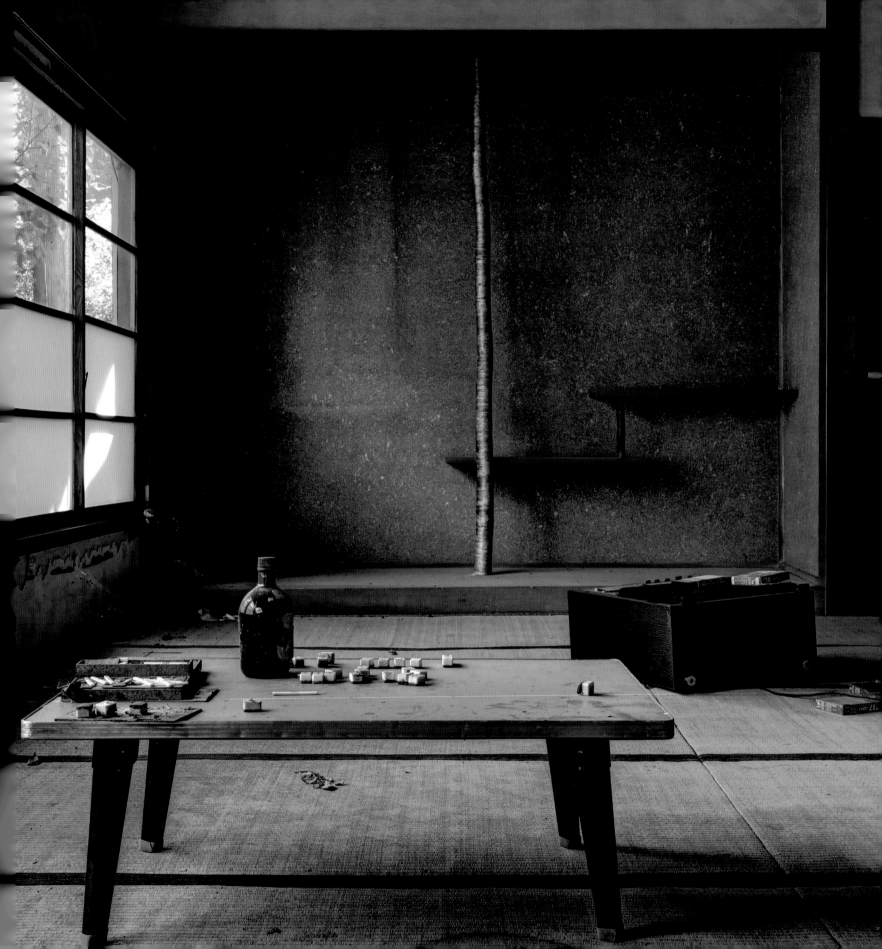

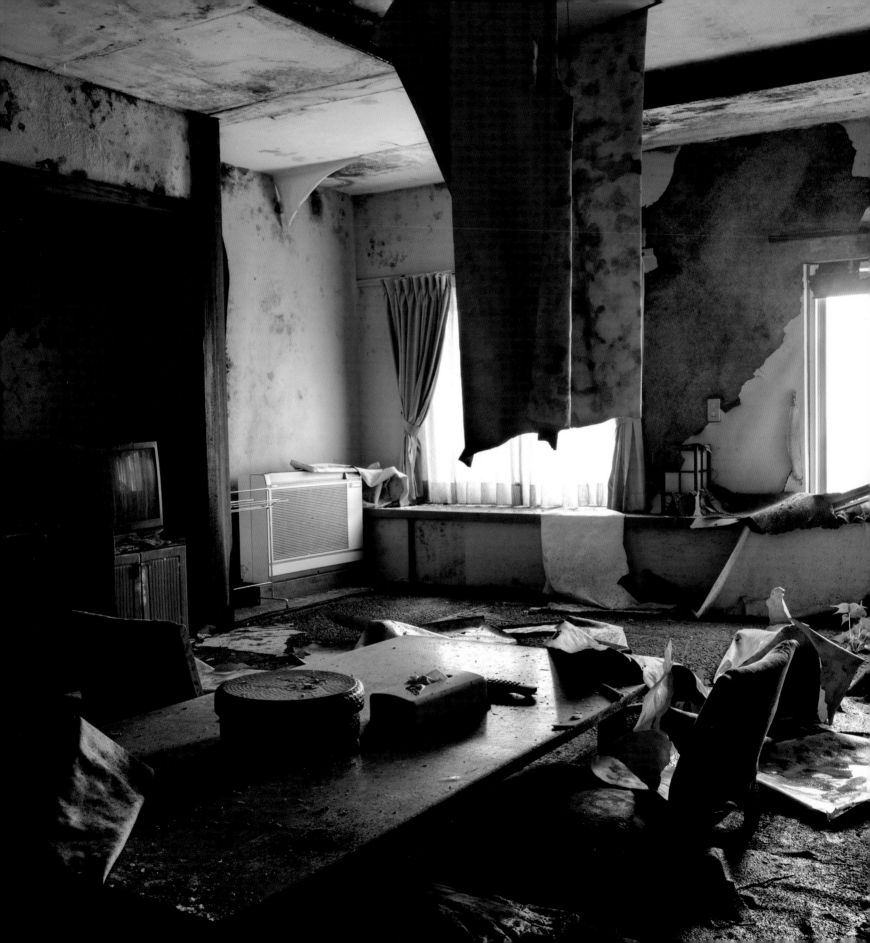

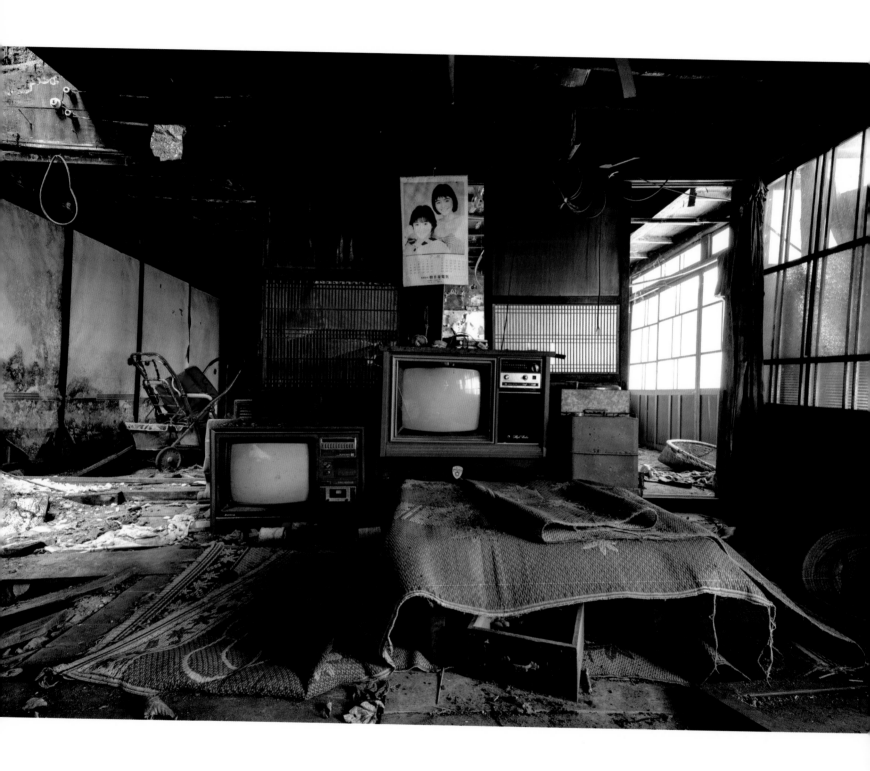

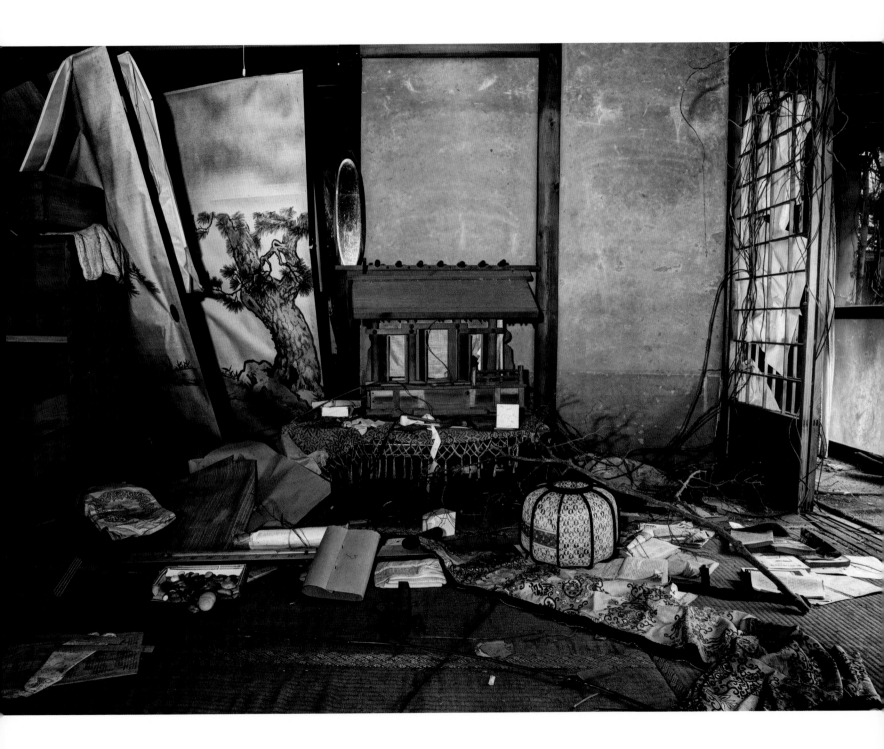

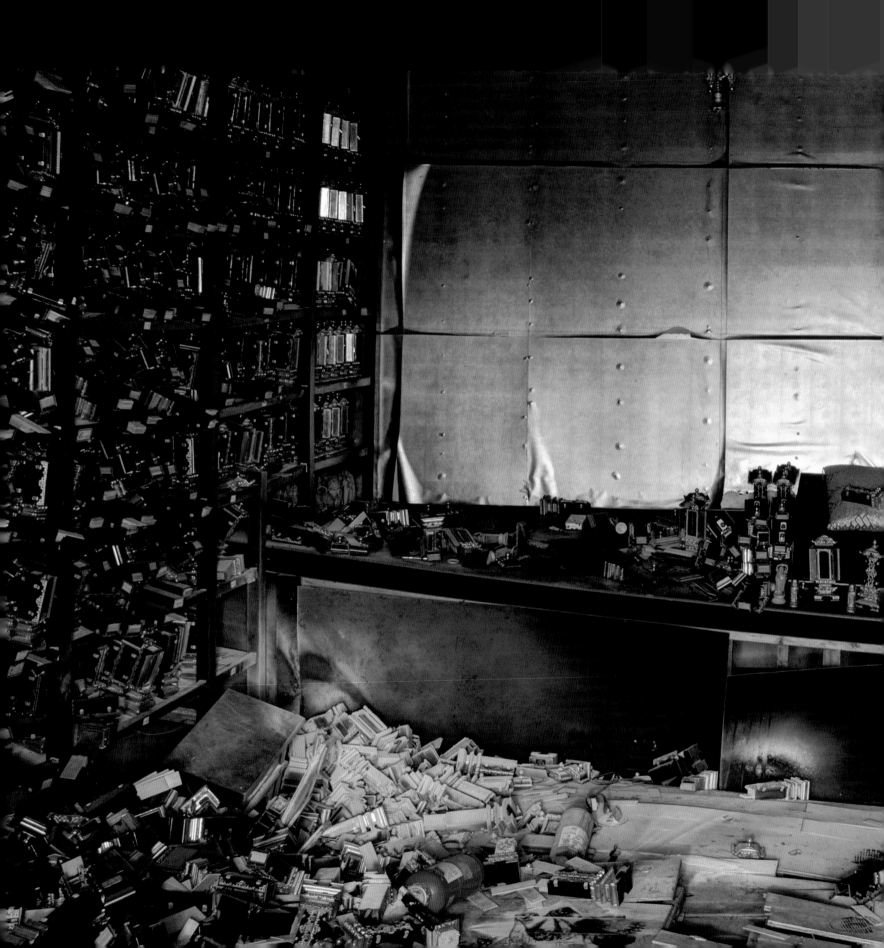

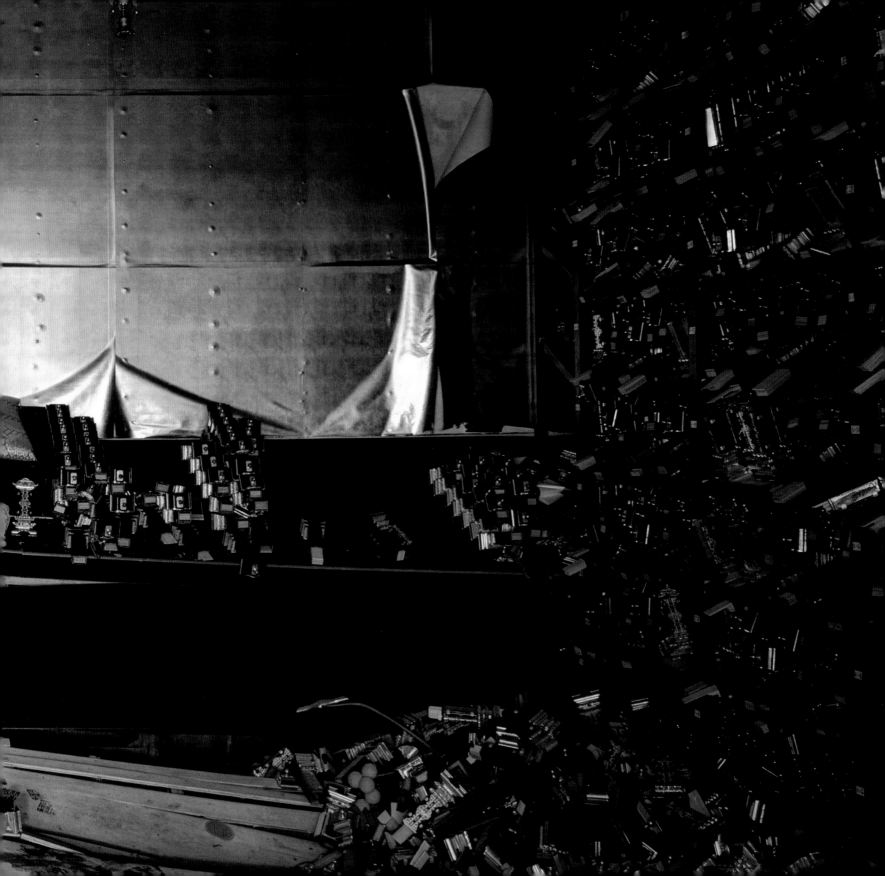

ACKNOWLEDGEMENTS

I would like to thank my parents Rick and Joan Thoms for their unconditional love - this book is dedicated to you.

I would also like to say a very special thank you to Andrew Katsonis, Karen Eager and my buddy Fuku (Darkness_Forest). Thanks also to the mates I've made along the way – Daisuke Hirade (Hiradearts), Miho (Shikibrand), Mayumi, Yasuto (8st), Ayato (Espinas3) and Moti (_krampus_).

More thanks to Katherine (Kat) Hayes and Elizabeth Flux for their editing skills and to Otsuki Toshiya and Tatsuro Hashiguchi for helping me with my Japanese. Many thanks also to Vanessa Grall from Messy Nessy Chic for blogging me.

Much love and respect to the masters, Robert Polidori and Shinichiro Kobayashi whose work will always will be a constant source of inspiration and awe.

And finally to Japan (love you with all my heart).

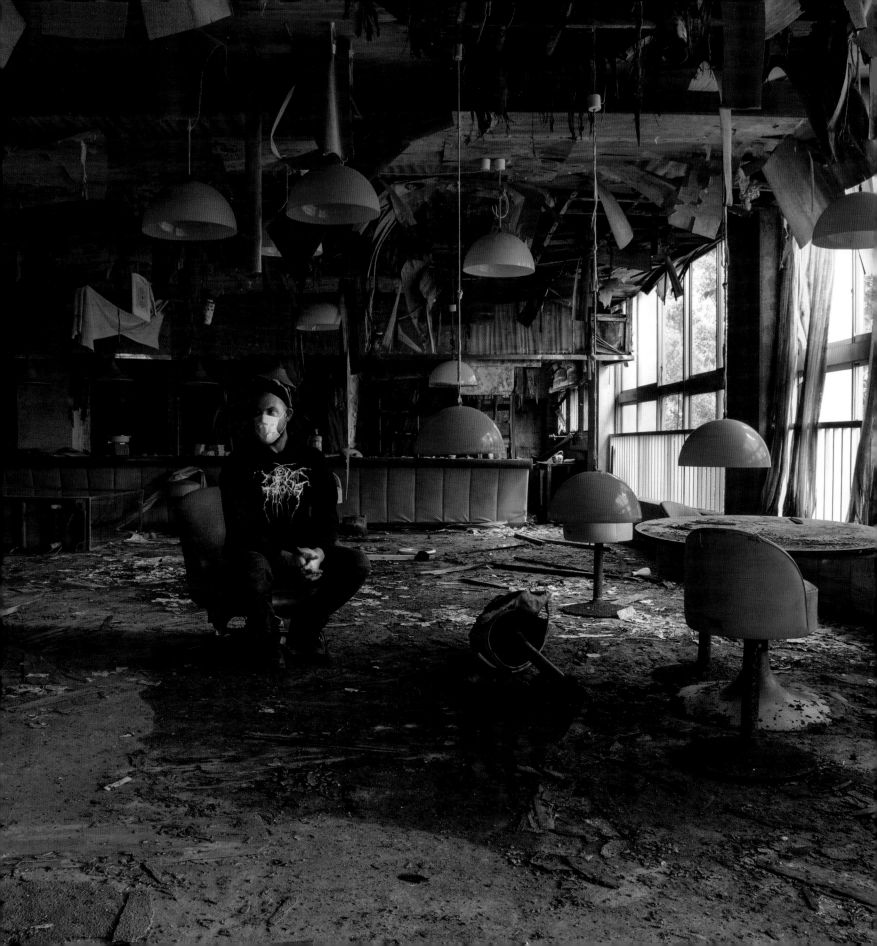

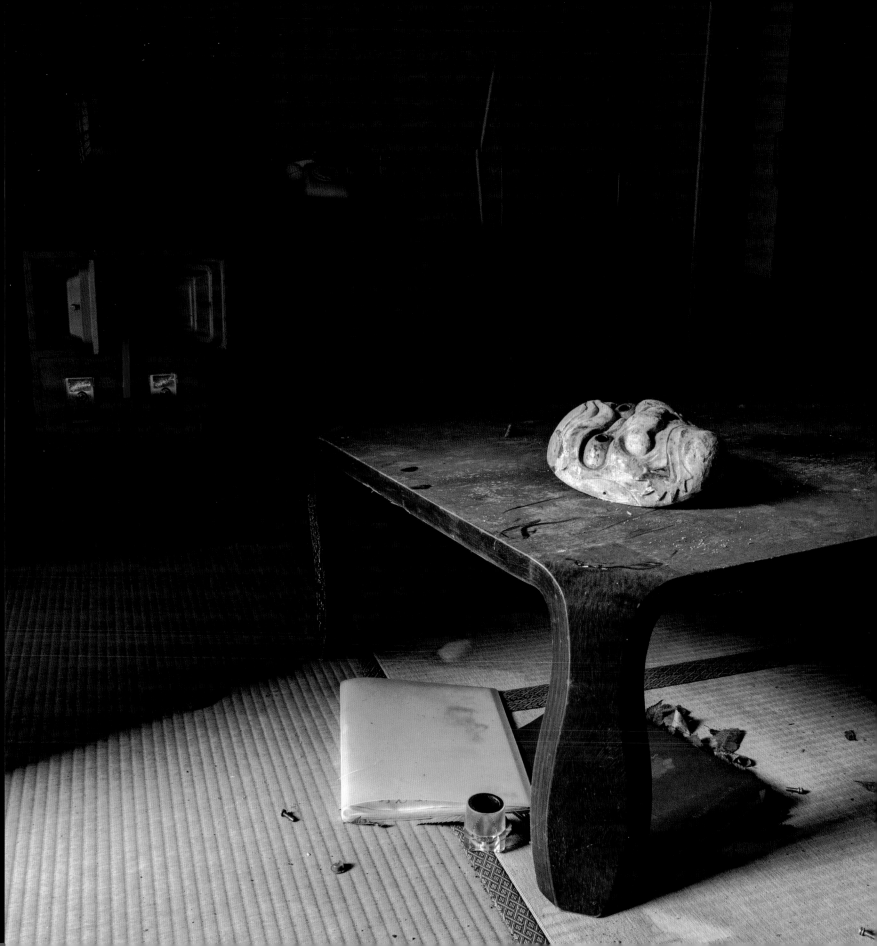